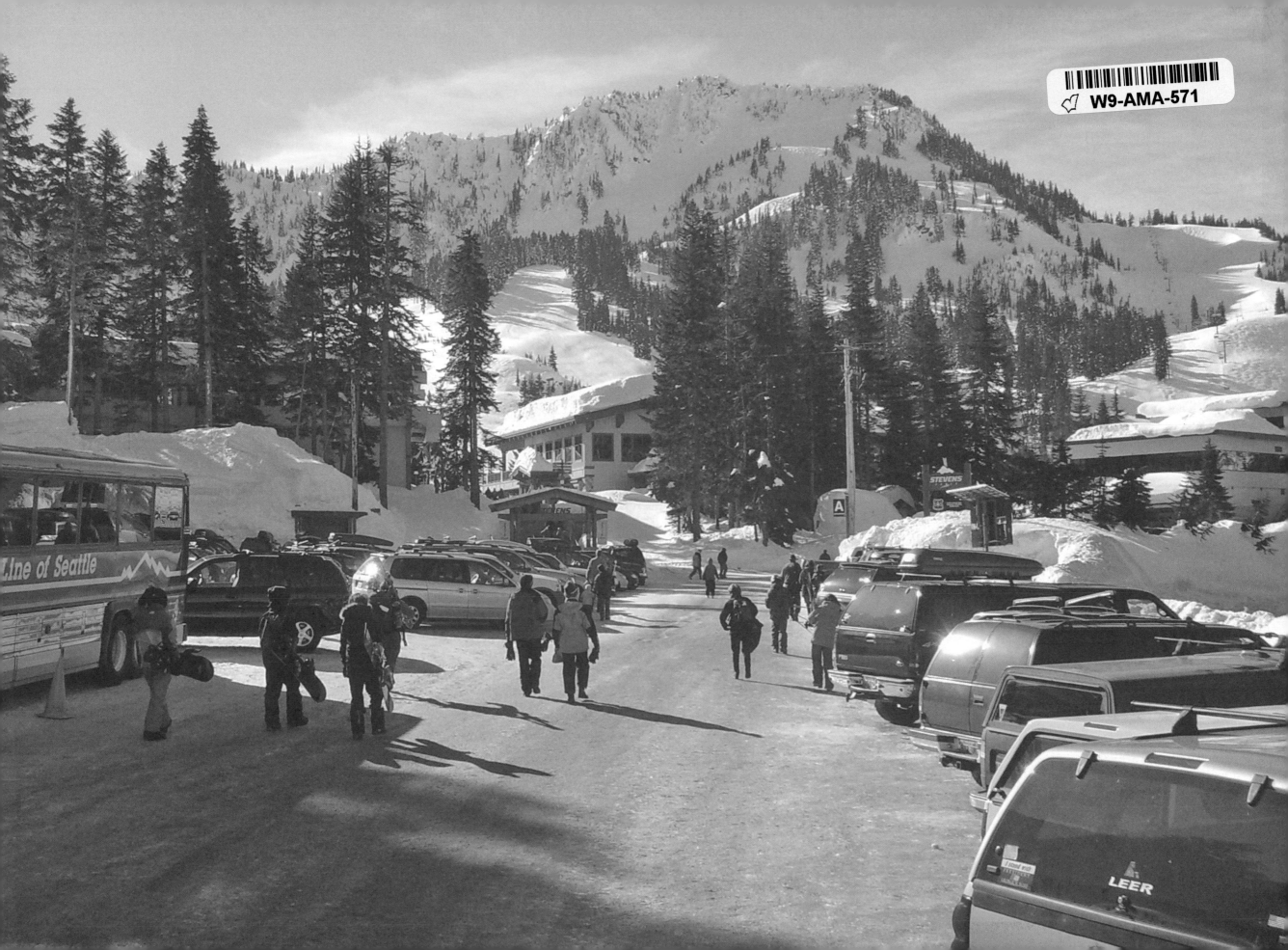

WASHINGTON THEN & NOW

TEXT AND CONTEMPORARY PHOTOGRAPHY BY

PAUL DORPAT

AND

JEAN SHERRARD

WESTCLIFFE PUBLISHERS

westcliffepublishers.com

CONTENTS

Introduction

Washington Then & Now is Westcliffe Publishers' eighth offering in its "Then & Now" series, pairing historical photographs with contemporary shots taken of the same locations. The reader may know the fancier name for this convention: "repeat photography." Westcliffe's founder John Fielder devoted the first title to his home state, and when *Colorado: 1870–2000* was a huge success, he looked to other states, publishing books on Arizona, New Mexico, Texas, Utah, Oregon, and Ohio. Now, six years later, this initiative has reached the northwest corner of the country, with the 163 examples of Washington state "repeats" featured here.

A sampling of Westcliffe's early "Then & Now" books reveals affection, among historical and contemporary photographers alike, for sweeping, picturesque landscapes. We include these kinds of grand vistas, and we often also mix heritage with our natural spectacles. For instance, in our best view of the Olympic Mountains, they show as a backdrop for the first professional portrait of the nearly completed Clallam County Courthouse (see p. 60). We found the oversize glass negative for this commemorative 1914 photo on the bottom shelf of a glass case in a century-old antiquarian bookstore that was sadly going out of business. Other photographic finds have been similarly fortuitous, even extending to sidewalk treasures. Our bird's-eye shot of the brand-new Grand Coulee Dam (see p. 143) was uncovered in a yard sale. Other sources are more routine, like our oldest historical view of the now booming Bellevue. It features a barn recorded during a Depression-era photographic survey by a Works Progress Administration taxman (see p. 40). Ours is a young state with no centuries-old sun-baked pueblos. We build of wood, and we expect it to rot. Here, 1914 is considered early history.

Our mountains, however, are both old and young, and we have some distinguished volcanoes among them. Both Mounts Rainier and St. Helens are obligatory photographic subjects and we include them here. We are also a state of lakes—thousands of them. At the end of the last Ice Age, they were splashed across the Northwest as if by a painter swinging a dripping brush. Fishtrap Lake is our example of one of these serpentine waterways, which may run for a few hundred feet or a few miles through our beautiful but unfairly named "scablands." Many of these lakes are noted for their rainbow trout, Fishtrap included.

The Columbia River is ours, 745 miles of it, and we happily share the last 250 miles of the "River of the West" with Oregon. Washington was ready to be named Columbia until Richard H. Stanton, a congressman from Kentucky, made the last-minute change. Not the brightest of political candles, he thought "Columbia" would be too easily confused with "District of Columbia," and now, instead, the two Washingtons refer to each other as the "other Washington."

We can certainly brag about what the pioneers called the "Mediterranean of the Pacific," our Puget Sound. At its widest point, Washington State is barely 450 miles across, but with Puget Sound, the length of its marine shoreline is five times that. The Olympic Peninsula rises between the Pacific Ocean and Puget Sound like a theme park for outdoor enthusiasts, with whistling elk, screeching jays, and stunning mountains. Parts of the state—the valleys on the east side of Puget Sound and the rolling hills of the Palouse—are so fertile that farmers who enter their fields at daybreak during growing season may have a hard time finding their way home in the evening. Paul Bunyan retired here in Washington, accompanying his literary creator, James Stevens, from the Midwest in the 1930s.

To cover the state's geographic and demographic diversity, we divided the book into 10 regions. Generally, our sectioning of the state has been conventional. Our few oddities more often result as a desideratum of design. Hence, Tekoa may have fit better spiritually with its Palouse neighbors in the section titled "Southwest Corner," but wound up instead with Ritzville in the "Spokane and Vicinity" section. But then, as the "Heart of the Inland Empire," Spokane thinks of its surrounds as reaching well into Montana and Canada. I know this from having delivered the *Spokane Spokesman Review* in my early teens.

The oldest photograph we use here is of Henry and Sara Yesler's home in Seattle's Pioneer Square (see p. 37). It is conventionally dated 1859. But two of our favorite historical landscapes are far from pioneer in origin: Horace Sykes' post-WWII view of the rolling Palouse from Steptoe Butte (see p. 118) and the Seattle Water Department's record of the Tolt River valley when it was being prepared for the city's second protected reservoir in the Cascade Mountains (see p. 42). One historical scene we chased but could not catch was the record of the lighthouse and longhouse on Tatoosh Island (see below). Finding no one to transport us to the island for a repeat shot, we gave up, and that failure also dashed our plan to feature the five farthest points of the state. Still, we came close with nearby alternatives.

The lighthouse on Tatoosh Island

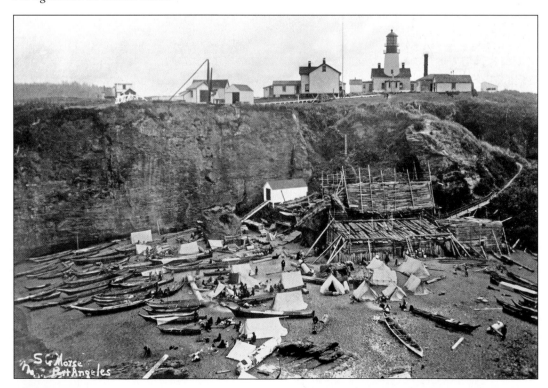

The pleasures of repeat photography have been a weekly routine for me for nearly a quarter of a century. My early forays into publishing repeat photography included the "Seattle Now and Then" feature for *Pacific Northwest Magazine* in the *Seattle Times* and, later, several books. For *Washington Then & Now,* I had imagined doing another book of Washington "repeats," but increasingly suspected that I could not accomplish the task alone. However, once Westcliffe asked, the solution was at hand: author, thespian, teacher, and parent Jean Sherrard. Jean and I have worked together on several stimulating projects, and, I reasoned, he wouldn't likely refuse the chance to explore the state for historical scenes, with the Nikon in hand to repeat them.

It also helped that Jean was much younger and braver than I, and prepared to reconnoiter the state's byways whenever the light was right. The fact that Jean stands 6'7", the better to see above the trees, helped, too. Although I joined him on a few of these adventures, ordinarily I stayed near my desk, the library, and the Internet, ready to respond when Jean checked in for one of our frequent telephone "reports and advisories." In effect, through much of this production, I was Jean's travel agent. Consequently, I dedicate this book—or my part in it—to the coauthor.

A number of other people made this book possible, both directly and indirectly. By coincidence, and a generation apart, Jean and I both took several literature classes from Whitworth's Professor Clarence Simpson. Because of Dr. Simpson's consistently wise and generous instruction, we join to also dedicate this book to him. Actually, we may owe it to the good professor, for both Jean and I were frankly too outspoken during many a class discussion.

Gladys Engles

Or we might have dedicated the book to Gladys Engles, whom we visited in her Sprague home during the summer of 2005. Confident, erect, and warmly commanding, the 96-year-old was a font of Lincoln County history—in 1982, she published a 927-page centennial history of Sprague and its suburbs. She introduced us to the long life of Main Street, and we include a few of its faces in the pages that follow. In the spring of 2006, Gladys did not survive a fall on the front steps of the Sprague Community Church. We will remember her because she remembered so many. Dozens of others also helped in the creation of *Washington Then & Now,* and they are thanked in the acknowledgments on page 155.

We also thank the state's historical photographers such as Frank Matsura in the Okanogan, the Libby Studio in Spokane and beyond, Asahel Curtis in Seattle and beyond, and more recently Boyd Ellis, an Arlington-based "real photo" postcard purveyor who knew the state's highways better than AAA and the Department of Transportation. Over the course of 40 years shooting Main Streets and much else, Ellis returned to many destinations dozens of times. We thank Matsura, Libby, Curtis, and Ellis for the quality and quantity of their work, but also thank them as representatives for all the other photographers we have leaned on. And, of course, we also want to thank their collectors, public and private—especially the sharing ones such as Dan Kerlee, John Cooper, and Michael Maslan.

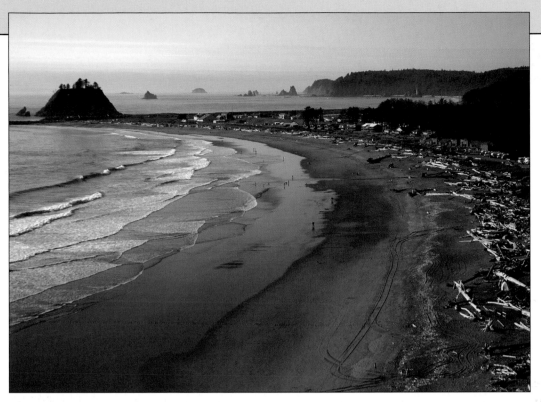

First Beach, taken from the headland cliffs looking north to La Push

In 1839, Louis Daguerre introduced photography to the French Academy of Sciences with the daguerreotype, a process that develops a wonderfully detailed copy of what it records. The Academy promptly gave Daguerre a pension and publicized his technique to the world. How much time needed to pass before it occurred to Daguerre, or more likely someone else, to return to a subject and record the changes? That, if we could find it, would be the first photographic "then and now." But the lessons and pleasures of this convention predate photography at least to the Renaissance, when artists, having learned the rules of perspective, recreated with pen and ink the landmarks of ancient Rome by extrapolating from their ruins. It occurs to us that with our repeat of Sam Hill's road at Maryhill (see p. 109) that we, too, have given you ruins to study.

The opportunities we have had these last two years are enviable. And it was, of course, a treat—rather like having parents who reserve time to take their children on trips and vacations all around the state. But hold on—those were our parents! The Washington travels of Reverend T.E. Dorpat and family took place during the excitement of the post-war 1940s, while the explorations of Dr. Don and Edith Sherrard and family began in the mid-1960s and have not stopped. Every year for the last 40, the extended Sherrards have made it to La Push (above), a site featured on page 72. For our families and countless others, these places come to comprise the texture of our personal histories. We hope that *Washington Then & Now* succeeds in weaving together all these personal memories with the collective history of our impressive, beautiful, and dynamic state.

—PAUL DORPAT

Reflections

In her book *Babel Tower,* the great English novelist A.S. Byatt describes a remarkable feeling. Familiar places, places in which our ancestors lived and died, are understood, or at least sensed, on a cellular level. "Every inch of this turf," she writes, "has absorbed . . . knucklebones and heartstrings, fur and nails, blood and lymph." There is, in this vast sense of continuity, a comfort and even a pleasure to be had. It provides a context for one's place on the earth—historical, cultural, and familial. But it is a sense that Americans—save, of course, those who were here when Europeans first arrived—never experience. Simply, we just haven't lived here very long. The places most of us walk were not trod by our ancestors for thousands of years, are not lodged in our bones, and cannot be understood in our cells.

My own family history is a case in point. My great-great-grandmother arrived in Seattle in the 1880s, and 120 years later, I still feel like a newcomer. One advantage to this newness: As immigrants and descendants of immigrants, with relatively shallow roots, we can pack up and go wherever we want and call it home. The lack of moorings gives us great freedom and flexibility, but often at the cost of that sense of context Europeans glean at an early age.

Lake Chelan, circa 1914

The hairpin turns of the road between Lake Chelan and the Columbia River are only dusty traces on a ruined bluff alongside today's Highway 150; the distant hills provided the key to locating this site.

With this book, we attempt to split the difference, exploring those elements of rapid growth and change that define this country for better or worse, and finding our "context"—if that is not too inadequate a word for the task—within those changes. How do we fit into a landscape that's constantly shifting beneath and around us? We build and rebuild, tear down and build anew (for an extreme example, flip ahead to the then-and-now photos of downtown Bellevue on pp. 40–41). Is there a place for us in that whirlwind? What have we lost and what have we found? Our attempt to document a few of those changes doesn't actually answer these questions. But somewhere in the tension between what was there then and what is there now resides the clue. I found a piece of it when I knew—from the way the rocks lined up on a distant hillside or the way the eave of one old house stood in relation to another—that I was standing in the footsteps of the historical photographer. The satisfying clunk I felt was like a piece of an enormously complex puzzle dropping into place.

Several years ago, as Paul and I were waiting at a stoplight on 2nd Avenue in Seattle's Belltown, I asked him to recount what he saw out of the passenger-side window. He launched into a narrative that boggled my mind. As if looking with X-ray vision right through the mortar and bricks and steel around us, he began describing another world: a homestead here, a mansion there, a hill that no

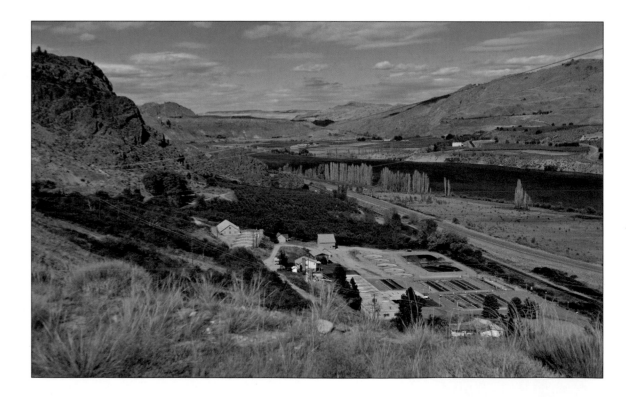

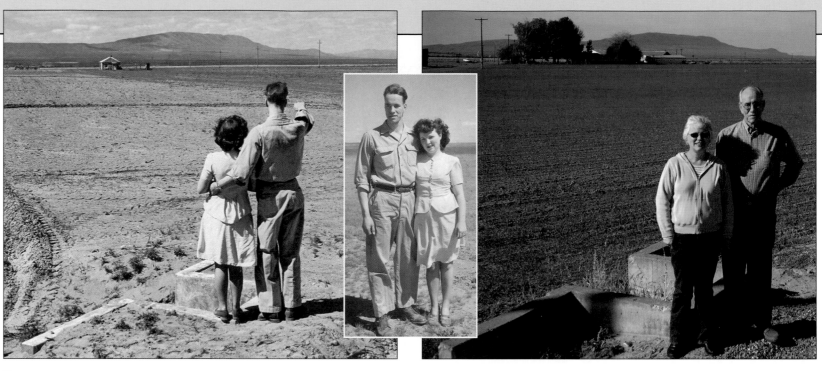

longer loomed, buildings whose footprints were buried under ever larger footprints of larger buildings—in short, layers upon layers of history that rose up in his telling like ghosts peering over their own gravestones. The study of history teaches us not so much about the passage of time as the depth and complexity of that surface we have assumed is flat. Paul's prodigious knowledge and memory combines with a genius for teasing out truth from grains of evidence; he is like an archaeologist building up a vision of civilization from a few shards of pottery and a jawbone. It can't hurt that his abilities include a preternatural skill at arm-twisting. One of his old friends and arm-twistees has given this ability a name: Dorpassion, he calls it, and once you've experienced it—as many who gave us aid and comfort around the state did—you're unlikely to forget it.

On my trips back and forth across the state, Paul was much more than a travel agent, as he modestly describes himself. His omniscient, occasionally divinely inspired, voice on the phone guided me along the most

Pasco, 1949

Newlyweds Warren and Audrey Clifford (below) moved from Puyallup in January 1948 to begin a new life as farmers. The first to acquire land in the newly-irrigated Block 1 Water District on Pasco Heights, they posed for this Bureau of Reclamation publicity photo in 1949. Their first crop, planted on 50 acres, was red clover seed, alfalfa, and red beans. Warren credits the Farmer's Home Administration with their early survival. In the repeat photo, Warren, now widowed, stands with his daughter Gloria (who lives in the original farmhouse at upper left) next to the same concrete abutment. Warren lives a couple of miles away amid cherry orchards overlooking the Columbia.

remote of blue highways. A sample of that advice: "You are now traveling north-northeast and should come to a gentle curve to the south in about two and a half miles. After that, the road will straighten out and head due east for 4 miles. Watch for a small cluster of buildings coming up on your right." His mastery of Google maps and its accompanying satellite imagery is astonishing.

Not that there weren't moments of friction. On occasion, maps can be imperfect records of reality and the handful of times when our tempers flared inevitably involved collisions between the map world and the real world. On Highway 150 between Lake Chelan and the Columbia River, I found myself furiously scrambling down a crumbling cliff face, determined to prove that the old switchback road in our historical photo (opposite page) no longer existed and that I was as close as I could get to the original prospect without a helicopter. Paul insisted that I must be in the wrong spot, and I swore I could see the cliffs in the distance lining up properly. If we hadn't been separated by several cell phone transmission towers, we might have strangled each other.

For the curious reader, a few more facts, technical tidbits, and credits: The first photo I took for this book was of Husky Stadium in the autumn of 2003. The last was taken leaning out of a small two-man helicopter above the town of Snohomish in the spring of 2006. I put more than 15,000 miles on my car, two-thirds of that in 2005 alone. All of my photographs were taken with a Nikon D70 and a Nikon D200, both light and sturdy enough to mount on 10-foot poles and carry up ladders or down

cliff faces. Digital format also allowed us to instantly send the images via e-mail around the state for advice and consent. General state histories that aided and abetted us throughout this project include the masterful *Exploring Washington's Past: A Road Guide to History* (1990) by Ruth Kirk and Carmela Alexander; the WPA classic *Washington: A Guide to the Evergreen State* (1941); historylink.org, a reliable font of information; and the encyclopedic *Building Washington: A History of Washington State Public Works* (1998) by Paul Dorpat and Genevieve McCoy.

After two years of work, Paul and I are still great friends: Oscar and Felix (I will leave you to work out who's who) and, perhaps, even George and Lennie (though Paul invariably describes me as Dudley Do-Right, given my height and jaw structure). And although he has expressly forbidden me from dedicating my portion of this book to him, I'll sneak in an acknowledgment to Dorpassion, which served to bring together all of the hundreds of people who helped inestimably in the making of this book.

—JEAN SHERRARD

Northwest Corner

Sunrise Lake • Whatcom County • Bellingham • Samish Bay • Chuckanut Drive • Edison • La Conner • Hotel Stanwood
Skagit River • Silvana • Everett Harbor • Snohomish • Sultan • Index • Eagle Falls • Skykomish Hotel • Stevens Pass

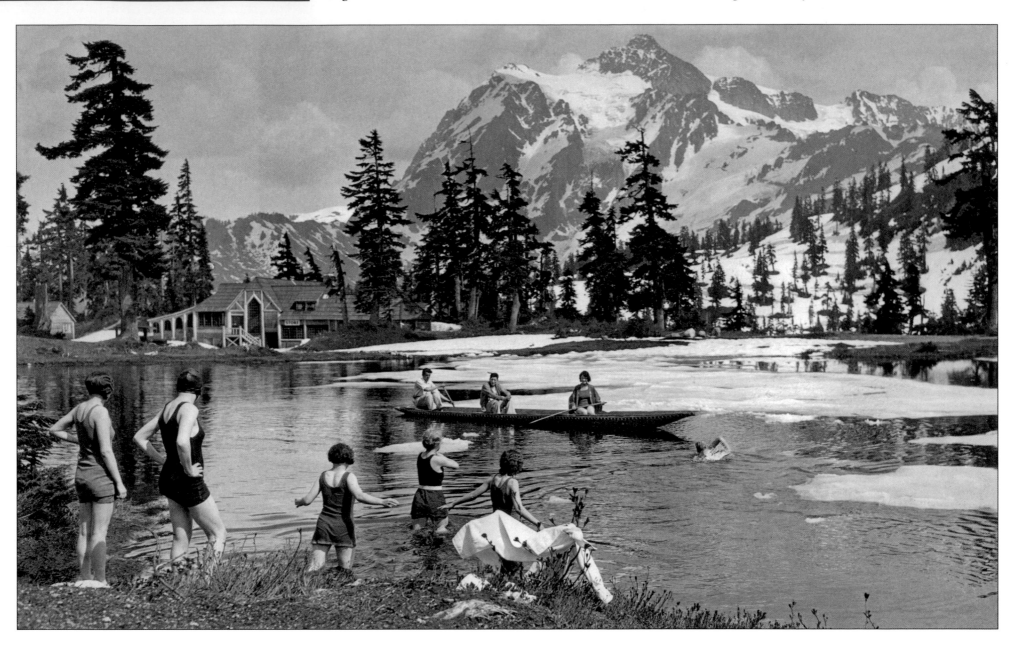

Mount Shuksan from Sunrise Lake, circa 1928

With the exception of Mount Rainier from Paradise Lodge, no mountain view in Washington has generated quite as much admiration as that of Mount Shuksan. Usually, it is reflected in Picture Lake or captured here, at nearby smaller Sunrise Lake. On the far shore in the historical photo is Mount Baker Lodge. Built in 1927 by Bert Huntoon, who also served as manager, the lodge entertained guests until it was destroyed by fire in 1931. On a spring afternoon during those few years, Huntoon photographed these exposed "polar bears" artfully testing the lake.

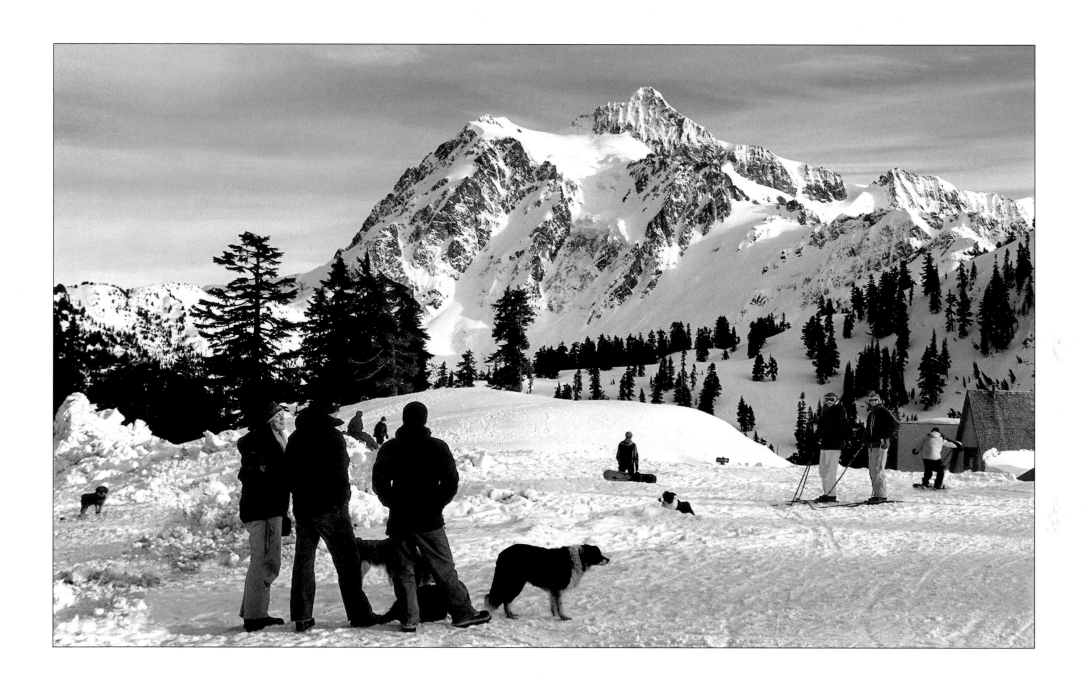

In the wintry repeat photograph by Grant Gunderson, everyone is standing on Sunrise Lake. Amy Howat, in profile on the left; her mother, Gail Howat; and Gail's sister, Bunny Finch, (both standing in cross-country skis and looking at Gunderson) are members of the family that has managed the ski facilities for the Mt. Baker Recreation Company for the last 36 years. And JoJo the border collie (in profile) has been taking it all in since 1996. —PD

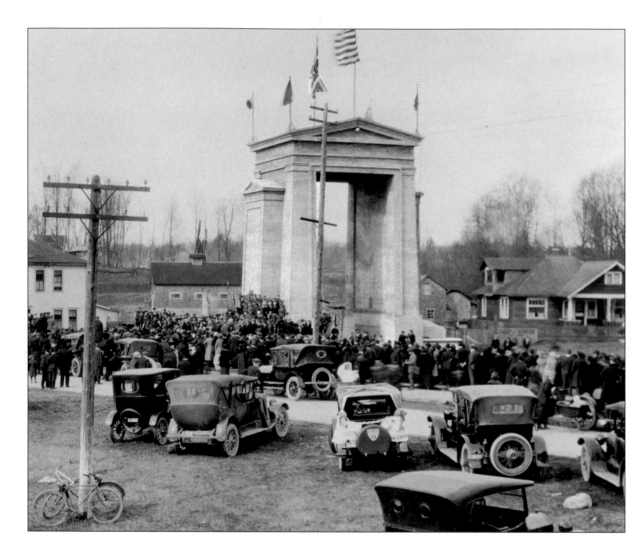

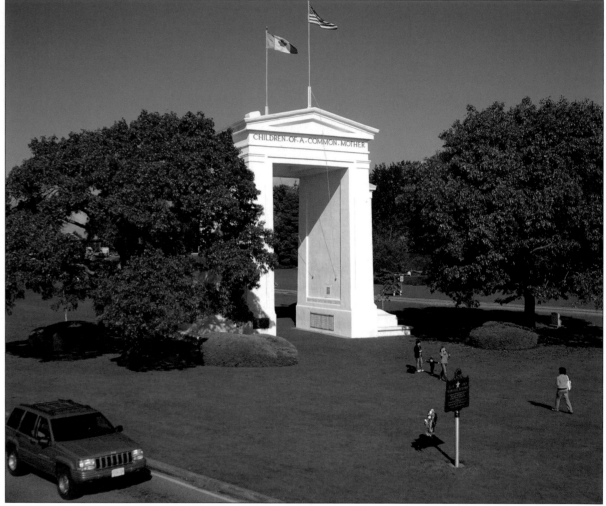

Whatcom County Landmarks, 1921 and circa 1898

Rising 67 feet above its own green sward, the Peace Arch at the U.S.-Canadian border between Blaine, Washington, and Douglas, British Columbia, was the inspiration of Sam Hill, the state's oversized promoter of highways, its "prophet of concrete." The monument to a peaceful border commemorates the centennial of the signing of the Treaty of Ghent, which ended the War of 1812, the last declared hostility between England and the United States. At the 1921 dedication, Hill placed inside the arch wood remnants of both the British steamship *Beaver* (the Hudson's Bay Company's first sidewheeler on the coast) and the pilgrim ship *Mayflower*. The September 6 dedication, captured by Asahel Curtis, was also an anniversary for the *Mayflower's* 1620 launch.

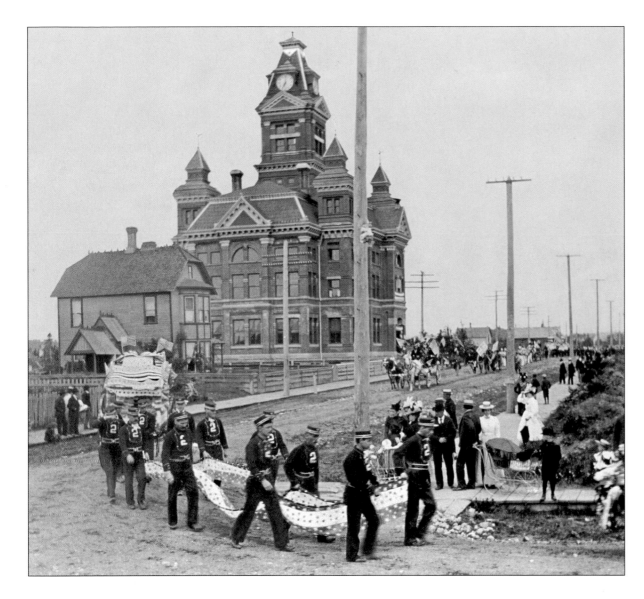
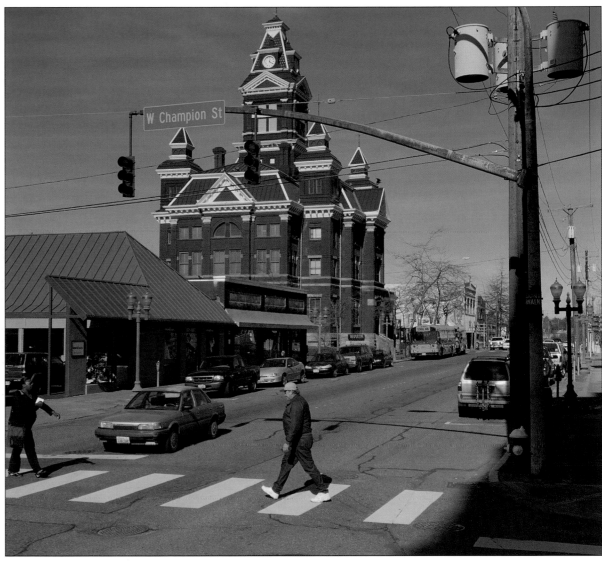

Bellingham's Old City Hall was nearly complete when the Depression of 1893 emptied town coffers. Unable to afford actual clockworks, the city fathers opted to paint the four sides of the tower with clocks set, unaccountably, to seven. Home since 1941 to the thriving Whatcom Museum of History and Art, the Old City Hall Building welcomes numerous visitors annually—and now boasts real clocks, as well. —JS

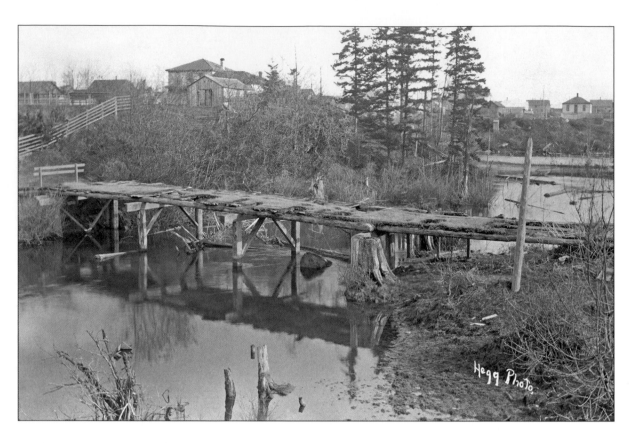

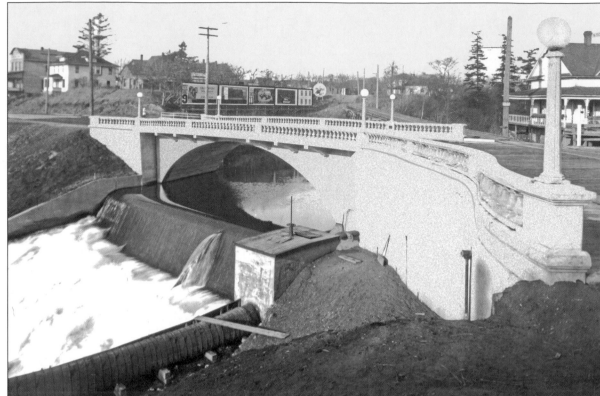

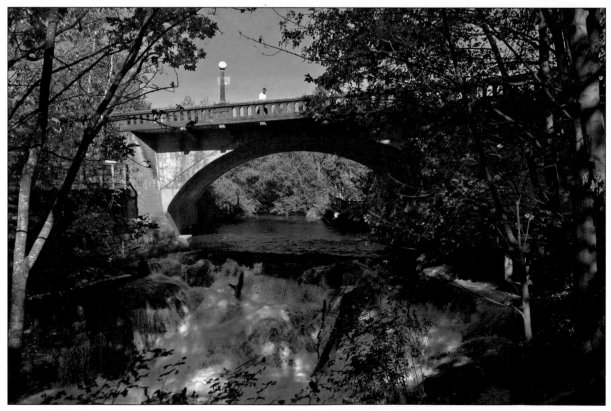

Pickett's Bridges, Bellingham, circa 1899 and 1919

Before he led his namesake "Pickett's Charge" up Cemetery Hill at Gettysburg, the Confederate general George E. Pickett was an army captain living in the town of Whatcom, or Bellingham, as it is now called. Pickett built this bridge as part of a military road to fight Indians or the British, depending on who proved to be the bigger threat. He and his regulars raised it in the summer of 1858, when Whatcom was briefly crowded with miners heading for gold—or so they hoped—on the Fraser River.

The Fraser River Gold Rush soon flopped, but not Pickett's Bridge. It survived until 1903, when it was without ceremony included in a "general cleanup" on Whatcom Creek. Local photographer Peter Hegg recorded the first Pickett's Bridge probably from the second, another timber structure that ran in the same general southeast to northwest direction. The second span was replaced by a third Pickett's Bridge, the 1918 concrete bridge recorded in 1919 by J. Wilbur Sandison. And it has survived for our recording as well. Aiming through its graceful arch, Jean has stepped back from Hegg's original angle to reveal the last of the Whatcom Creek cataracts, where it begins its fall directly into Bellingham Bay. If Pickett's original bridge were still in place, it would be easily seen beneath and beyond the concrete arch. —PD

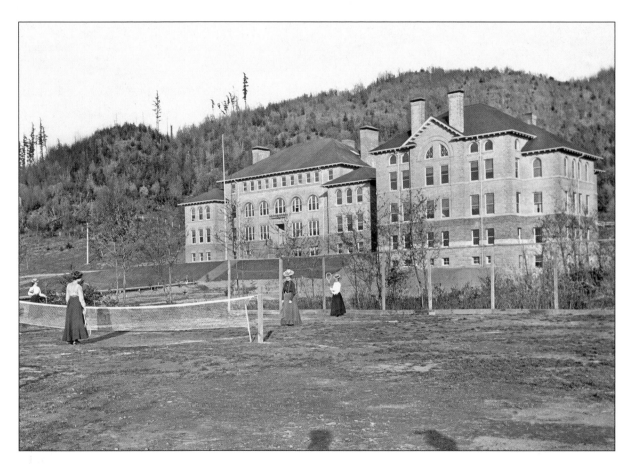

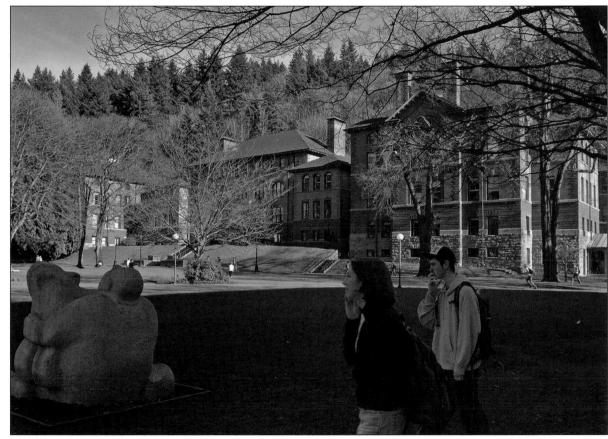

Old Main, Bellingham, circa 1905

Bellingham's Western Washington University has grown into the largest of Washington's three "normal schools," institutions founded in the 19th century for teacher education that eventually developed into universities. Sited below Sehome Hill in the mid-1890s, the school's first all-purpose home was sensibly named "Old Main." The architecture was also restrained, resembling the Boston Public Library. For some, the design was too grave, departing from the elaborately ornamental High Victorian style that was more popular at the time. —PD

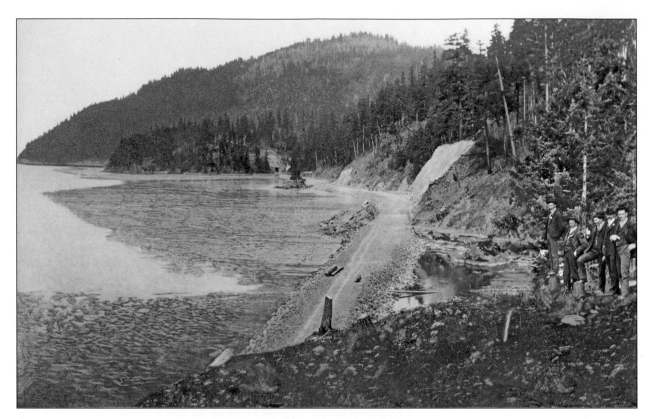

Windy Point/Samish Bay, circa 1902 and circa 1915

The names of the mostly young gents posing on Windy Point are lost to time. But Carl J. Johnson, a track inspector for the Burlington Northern Railroad, is intimately familiar with the rest of the landscape. This is a rare record of construction on the Great Northern Railway below Chuckanut Mountain. Johnson saw it first in Noel Bourasaw's periodical *Skagit River Journal of History and Folklore.* Johnson then climbed Windy Point and repeated the scene with a Burlington Northern freight train heading south from Tunnel No. 18 under Pigeon Point at Oyster Creek. You can see the entrance under Pigeon Point at Oyster Creek. The careful eye will find the dark opening to the tunnel by following the line of the track to Pigeon Point where it enters the still unfinished portal. A Great Northern 10-wheeler (left) heads south from Dogfish Point in this photo from about 1915. Chuckanut Drive is visible on the slope above. —PD

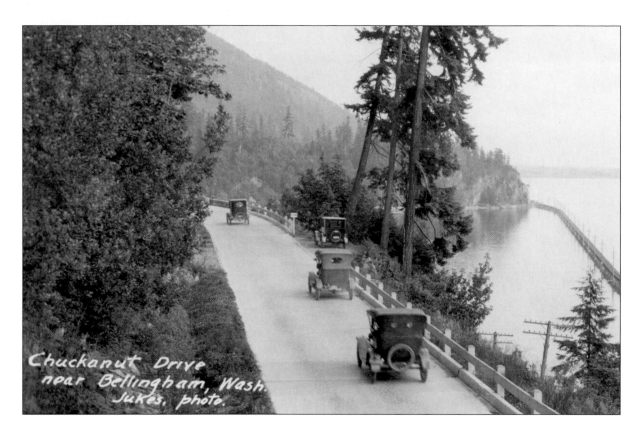

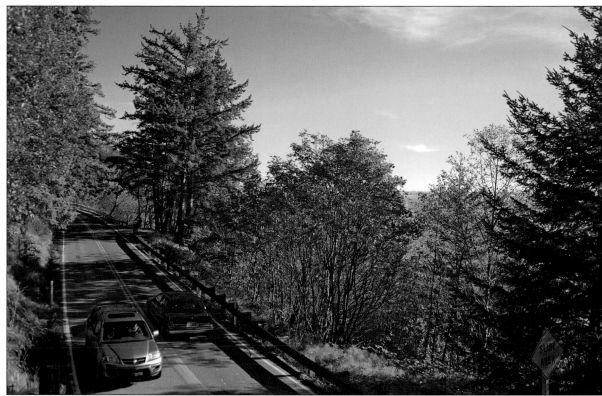

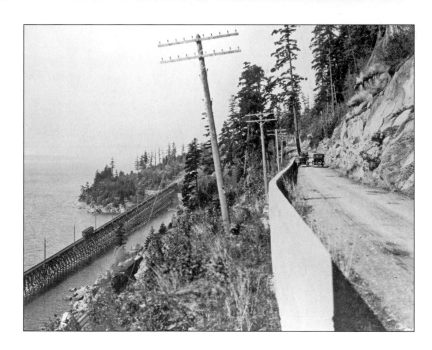

Chuckanut Drive, circa 1920

Delightful Chuckanut Drive originally provided a stunning series of uninterrupted Samish Bay vistas, repeatedly and deservedly captured by postcard photographers such as this Jukes' photo. Carved from the side of the hill by prison labor, Chuckanut was opened to traffic in 1916 and climbed instantly to the top of scenic drive lists, where it remains to this day. In the historic photo at right, Chuckanut Drive clings to the slope of Chuckanut Mountain and visible below is the trestle for the Great Northern railroad.

Our attempts to repeat this Bellingham photographer's photo were frustrated by a veil of trees, deciduous and evergreen, planted on the western side of the road by the highway department, presumably to encourage drivers to keep their eyes on the narrow twisty road. Finally, on my fourth trip, I found what I believed was the correct stretch of road and clambered up a 15-foot-high boulder looking for Jukes' perspective. A hundred yards down the road, a now-vestigial turnout provided confirmation I was in the right spot. Alas, an enormous fir, grown up alongside the boulder, obstructed this view as well, requiring I make my best approximation of the angle using a 10-foot extension pole. Careful observers may note—or perhaps only imagine—the oncoming driver's somewhat grim expression as he negotiates a path between me and the Lincoln Continental traveling in the opposite direction. —JS

Edison, 1910

Named to honor inventor Thomas Alva Edison, cozy, flood-prone Edison has been celebrated for its community spirit since its beginnings as a post office and trading post in 1876. Situated a mile from Samish Bay and occasionally overwhelmed by the nearby Samish River, Edison and environs are comprised of rich dairy and farmland, painstakingly carved out of Skagit Valley tideflats. In this photo taken on the Fourth of July 1910, an Edison town band marches west to east, kicking up dust on what appears to have been a windless summer day.

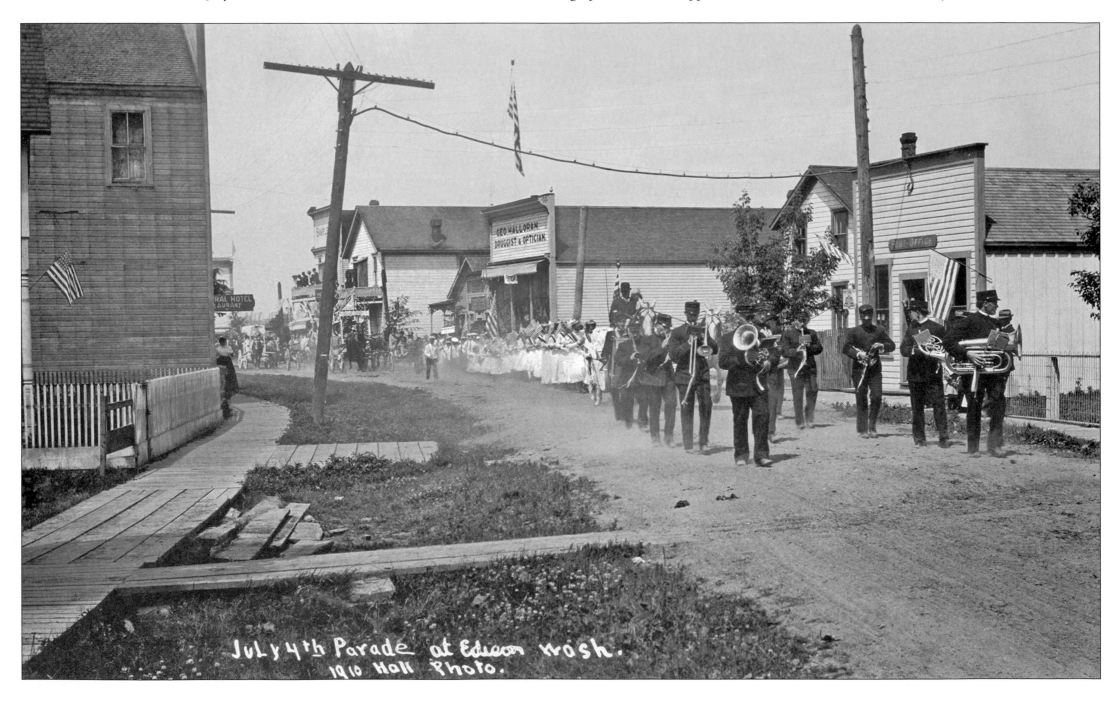

July 4th Parade at Edison Wash.
1910 Hall Photo.

In 2005, several hundred children participated in an annual tradition, the Halloween parade. Each year, they arrive at school in full costume and are released at lunch to march after the town fire engine. Parents gather along sidewalks to throw candy at the marchers, transforming Edison into a giant piñata. At the parade's end, Carmen Miranda and Kiss, amongst others, turned to face the camera. Credit must be given to eagle-eyed Edison denizen Nancy Williams, who recognized a singular post on the far left of the old photo and from that was able to determine the proper location for the "now" shot in an otherwise altered landscape. For our modern repeat, I widened the angle to lend the post a porch to support. —JS

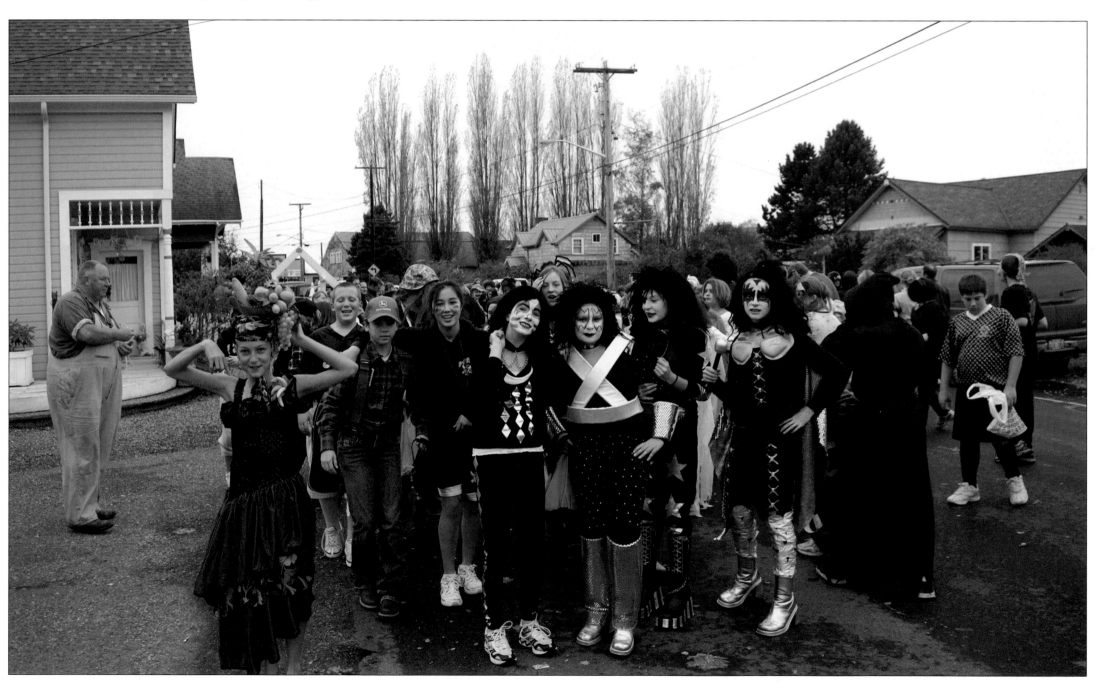

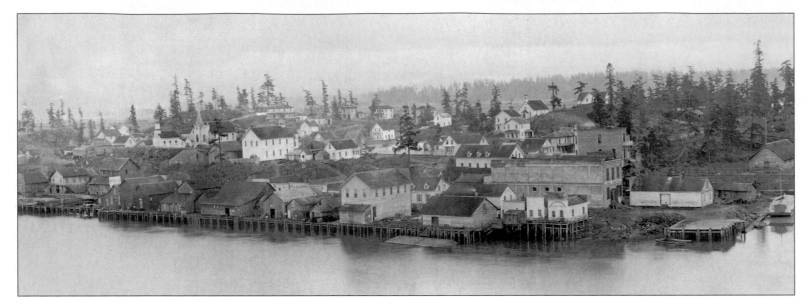

La Conner, circa 1896 and circa 1902

Devoted husband John Conner, La Conner's first permanent settler, named the town after his wife Louisa Ann. La Conner first prospered as a way station for the steamboats using the protected slough as a shortcut between Bellingham Bay and Puget Sound. According to Skagit Valley historian Noel Bourasaw, it was a burgeoning center of the hop, bay, and grain harvest from the surrounding flats. Subsequent economic developments ushered in canneries and a fishing fleet and, in the 1960s, a "low-rent" bohemian funk—now prettily gentrified and touristy, but still faintly smelling of fish and patchouli oil. The repeat photograph required a steep slog up a bluff overlooking Swinomish tribal lands. —JS

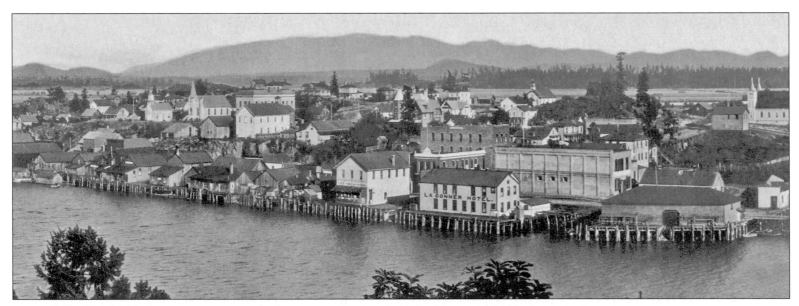

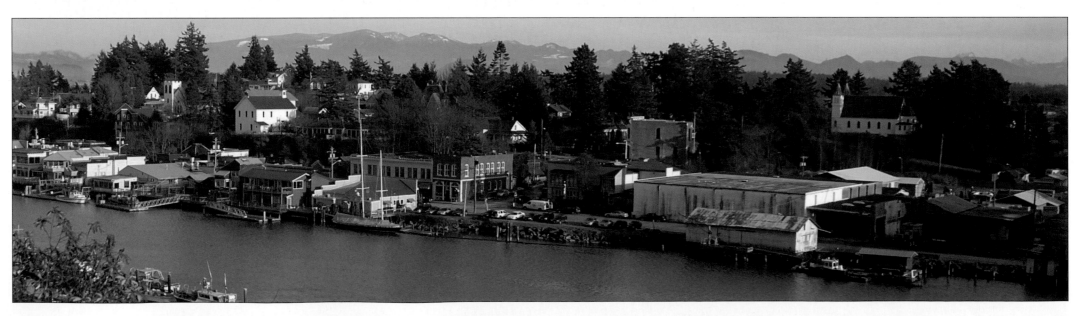

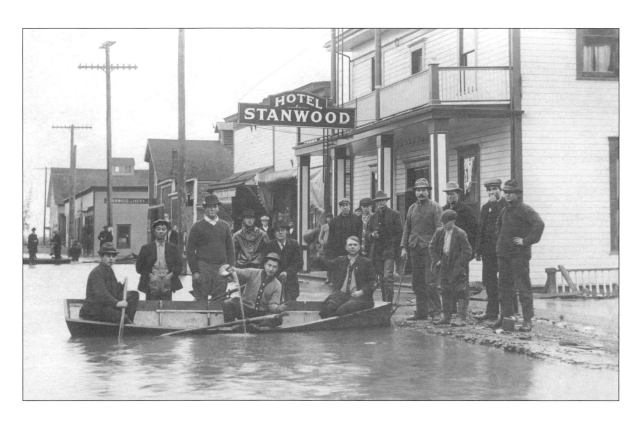

Hotel Stanwood, 1909 or 1911

This tableau of posing citizens was artfully arranged either in 1909 or 1911, both big flood years. Raised by sturdy Norwegians from a flood plain at the mouth of the Stillaguamish River, Stanwood was a town that could expect to be flooded. The Hotel Stanwood on Market Street was built after the "great fire" of 1891 destroyed most of Stanwood. Big fires were commonplace in Washington towns, which were built mostly of lumber. But fires also spurred a variety of "urban renewal" projects, with the burned buildings often replaced by grander ones such as the Hotel Stanwood.

The new Stanwood served as a temporary home, serving hot meals for many a logger. More recently, Maddog's Stanwood Tavern became the "punk rock capitol of the Northwest" until the city condemned the building. Vacant for a year, it was rescued for restoration in 2006 by a developer whose taste, it was hinted, ran more to country music. —PD

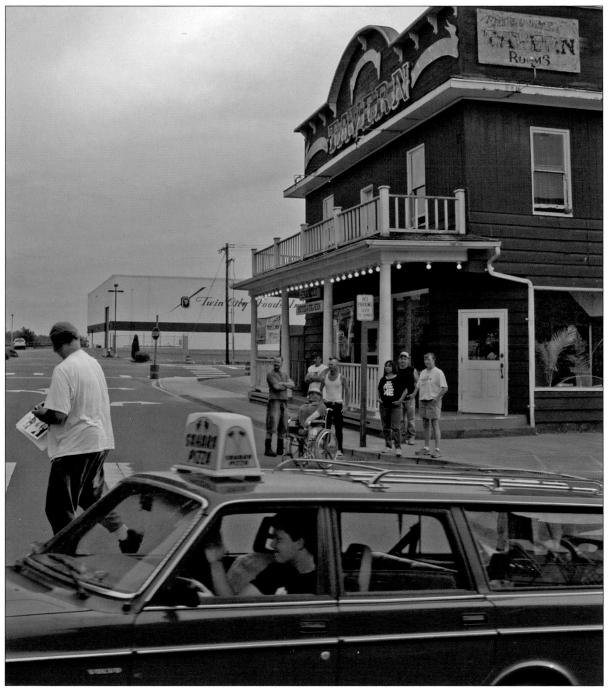

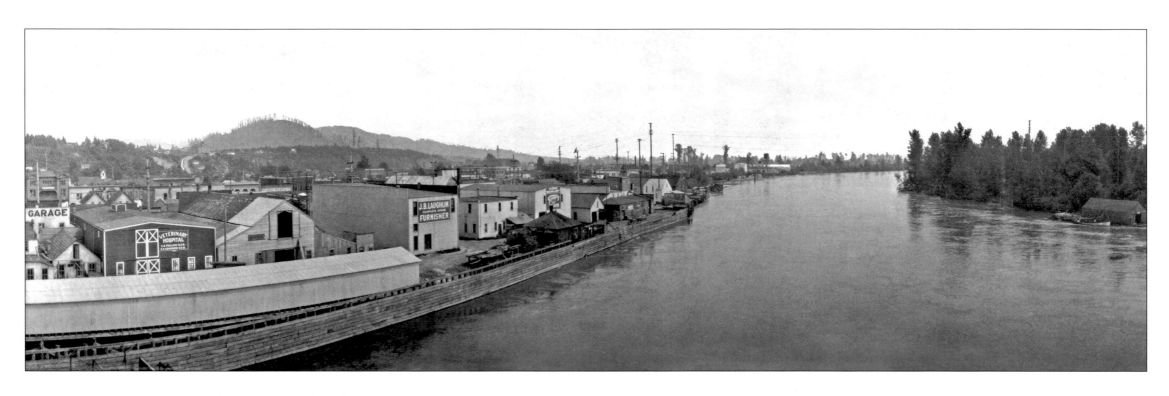

Mount Vernon on the Skagit River, circa 1920

It took nearly three years to clear an ancient logjam near Mount Vernon, but in 1878 the debris was finally removed from the Skagit River and the town became a busy port for steamers. The arrival of the Seattle & Northern Railroad in 1891 added to the town's economic prospects, but also lent hope after the city's "great fire" of the same year destroyed most of the businesses along the waterfront.

The first bridge to west Mount Vernon was built in 1893—a draw span that the bridge attendant opened by hand. Signs at both ends of the bridge announced: "$25 fine for riding or driving over this bridge faster than a walk." Mount Vernon now uses its third Division Street Bridge, built in 1954, to cross the Skagit River to the west side. Jean took the repeat photograph from its deck and over the housing that fits its swing span, capturing a delicate sweep of clouds and a scattered flock of crows flying to their roosts at sunset. —PD

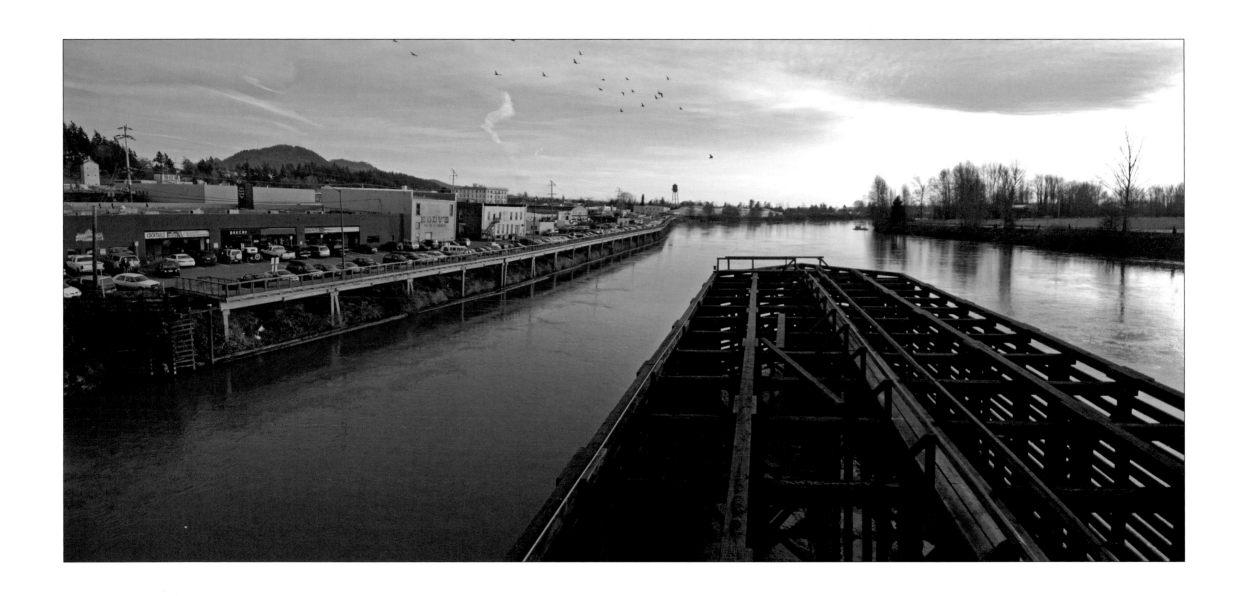

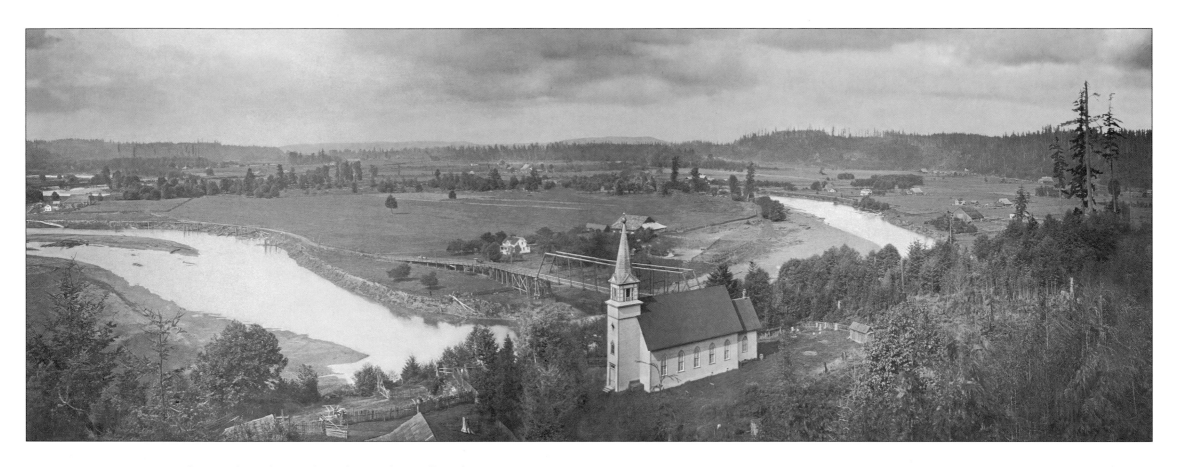

The Little White Church on the Hill, Silvana, circa 1900

Founded by Norwegian farmers in the 1880s, the town of Silvana faced both the blessings and curses of a fertile floodplain. To cope with the frequent overflow of the Stillaguamish River, the houses and sidewalks were raised several feet above ground level. It's little wonder that the congregants of Silvana Lutheran, led by their pastor Christian Jorgenson, elected to build their church on a hill. In 1890, spending a mere $750 on materials, the members built their church, donating their labor and clearing land for a small graveyard. Then and now, its view of the rich delta farmlands belongs in a Dutch master's painting. Today, the congregation gathers in a more suitable building in Silvana proper—now lowered to ground level—although "the little white church on the hill" is coveted throughout the spring and summer as a wedding venue. —JS

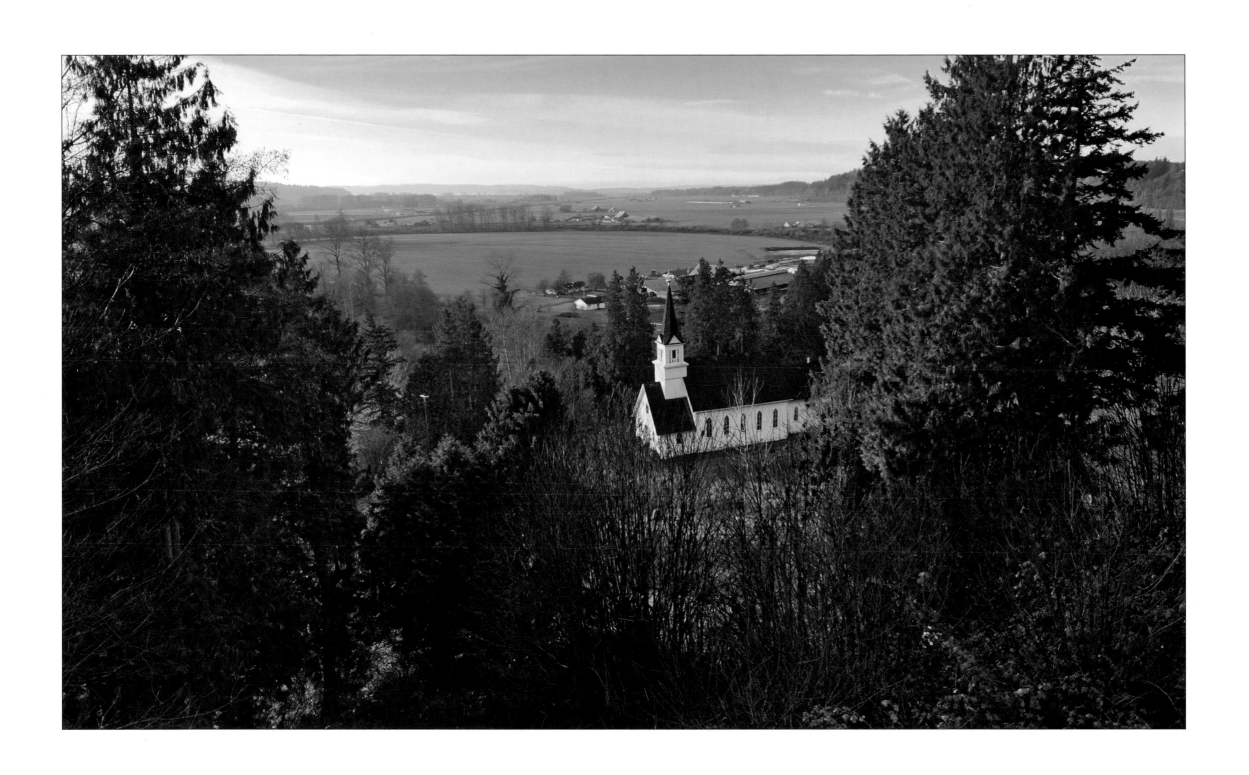

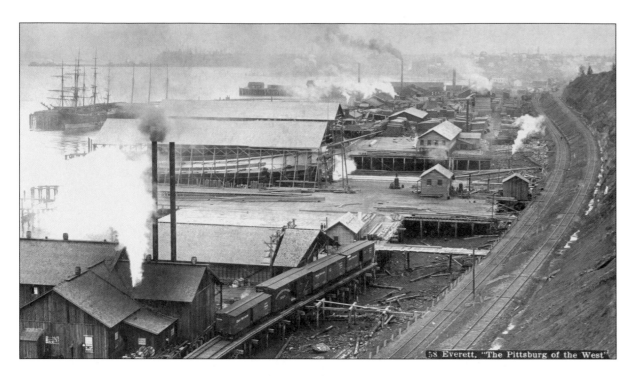

58 Everett, "The Pittsburg of the West"

Everett Harbor, circa 1904

In celebration of his wedding and successful real estate speculations, Bethel Rucker built his namesake mansion (right) on his namesake hill in 1904 as a present for his bride. He also hired Asahel Curtis to photograph the sweeping panorama (below) of the Everett Harbor from the porch. A century later, the view is mostly hidden behind a broken screen of trees (opposite page, at top), so Jean used the deck of a neighbor to gain an unobstructed shot. Everett photographer George W. Kirk's 1902 detail (left) of the same waterfront from nearly the same vantage is captioned "Everett, 'The Pittsburgh of the West.'" Pittsburgh, indeed—except this town was built of lumber, not steel.

—PD

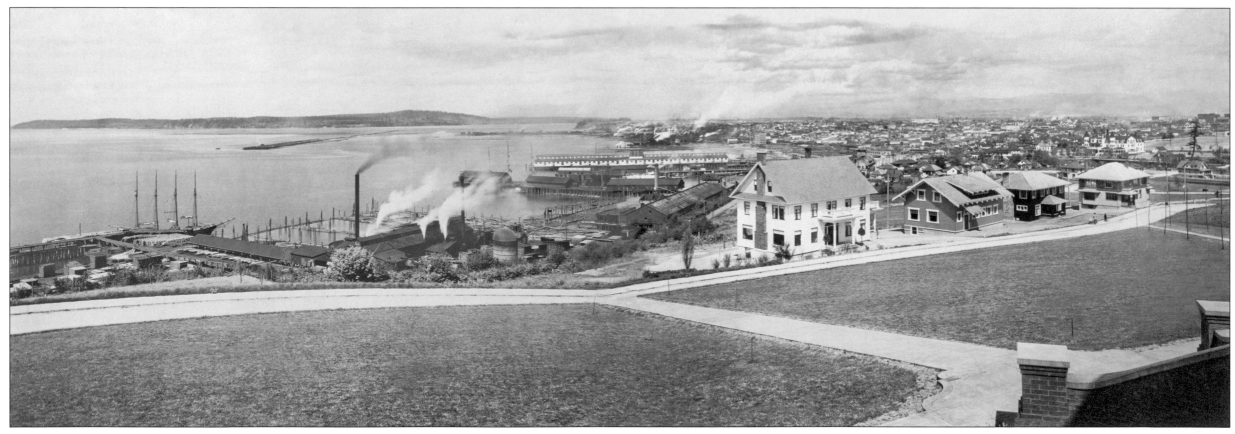

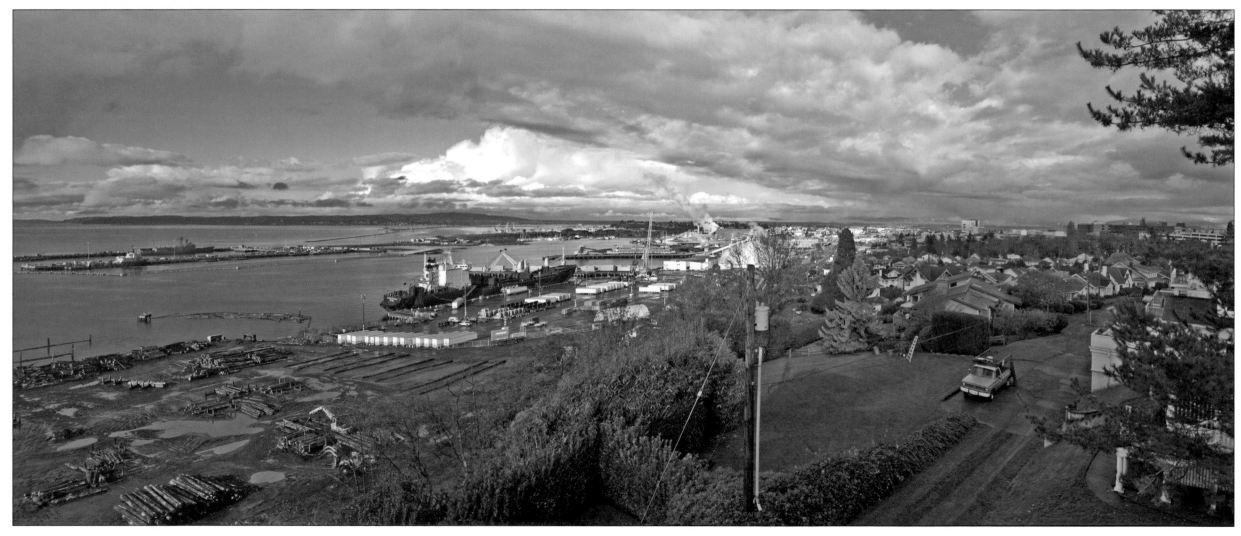

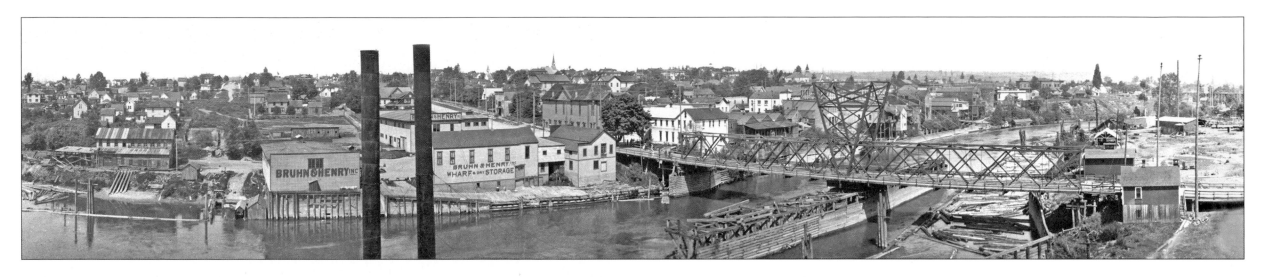

Snohomish, circa 1909 and 1909

The Snohomish Condensery water tower, rising to the left of the tall silo burner near the center of the 1909 Snohomish River flood scene (opposite page, at top), was the most likely vantage point for the Snohomish panorama above, taken perhaps the same year. The condensery was built on the south side of the river in 1908, and, we surmise, the opportunistic photographer soon climbed its tower for this grand record of Emory Ferguson's town. A half century earlier, the founder unloaded a portable cabin here from a steamer and set up a store in the path of the planned military road. This government thruway never amounted to much more than a horse path, but Ferguson held on and ultimately his riverside town prospered in the service of lumber and agriculture. It was opportunism typical of many communities in the forested and fertile valleys along the east side of Puget Sound. The bridge to Snohomish, advertised as "the longest swing bridge in the world," was nearly 20 years old when the panorama was recorded.

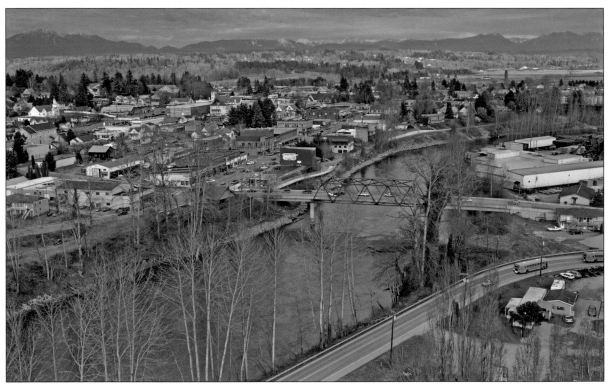

The flood photo (opposite) was taken from the first bridge to Snohomish, the Seattle, Lake Shore & Eastern Railroad's 1888 timber trestle. When it was completed, the new bridge put Snohomish a mere two hours from Seattle. Jean's repeat photograph of the 1909 flood view looks downriver from the steel trestle of the Burlington Northern Railroad that replaced the wooden span. While open to photographers with the will to walk it, this "new" bridge has long been closed to trains. —PD

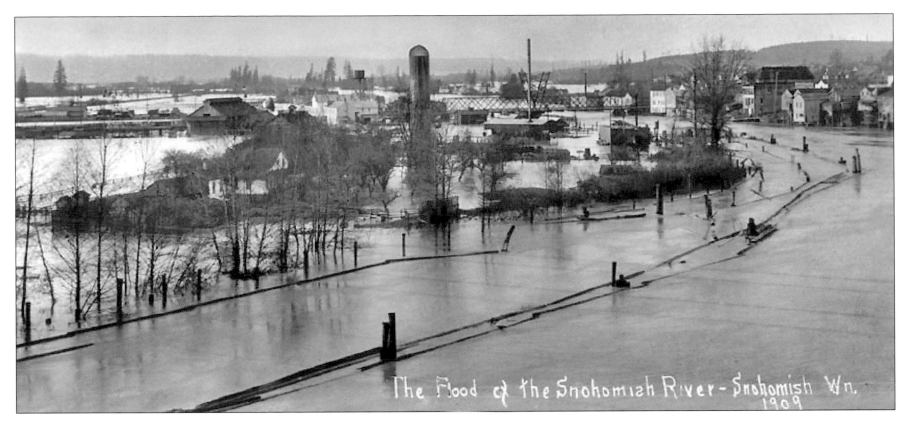

The Flood of the Snohomish River - Snohomish Wn. 1909

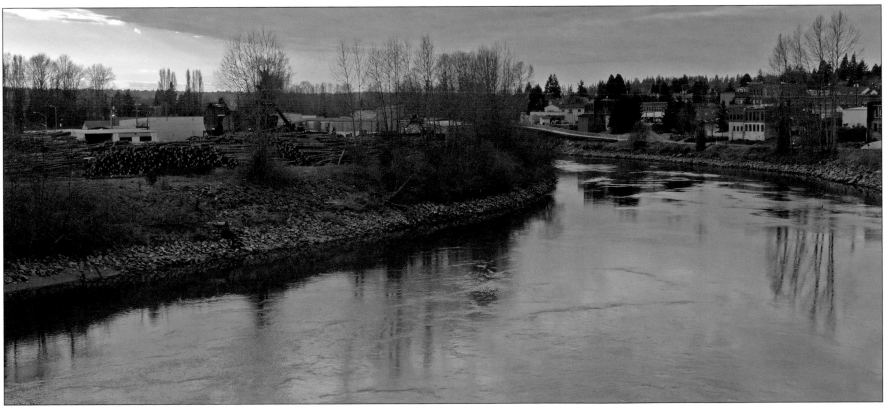

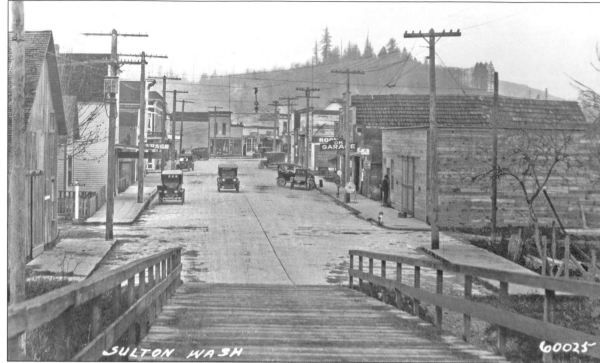

SULTON WASH 60025

Sultan, 1891 and circa 1924

Even before flat-bottom steamers first reached Sultan in the late 1880s, it was a rowdy town catering to lumberjacks and miners. Where the swinging bridge once hung, busy Highway 2 now hums with traffic headed toward Stevens Pass and beyond. Fire frequently visited Sultan, leaving few wooden structures untouched for posterity. What does remain (though concealed in the "now" photo) is the dogleg that Main Street makes at 3rd Street. In the 1891 shot, two barely visible sheds block the road. David Damkaer of the Sky Valley Historical Society imagines the recalcitrant owner of those sheds saying, "Go around or beside"— a reasonable explanation for why Main Street takes a turn there to this day. A 1920s photo (top right) also looks east down Main Street from an old wagon bridge torn down in 1940. —PD

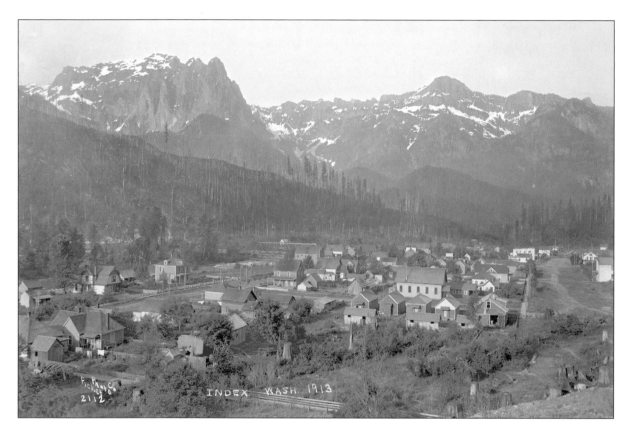

Index, 1913 and 1893

In 1888, Persis and Amos Guy homesteaded here, opening a hotel and tavern to serve miners, loggers, and railroad workers carving the Great Northern line through the Cascades. The town, platted in 1893, was named after nearby Mount Index; although dramatically ringed by mountains like an alpine village, Index stands a mere 500 feet above sea level. Its distinctive granite was used in the capitol steps in Olympia. Notably, photographer Lee Pickett made his home here and, for nearly 40 years, documented the life and work around him. His photograph of Index was taken from the bluff on which the old schoolhouse stood. Pat Sample, of Paradise Sound Recording, kindly allowed me on his roof to retake the shot.

—JS

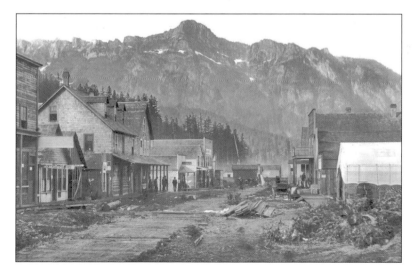

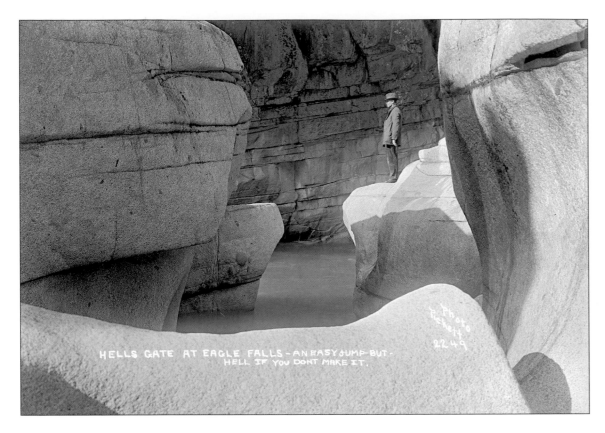

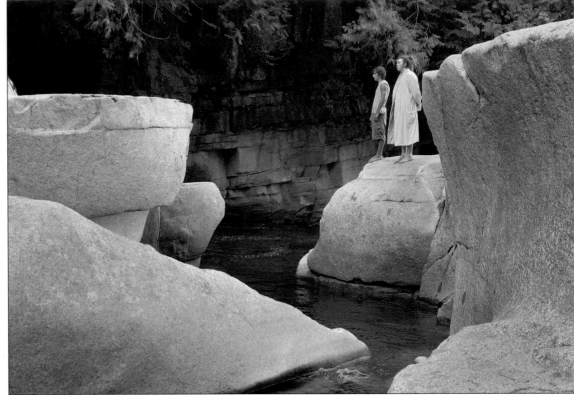

Hells Gate at Eagle Falls, mid 1920's and 1926

The changes in the rock formations in the above photo and its repeat demonstrate not the power of erosion, but the explosive charges placed by the builders of the Great Northern railroad to smooth the bed of the railway, increasing photographer Lee Pickett's "easy" jump by several feet. Generations of young cliff jumpers have dived into the pool visible beyond the boulders. Two of them posed for the "now" photo.

On Labor Day of 1926, Al Faussett, a logger who became a professional daredevil, drew an enormous crowd to the banks of the Skykomish to watch him shoot Eagle Falls in a bullet-shaped "canoe" of his own design. He became wedged in a narrow channel halfway down until friends pried him loose with a pike. Faussett went on to greater heights (and broken bones) gaining renown as the Evel Knievel of his day. The Pickett photo (right), taken at the base of the falls, captures Faussett's strange craft emerging from the foam. —JS

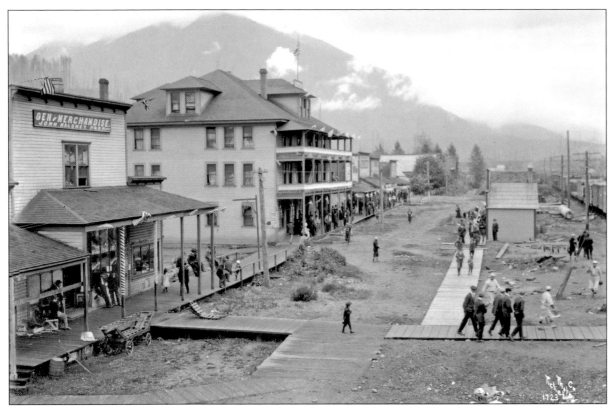

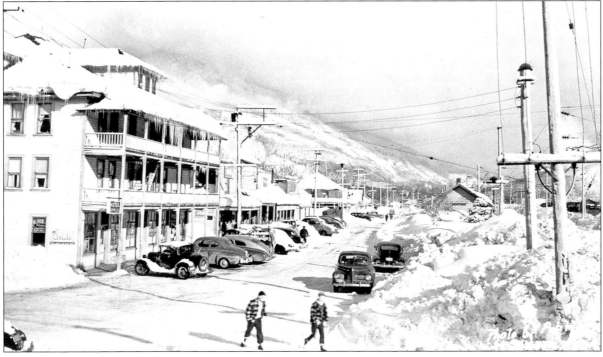

Skykomish Hotel, circa 1913 and circa 1947

The published photographs of this imposing roadhouse-hotel could paper its walls. Built in 1905 to accommodate the men working on the Great Northern Railway, it helped make Skykomish a railroad center for more than 60 years. While the population of Skykomish has dropped from more than 8,000 in the 1920s to fewer than 300, the town is still well invested with landmarks, including the Skykomish Hotel, which is open some months and others not. In 2005, the year that Jean photographed it, the big hotel celebrated its centennial, empty and silent. —PD

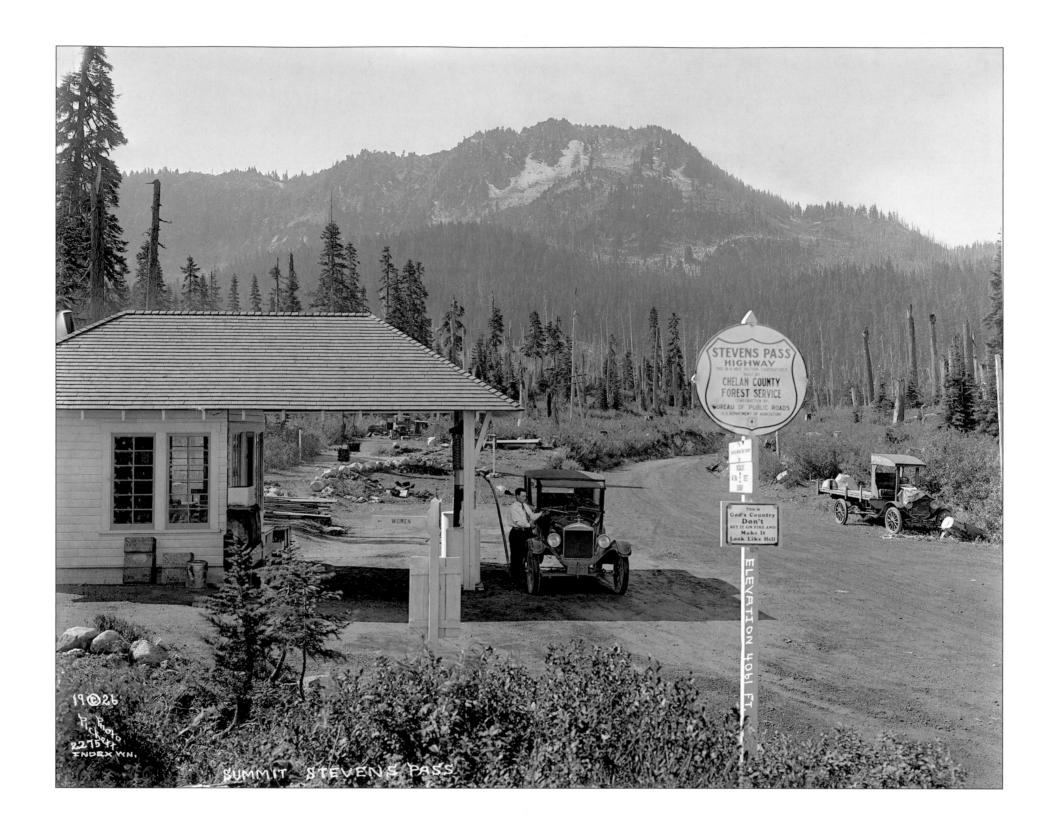

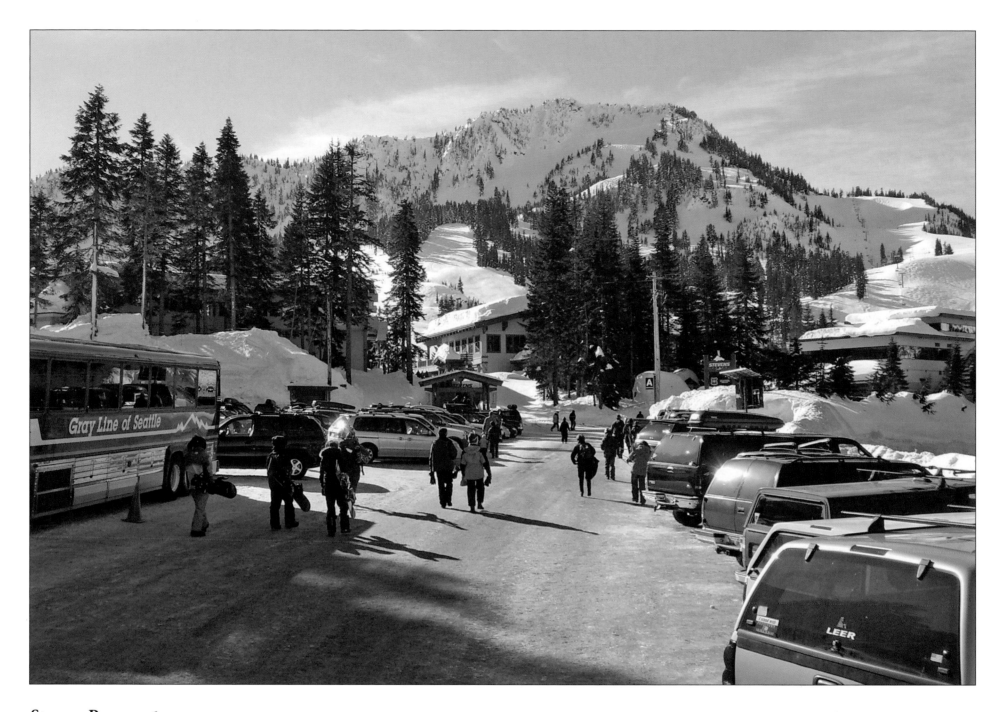

Stevens Pass, 1926

The highway over Stevens Pass opened officially on July 11, 1925. At 4,061 feet elevation that was 1,039 feet higher and ten years later than the Snoqualmie Pass Highway. Index photographer Lee Pickett reveals how civilized the pass was in 1926 by posing Cowboy Mountain as backdrop for a gas station and a highway sign that reads, "This is God's Country. Don't set it on fire and Make it Look Like Hell."

 Skiing at Stevens Pass began in earnest in the winter of 1937–1938 with a rope tow powered by a Ford V-8 engine. Cowboy Mountain was first approached with a mile-long T-bar lift in 1947. In 1960, a chairlift nearly reached the Cowboy Mountain summit and was impressively named Seventh Heaven. Stevens Pass Properties purchased the ski area in the mid-1970s and its additions have included many new lodges and lifts, lights for night skiing, and a ski school center. —PD

Seattle and Vicinity

*Alaska-Yukon-Pacific Exposition • Husky Stadium • Lake Washington Boulevard • Pioneer Square • Pike Place Market
The Denny Regrade • Bellevue • Tolt River Valley • Snoqualmie Falls • Rattlesnake Lake • North Bend • Renton*

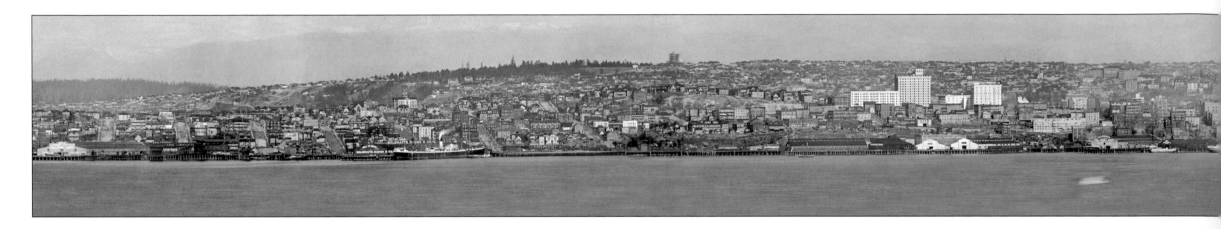

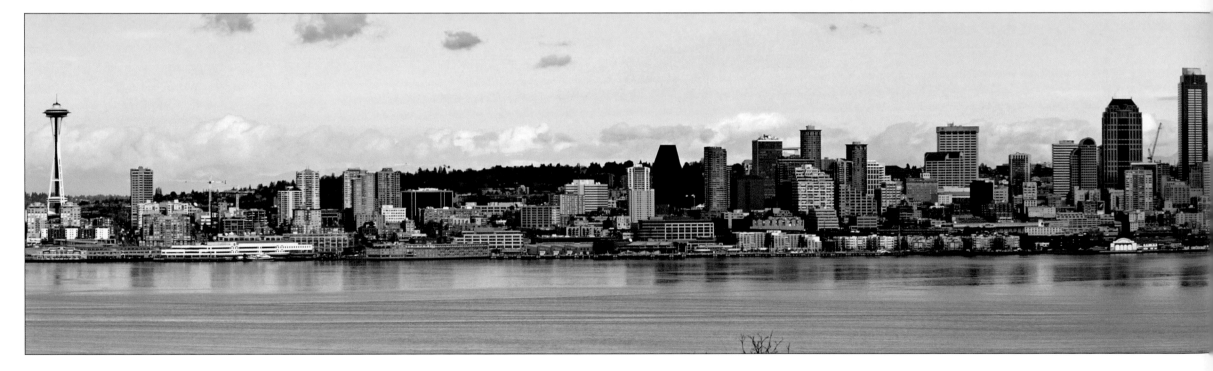

Seattle, 1908

As a city built on seven hills, or seventeen or seventy, Seattle offers no shortage of expansive vistas. The pair of panoramas at the top were photographed from Duwamish Head in West Seattle and extend from Pier 70 at the foot of Broad Street south to the old Moran shipyards. Pier 70 survives from the 1908 view and is now topped, from this viewpoint, by the Space Needle, the surviving symbol of Century 21, the 1962 Seattle World's Fair.

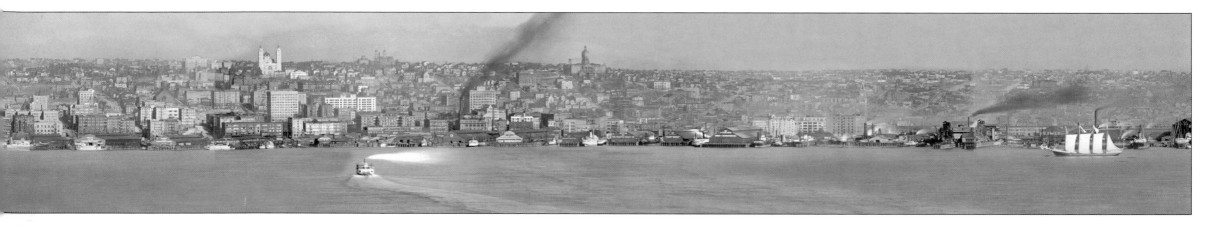

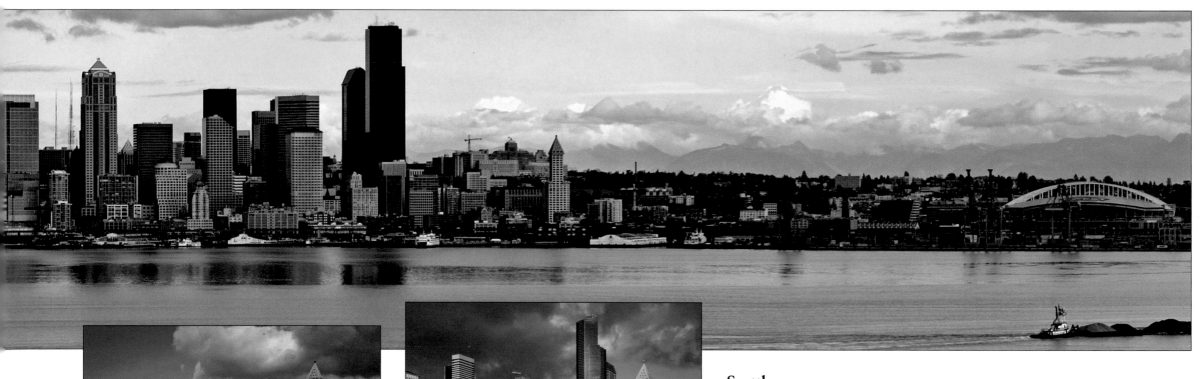

Seattle, 1953

The Kodachrome slide to the left records the Seattle skyline from the Alaskan Way Viaduct just before it opened to traffic in 1953. The landmark 1914 Smith Tower still holds its place on the far right in the repeat 2006 view, and the now venerable tower seems to anchor a central business district that began its serious architectural ascension in 1968. —PD

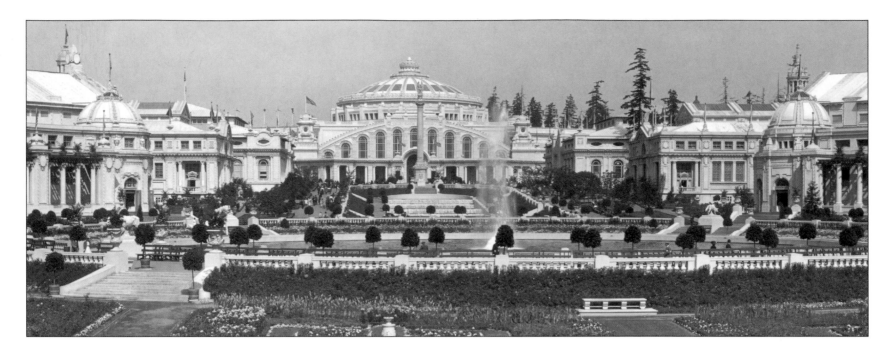

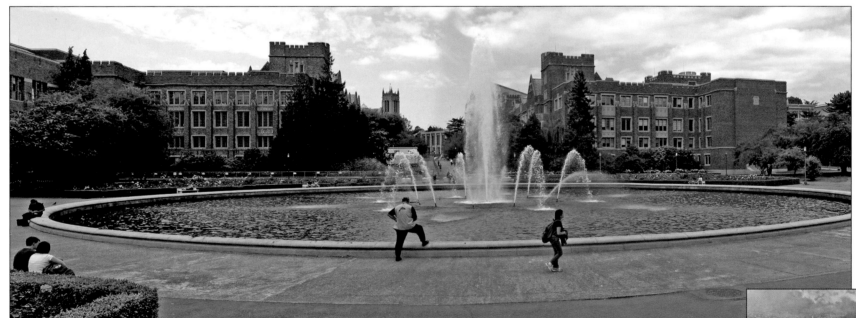

Alaska-Yukon-Pacific Exposition, 1909

The 1909 Alaska-Yukon-Pacific Exposition (A.Y.P.E.) on the University of Washington campus in Seattle showed two faces. For the sensationally inclined, there was the Pay Streak, stuffed with gaudy carnival attractions. But for the contemplative, this scene was the main draw: a sublime "white city" of Beaux Arts beauties built about the Arctic Circle and its fountain.

When shown this comparison of the A.Y.P.E. and the contemporary campus, people typically ask why the city did not keep the exhibition buildings. The answer is easily had. These structures were characteristic of fairs: Made of poorly sealed plaster, they were inexpensive to build and not meant to last. Here, only the fountain survives. Named Drumheller Fountain today for a school trustee who paid for the hydraulics, it is more popularly known as "Frosh Pond" after the tradition of throwing freshman into it. —PD

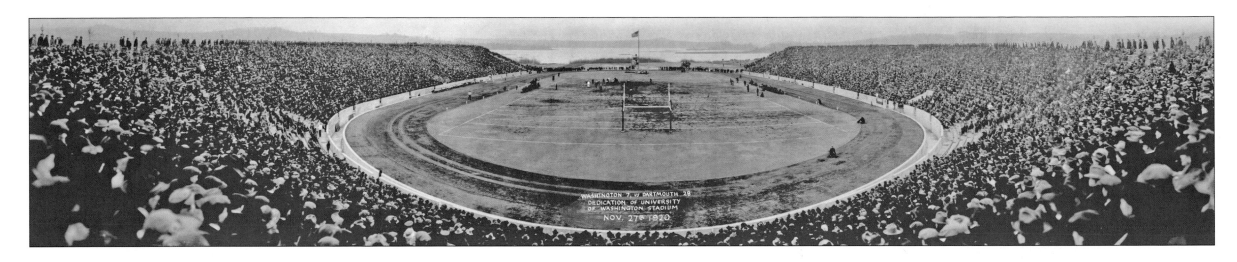

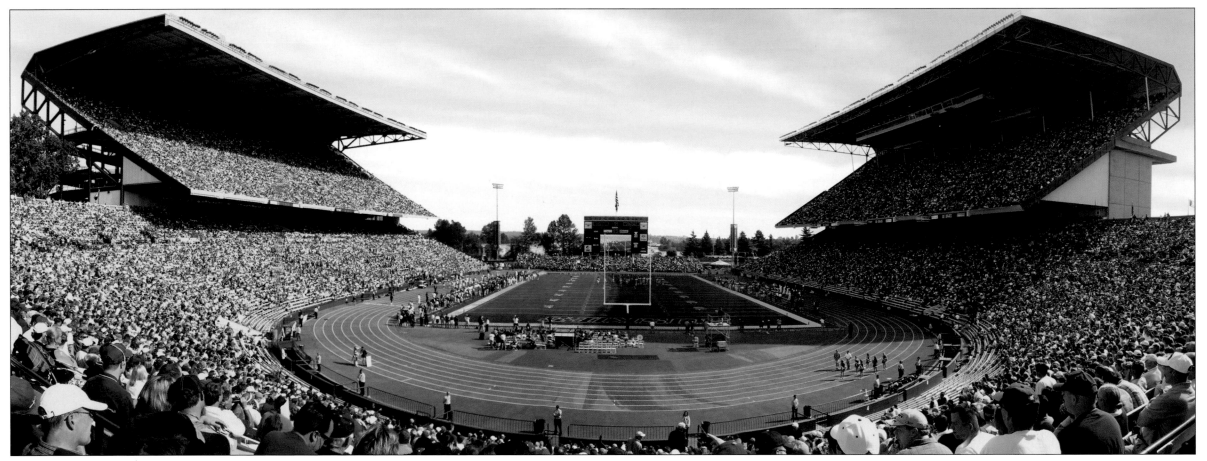

Husky Stadium Opening Day, University of Washington, 1920

With the help of $220,000 raised through the sale of plaques and advance tickets, the University of Washington's Husky Stadium was completed just 12 hours before the inaugural game against Dartmouth College on November 27, 1920. The Tacoman Chapin Bowen recorded this sweeping impression of that dark day when the locals lost to the Ivy Leaguers 28 to 7. Since that first loss, the Huskies have won about 75 percent of their games here, and the seats have multiplied to 75,000. In the contemporary panorama, the Huskies are making mashed potatoes of the Idaho eleven, winning 41 to 27. —PD

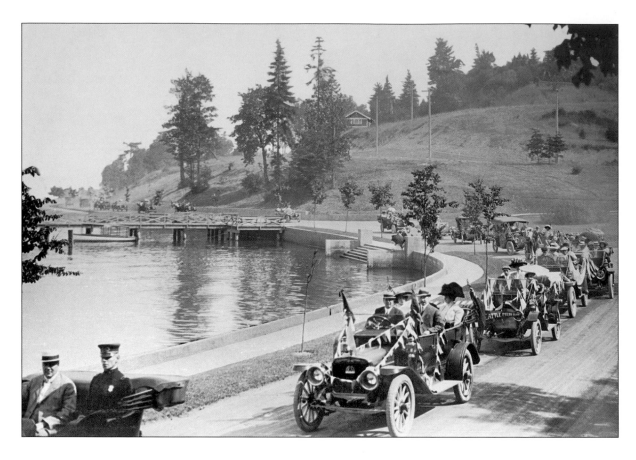

Mount Rainier from Lake Washington Boulevard, 1911 and 1914

Of the many changes since Asahel Curtis and Walter Miller constructed their picturesque 1914 depiction of Mount Rainier over Lake Washington Boulevard, the size of that volcano—originally known as Mount Tacoma—is the most obvious. Now glowing in the pink light of the setting sun, Mount Rainier just peeks above the bushes (right). In the 1914 historical scene, it ascends with an ambition that justifies its other name, "The Mountain That Was God." In effect, Curtis and Miller made it the highest mountain in the world by retouching the photo. The partners have tricked us many times over, for this is one of Seattle's most often printed historical scenes. Figured against the 14,411 feet of the mountain in the contemporary scene, this retouched pseudo-Himalayan would be a few thousand feet taller than Mount Everest! Another change to the scene occurred in 1916, when the opening of the ship canal lowered Lake Washington by 9 feet. At the same curve, the earlier historical view above shows a 1911 auto caravan celebrating the boulevard. Here, more typically, Mount Rainier is hidden. —PD

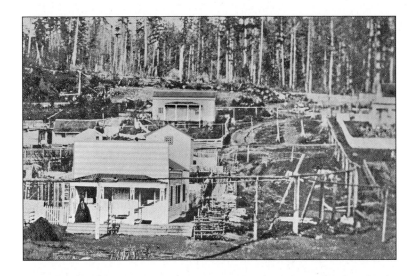

Pioneer Square, 1859 and 1909

As its name indicates, Pioneer Square lies at the heart of Seattle's heritage. It has seen many victories for preservation and weathered a few notable losses. The 1961 destruction—under protest—of the draped Seattle Hotel (in the center of the photo, below left) was the impetus for designating the surviving neighborhood as a historic district, with safeguards for its ambience and architecture. The hotel, seen here during the citywide celebration of the 1909 Alaska-Yukon-Pacific Exposition, was replaced by the concrete "Sinking Ship" parking garage seen in the "now" photograph. The view looks east on Yesler Way, where Henry Yesler's Pioneer Building, on the left, survives. Yesler built it in 1889 on the site of his first home, captured in 1859 (left) in the oldest surviving photograph of any part of Seattle. —PD

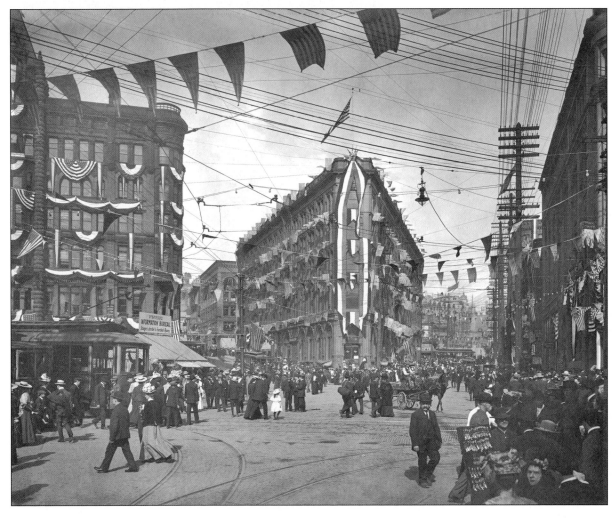

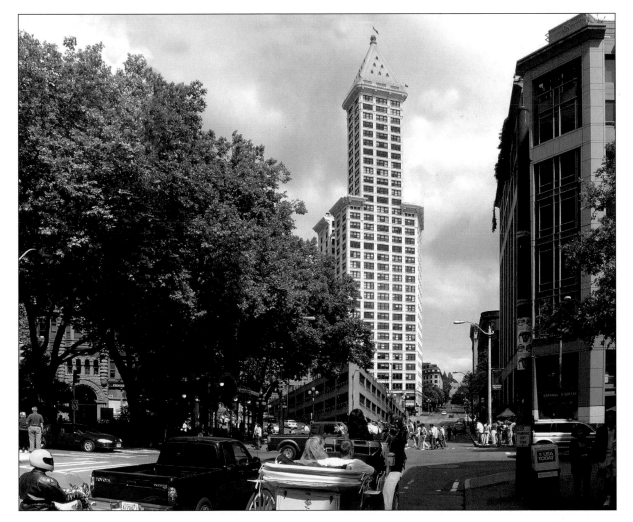

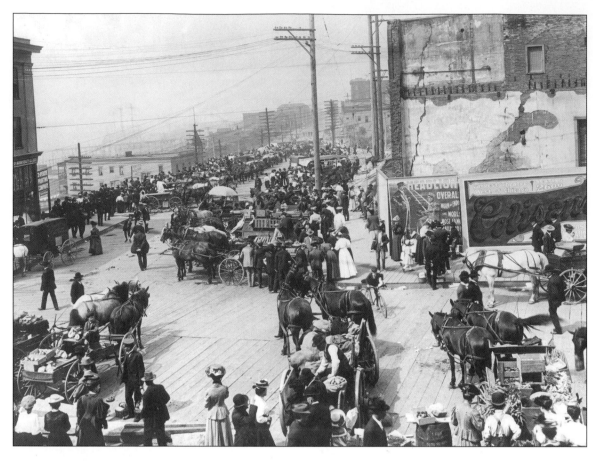

Pike Place Market, 1907 and circa 1908

A century ago, "Seattle's Heart," the Pike Place Market, was created in a joyful conspiracy of families and farmers. Growers and shoppers first conducted business from the backs of farmers' wagons, but soon the market required more permanent housing, moving to the covered stalls seen in the photo below (at left), dating from about 1908. By selling their carrots and cabbages directly to consumers, farmers got around the middlemen who normally controlled the flow of food from the Commission District, which was then located on the waterfront and near the public market. The market informally opened in the late summer of 1907, when the covered shed was not yet in place (left). The century-old public market survives as Seattle's most cherished destination—a cornucopia of crafts, fresh fish and produce, and a thousand indigenous delights.

—PD

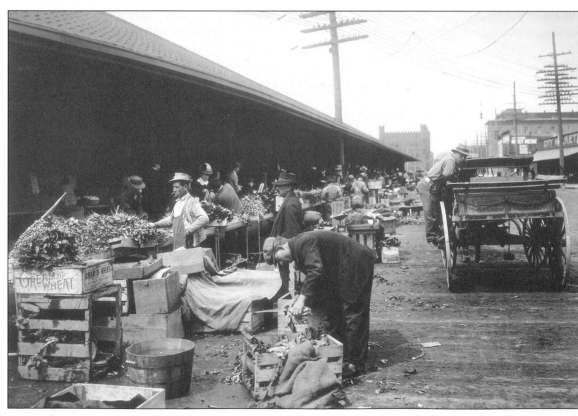

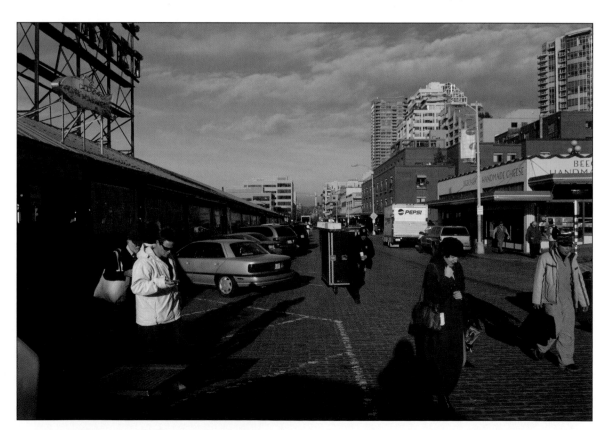

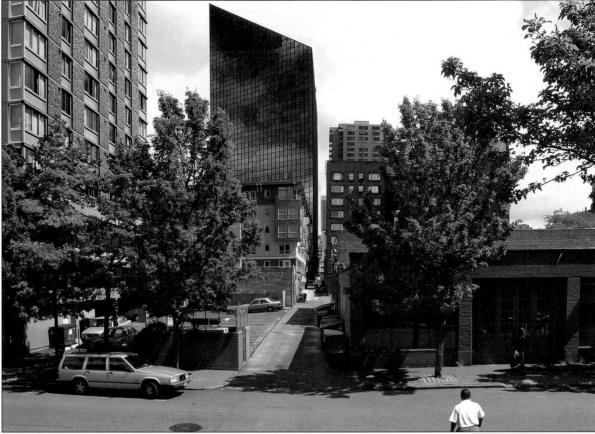

The Denny Regrade, circa 1910

A city of razed hills, graded streets, and reclaimed tidelands, Seattle is known for its engineering feats. But perhaps its most locally famous public work is this one, the Denny Regrade. This very melodramatic circa-1910 view (above) south through its "spite mounds"—so named because some residents of Denny Hill resisted paying for their removal—is its most popular record. At the scene's center is one of the blasting water cannons that washed the hill into the ditch that runs along Bell Street at the bottom of the photograph. From the ditch, the muddy water was carried by flume above an offshore trestle and shot into Elliott Bay. Eventually, this submerged Denny Hill became a hazard to shipping and had to be dredged.

The rooming house (right) is the largest of the few structures saved from the old neighborhood and is also visible in the larger view above, just left of center. It safely reached its new grade near 4th Avenue and Lenora Street, where it survived into the 1950s. The deepest cut in the Denny Regrade was about 110 feet, or about one-third of the way up the "glass spike" of the 24-floor Fourth and Blanchard Building seen up the alley in the contemporary repeat. —PD

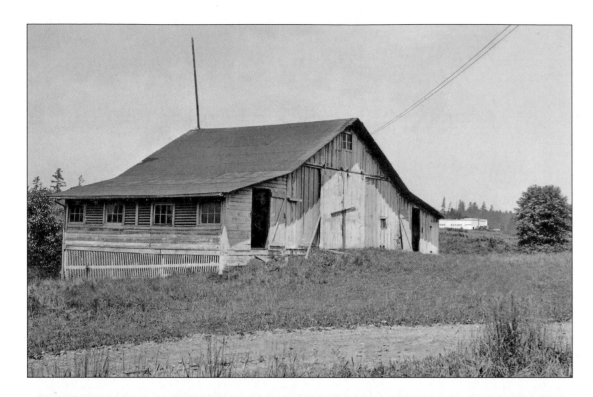

Bellevue, 1938 and 1942

After Bellevue rezoned its downtown in 1981 to allow buildings higher than 40 feet, its skyline rapidly began to rise to encompass what is now the third-largest business district in the northwest United States. Jean climbed to the roof of a bank at the northwest corner of Northeast 4th Street and 106th Avenue Northeast to record this "Bellevue Miracle" in panorama. Sixty-seven years earlier, in 1938, a photographer for the Works Progress Administration visited the corner and found this barn (left). In 1940, another WPA agent described Bellevue as "a trading center for berry farmers and vineyardists in the rich lowlands." The first floating bridge to Seattle opened that year, but World War II stymied the expected suburban growth. Meanwhile, Bellevue remained synonymous with strawberries.

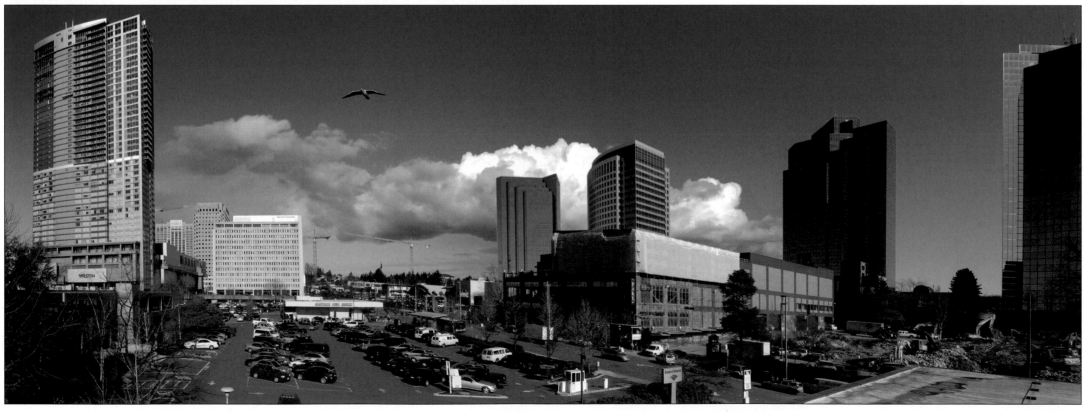

A hint of Bellevue's bright motorcar future can be seen around the right corner of the barn on the opposite page. In 1929, Bellevue visionary James Ditty opened this gleaming Lakeside Super Market about two blocks from the barn, near the southeast corner of Northeast 8th Street and Bellevue Way—or Lincoln Avenue as he named it. The later view of Ditty's market (below) looks across Bellevue Way from Bellevue Square, the site of one of the region's great shopping malls since 1946. Its contemporary repeat looks from one square into another—from Bellevue Square into a lower section of the city's new Lincoln Square, which includes One Lincoln Tower. At 42 stories, it is Bellevue's new skyline topper. On the facing page, the tower is nearing completion to the left of a soaring seagull most likely heading for Meydenbauer Bay. —PD

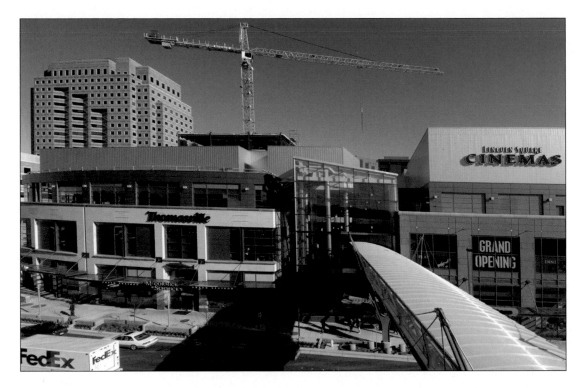

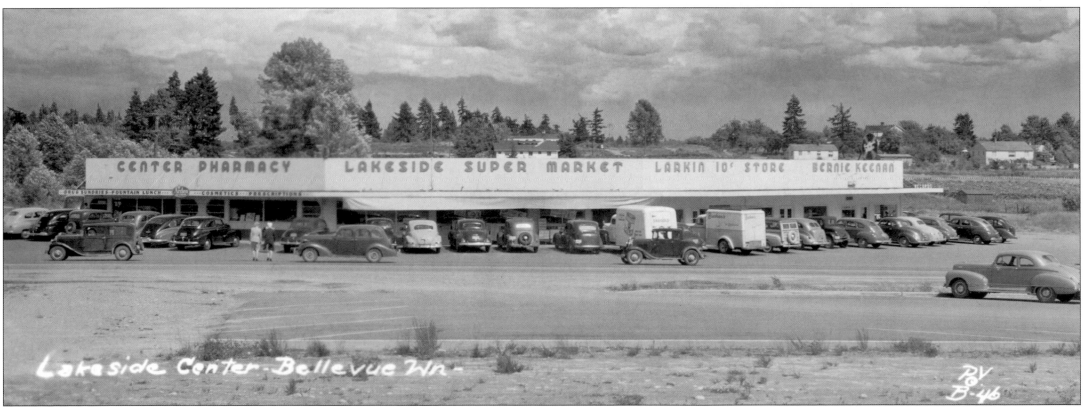

Tolt River Valley, circa 1958

In 1936, Seattle city officials applied for water rights to build two reservoirs on the South Fork of the Tolt River to supplement the city's main Cedar River supply. It wasn't until the mid-1950s that Water Superintendent Roy Morse convinced the city council that the thirst of a growing population would require additional resources. The Tolt River valley was cleared in preparation for damming soon thereafter, as illustrated by this somewhat apocalyptic-looking Seattle Water Department photograph.

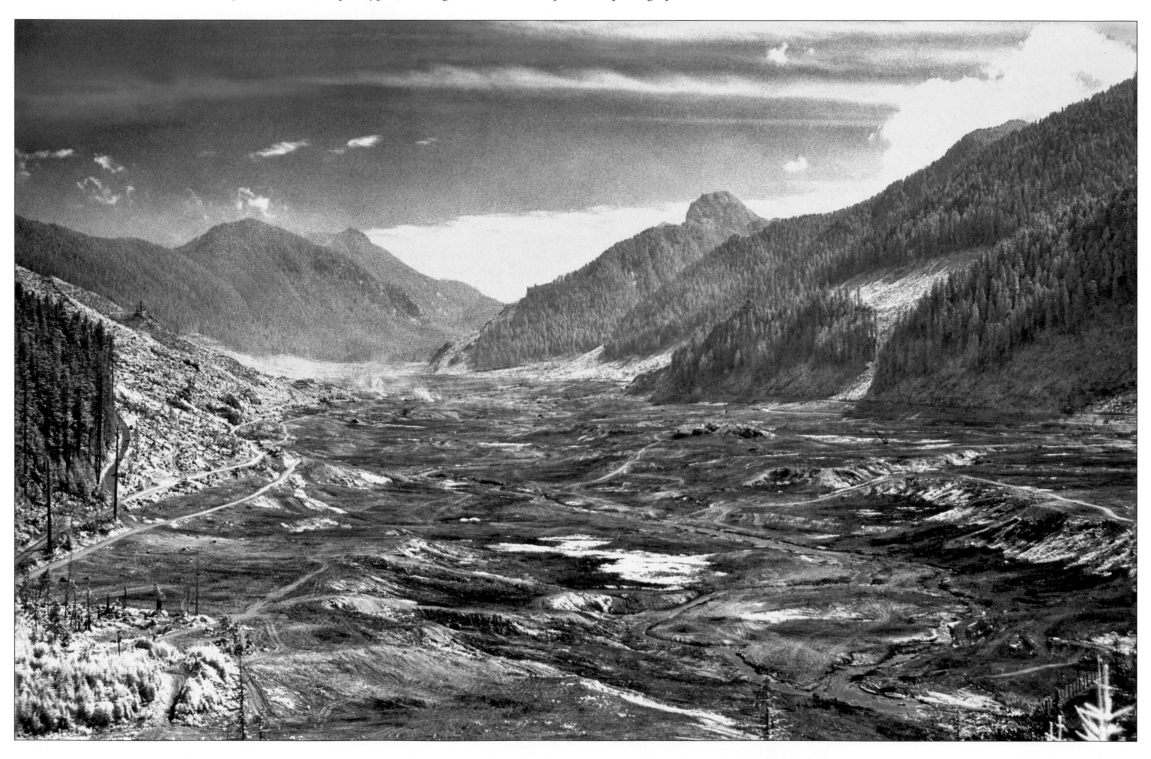

Wandering through the Tolt River Watershed is strictly regulated, but with the gracious accompaniment of the Seattle Water Department's Lee Ambler, I was able to pass through a dozen locked gates to discover that 50-year-old hemlocks blocked the original view. An unobstructed ledge 20 feet above the water provided an imperfect repeat of a rarely seen vista. The scallop-shaped mountain right of center is part of the McClain Peaks. —JS

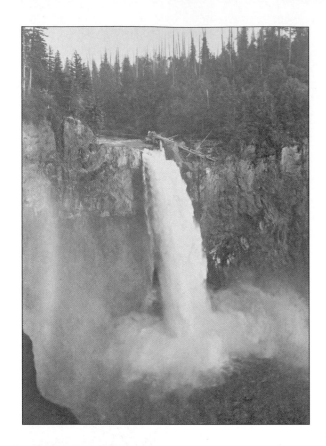

Snoqualmie Falls, 1888, circa 1898, and 1949

Arthur Churchill Warner, known for hauling the first camera to the top of Mount Rainier in 1888, posed his family on this precarious perch above Snoqualmie Falls sometime after 1898 (below left), when a power generator was built into the falls. The ledge on which his family once stood has since collapsed into the basin 276 feet below.

The Snoqualmie Falls facility was the state's first large hydroelectric plant. Though constructed in less than a year, it was built to last. The original generators have added electricity to the Seattle power grid for more than 100 years. The photo at right is from the great freeze of 1949, when the falls, along with much of the Northwest, turned quite spectacularly to solid ice. The photo at left may be the oldest known photo of the falls. It must have been taken before the arrival of the Seattle Lake Shore & Eastern rail line in 1889 since there is no evidence of a rail cut in the far bank above the falls. Snoqualmie Falls endures as a popular tourist attraction, and the adjoining lodge is especially famous for its ample breakfasts. —JS

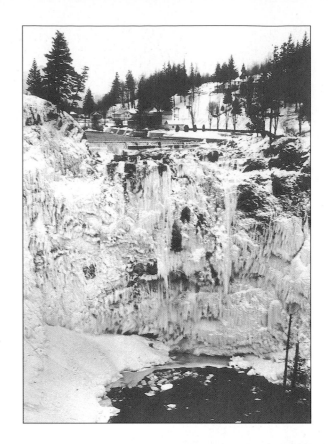

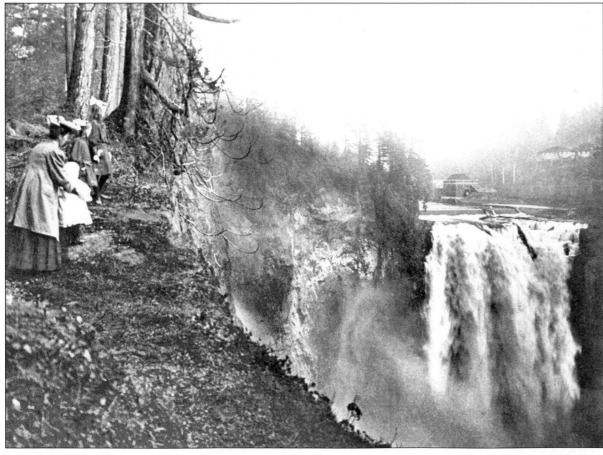

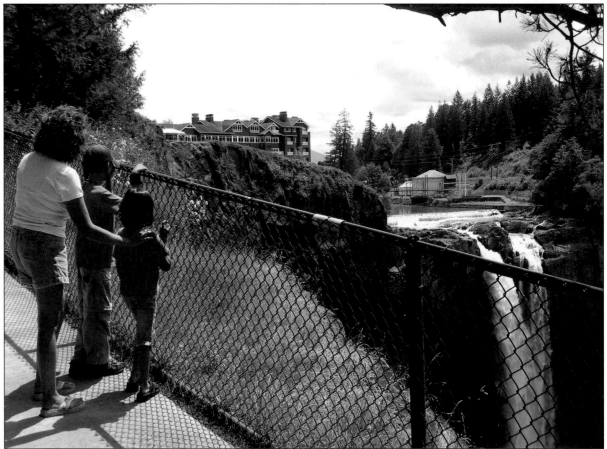

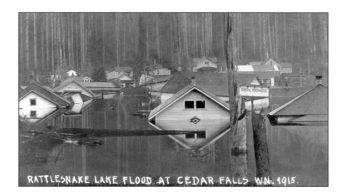

RATTLESNAKE LAKE FLOOD AT CEDAR FALLS WN. 1915.

Rattlesnake Lake/Moncton, circa 1905 and 1915

In the spring of 1915, Rattlesnake Lake began to flood the tiny town of Moncton. For the rest of that year the waters rose slowly but inexorably until the town was eventually uninhabitable. The culprit was a leaky masonry dam above the lake, built by Seattle City Light to generate electricity. The town was abandoned and condemned. In dry years, come September, the foundations of Moncton can still be seen, a murky palimpsest of past life.

—JS

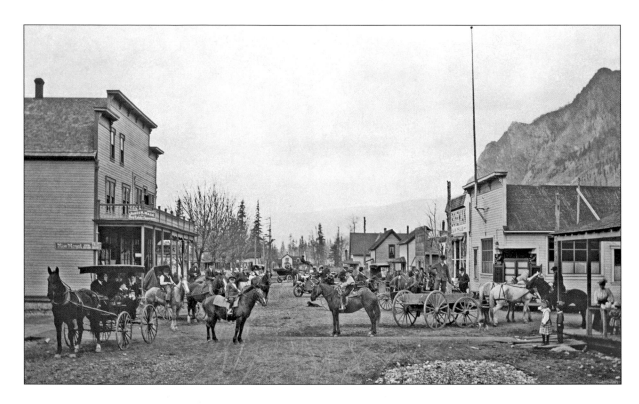
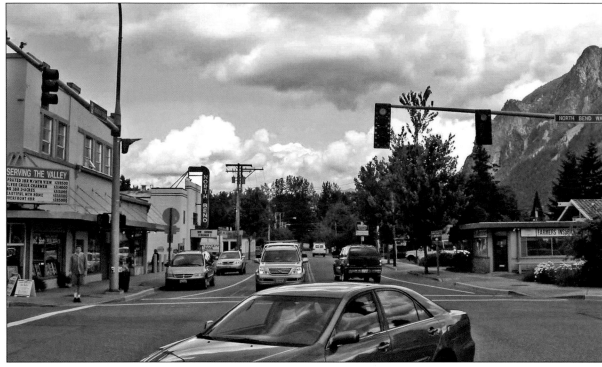

North Bend, 1909

In the spring of 1909, North Bend photographer E.J. Siegrist persuaded a few hometown citizens to take a scattered pose on Bendigo Avenue, the town's "Main Street," now designated a boulevard. Will Taylor, the town's founder, discovered the street name on a map of Australia. Mount Si, which rises above the town to the east, is easily the most familiar mountain face in the "Cascade Curtain" of low mountains and high foothills that face the Puget Sound lowlands between Stevens and Snoqualmie passes.

When only a blazed trail crossed Snoqualmie Pass, North Bend considered itself the gateway to the Puget Sound. Later, when the Sunset Highway came through this intersection, the locals installed a traffic light. It was notorious for causing long delays before the Interstate 90 freeway avoided North Bend altogether in the late 1970s. —PD

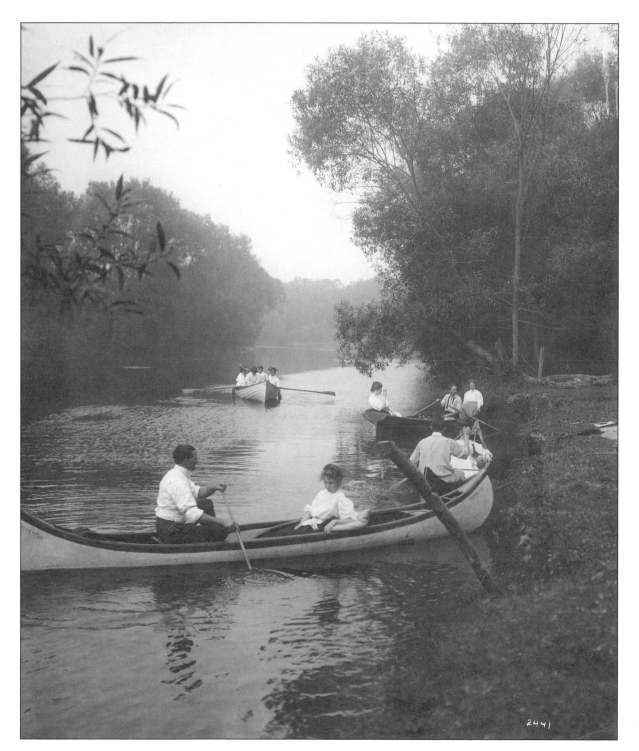

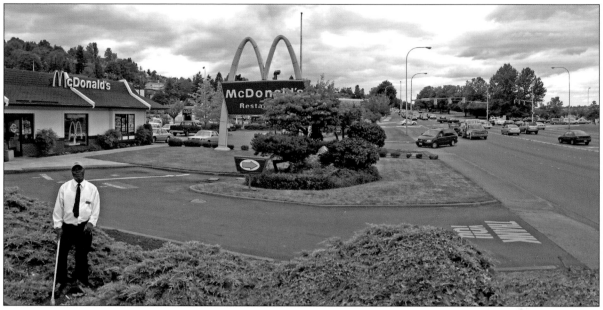

The Black and Cedar Rivers, Renton, 1906 and circa 1944

The romantic explorers on this 1906 flotilla (left) are making their way from Lake Washington to Elliott Bay along the Black River, a waterway that most modern Renton residents have probably never heard of. The story of the journey was printed in the *Seattle Post-Intelligencer,* where this scene, which looks north, is described as "near" the Cedar River. At that time, the Cedar River joined the Black River near where Airport Way now crosses Rainier Avenue—the intersection on the right in the "now"

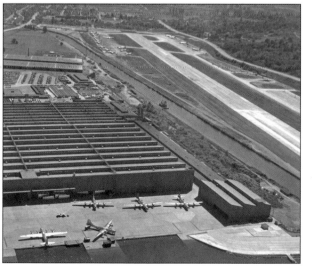

photo, near the McDonald's golden arches.

The Black River quickly went dry in 1916 when its source, Lake Washington, was dropped 9 feet to the level of Lake Union for the completion of the Lake Washington Ship Canal. By then, the Cedar River, which once flowed into the Black River, had already been diverted to reach Lake Washington—not far from where the Black River flowed from the lake. The new channel can be seen along the right side of the World War II Boeing B-29 plant at left, situated at the south end of the lake. The view looks south into Renton. —PD

47

Tacoma and South Sound

Mount Rainier • Paradise Lodge • Pacific Avenue • Tacoma Waterfront • Old St. Peter's Church
Tacoma Narrows Bridge • Steilacoom • Olympia

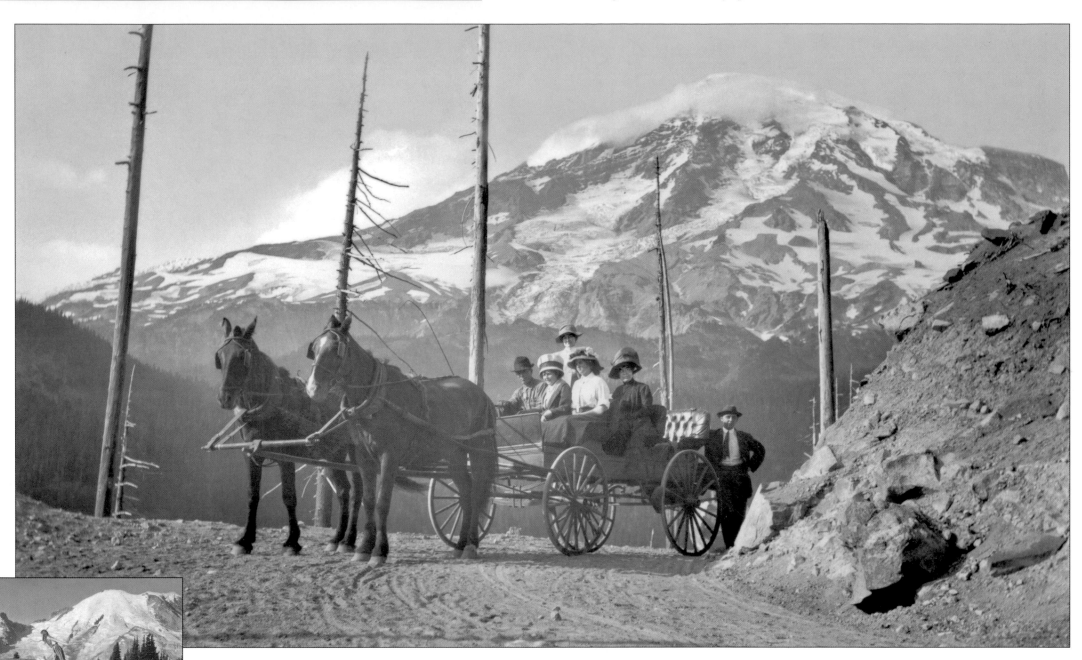

Mount Rainier, circa 1910

A team and wagon pose with four bonnets at Ricksecker Point on the road to Paradise. The point was named for Eugene Ricksecker, the engineer who surveyed the road in 1903. At an elevation of 4,214 feet, this prospect on the south side of Mount Rainier is 10,197 feet below the summit, which gained a foot in 1988 when the mountain was measured by satellite at 14,411 feet. Scenic Mount Rainier has always been a popular photographic backdrop. At left, dancers from the Mary Ann Well School in Tacoma prance around a new sedan in 1931.

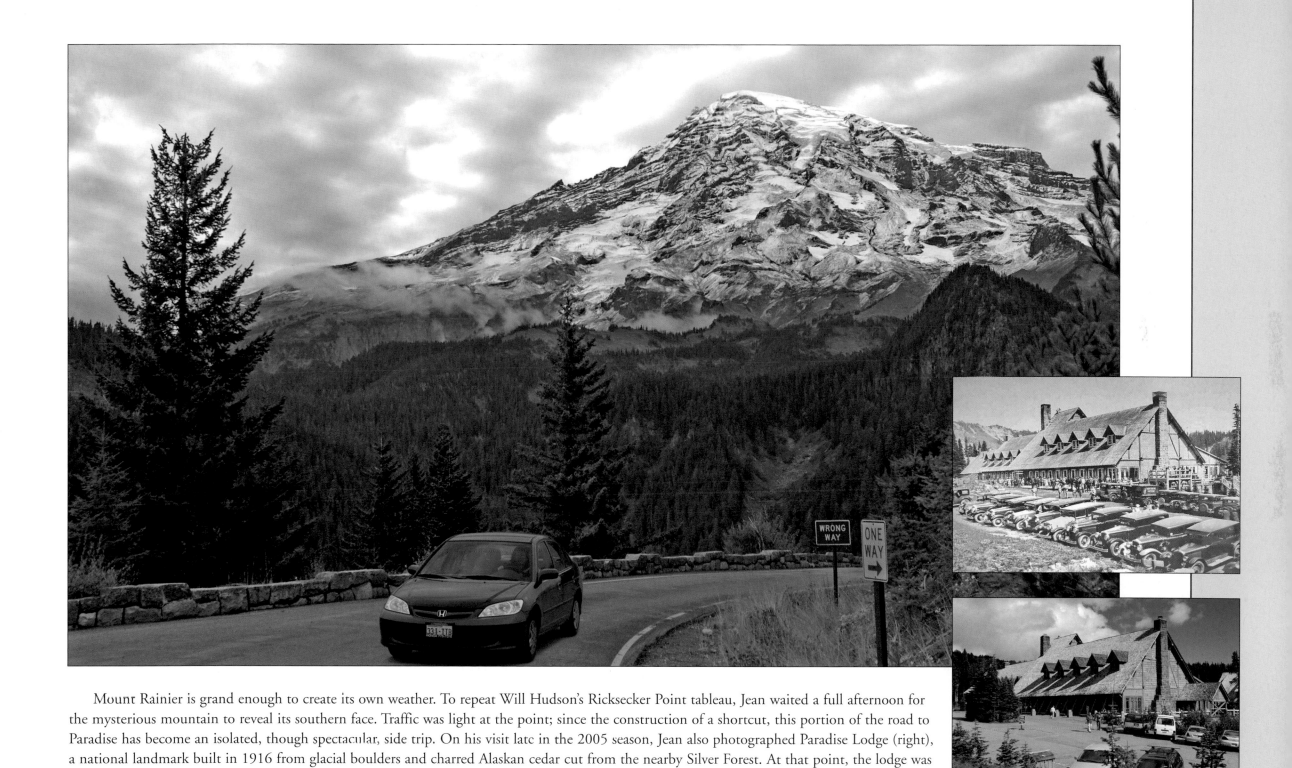

Mount Rainier is grand enough to create its own weather. To repeat Will Hudson's Ricksecker Point tableau, Jean waited a full afternoon for the mysterious mountain to reveal its southern face. Traffic was light at the point; since the construction of a shortcut, this portion of the road to Paradise has become an isolated, though spectacular, side trip. On his visit late in the 2005 season, Jean also photographed Paradise Lodge (right), a national landmark built in 1916 from glacial boulders and charred Alaskan cedar cut from the nearby Silver Forest. At that point, the lodge was preparing to close for two years for restoration. —PD

Pacific Avenue, Tacoma, 1888 and 1890

A fresh arrival to this boomtown in 1888, the photographer Thomas Rutter most likely rode a construction elevator up the street side of the Northern Pacific Railway's new headquarters at South 7th Street to capture this impressive record of Tacoma's wide Pacific Avenue (right). Most of the brick buildings in the foreground were recent, built after the city's devastating fire of 1885 when new ordinances required brick and masonry construction. For his repeat, Jean had no elevator; he was required to scramble across the roof from the Commencement Bay side of the building and lean over the ledge of the landmark structure, today used for offices. The headquarters of the Northern Pacific Railway (below) was one of more than 1,000 structures built in Tacoma in the first year after the opening of Northern Pacific's direct service over Stampede Pass in 1887. —PD

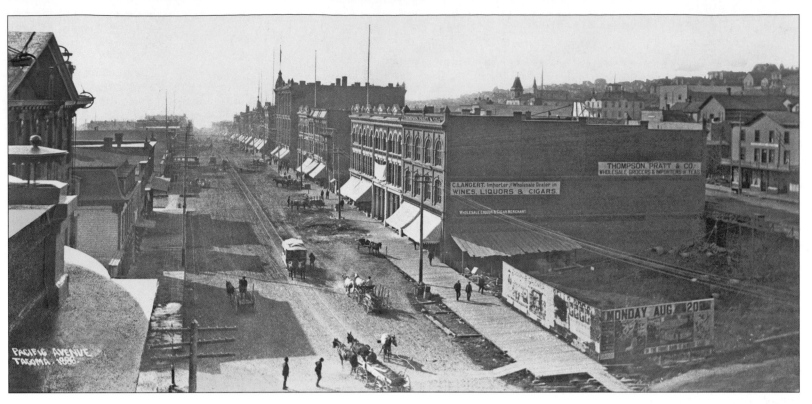

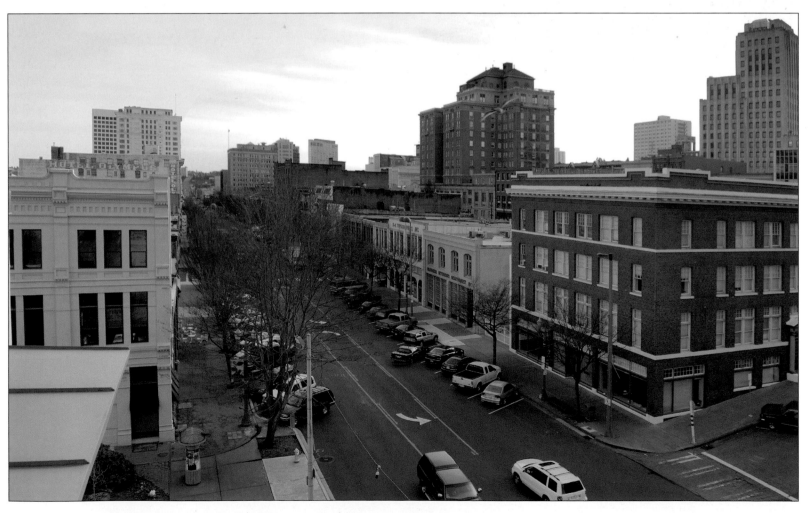

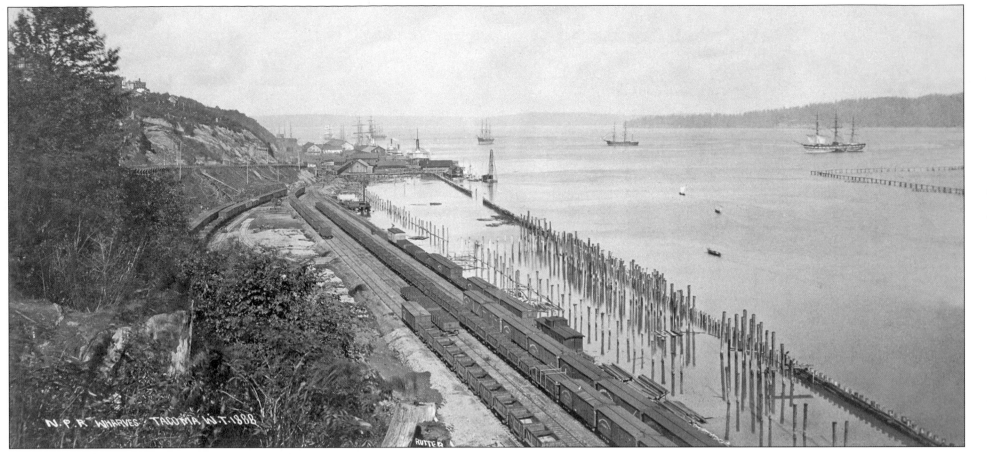

N.P.R. WHARVES. TACOMA. W.T. 1888

Tacoma Waterfront, 1888

The Northern Pacific Railway decided in 1873 to head for Tacoma rather than Seattle, in part because the former had Commencement Bay, a harbor the railroad considered more promising. The railroad also liked the fact that there were considerably fewer citizens in Tacoma— about 200. Consequently, the waterfront a mile south of what became Old Tacoma was free for the railroad's confident speculations on what they hoped would be the New Tacoma.

Like his view of Pacific Avenue on the opposite page, Thomas Rutter also recorded this scene in 1888 from the site of the new railroad headquarters, but looking in the other direction. In the distance is the Northern Pacific wharf, stretching below today's Stadium Way very near to Old Tacoma, the original settlement that the Northern Pacific chose to skip over in order to develop and exploit its own townsite. Early proposals to build a road between the railroad's wharf and Old Tacoma were jealously blocked by the railroad. —PD

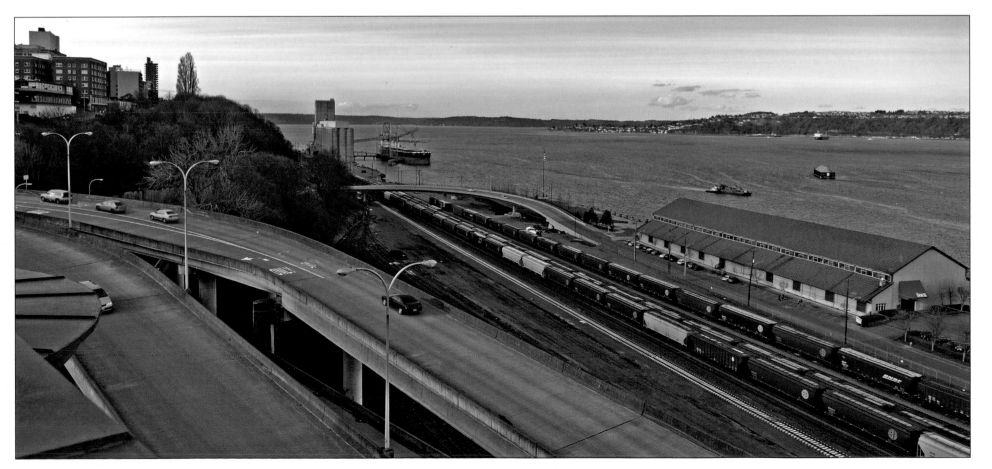

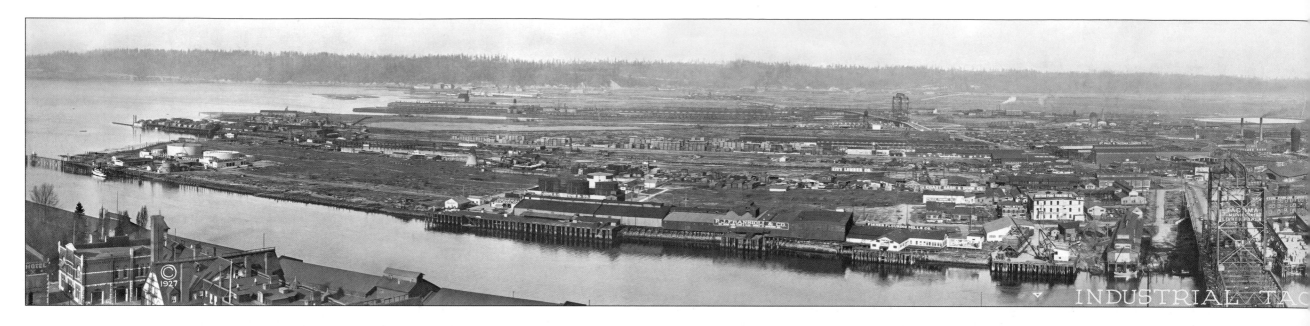

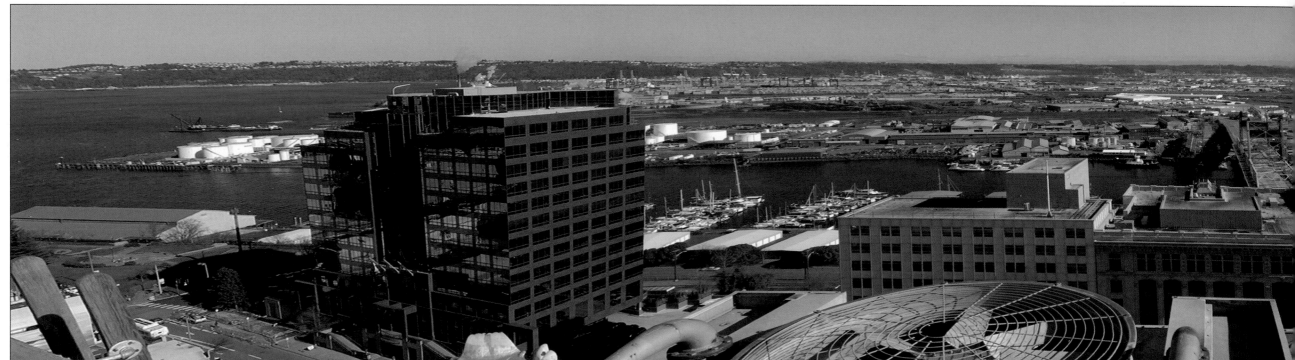

Industrial Tacoma, 1927

In 1927, someone from the Tacoma photography studio of Chapin Bowen stepped to the roof of the nearly new 18-story Washington Building and recorded this panorama, entitled "Industrial Tacoma." To the left and right of the 11th Street Bridge—one of the largest lift bridges ever built—the reclaimed tideflats of Commencement Bay are marked with factories, warehouses, shops, docks, and mills. Most notably among them is the St. Paul & Tacoma Lumber Company. St. Paul first located in "The Boot," a sabot-shaped island at the mouth of the Puyallup River in 1883, the year the ornately turreted Tacoma Hotel was built overlooking the mill and the bay. The mill is right of center, and the roof of the hotel appears at bottom left with the date of the photograph written on it. At far right is the domed Union

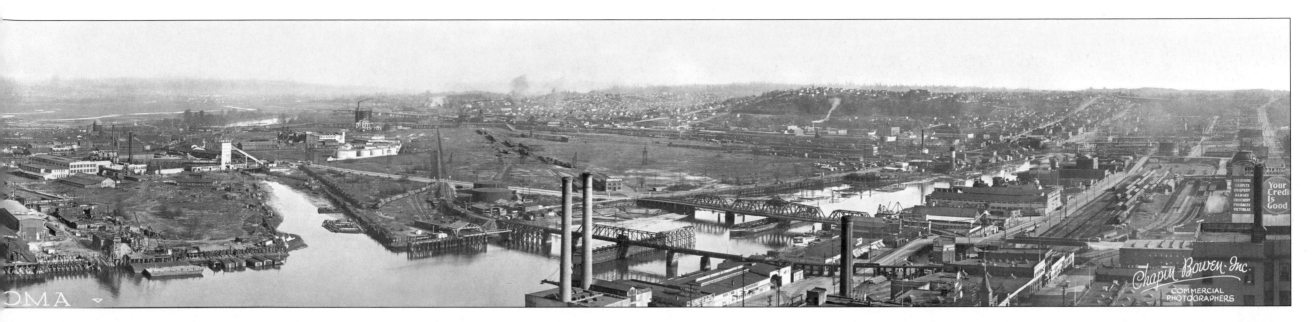

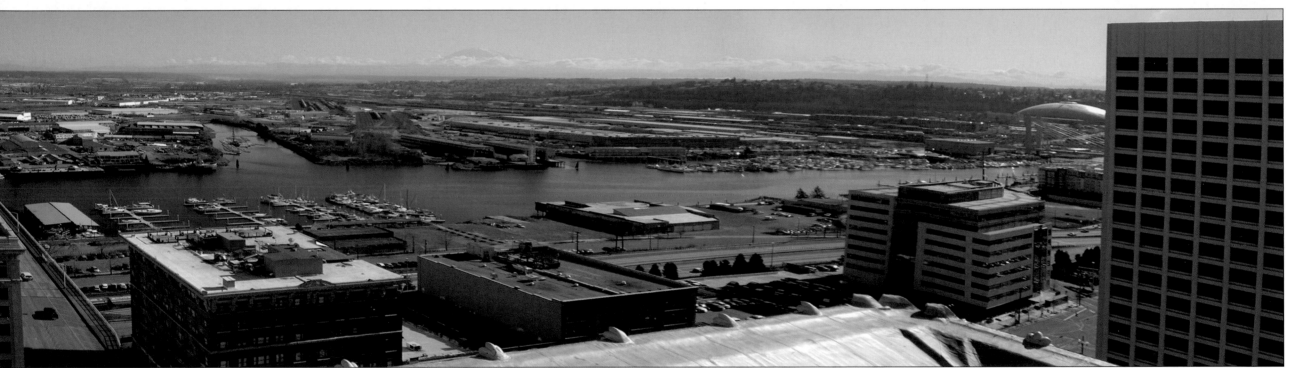

Depot at Pacific Avenue and 19th Street. Opened in 1911, it survives as the keystone for a designated historic district that includes the Washington State History Museum and the Tacoma branch of the University of Washington.

In 1927, Tacoma was bullish with the "Coolidge boom": talkies, bootleg liquor, and installment buying propelled a giddy economy. Two years later, Tacoma, too, stumbled with the Hoover bust. Some Tacomans would have remembered Herbert Hoover's visit in 1926 when he lent his name to a petition for dropping the name Mount Rainier in favor of Mount Tacoma. —PD

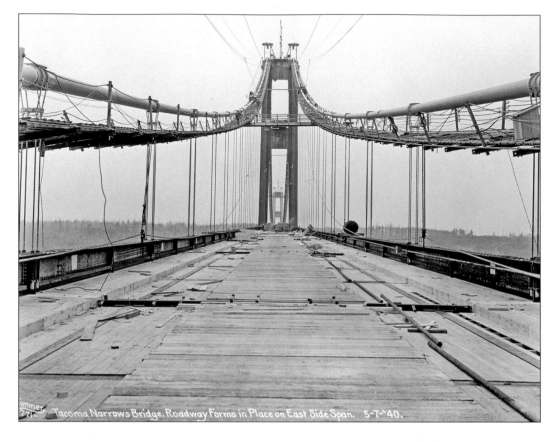

Tacoma Narrows Bridge. Roadway Forms in Place on East Side Span. 5-7-'40.

The Tacoma Narrows Bridge, 1940

The dramatic photograph (bottom left) by University of Washington Engineering professor Fredrick Farquharson captures the stunning demise of "Galloping Gertie," the 5,939-foot suspension bridge that finally linked the east and west shores of Puget Sound. On Thursday, November 7, 1940, the bridge twisted, snapped, and splashed into the water 190 feet below, succumbing to a wind of only 42 knots.

Alfred Simmer's photograph of the intact bridge (left), dated six months before Gertie's collapse and two months before it opened to traffic, provides evidence for the disaster. The flaw is in the solid side plates. Without holes for the wind to pass through, the bridge vibrated like a reed in a saxophone, giving it its "galloping" nickname. When the replacement span opened 10 years later, it was bigger and provided space for wind to pass through. The third bridge, in 2006 a work in progress, is wider still. —PD

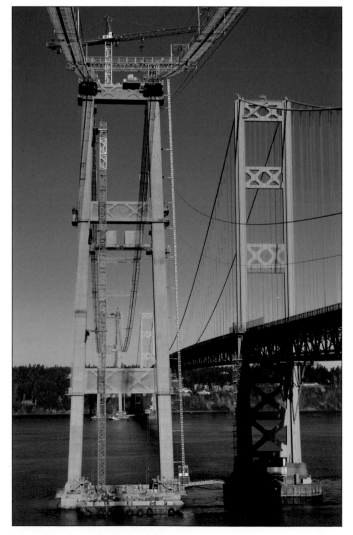

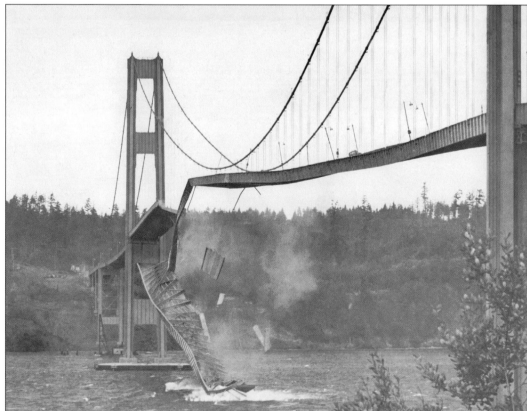

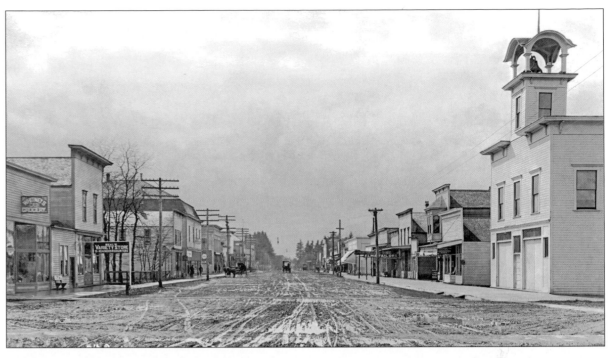

Steilacoom, 1860s

Founded twice, Steilacoom is a town of many Washington firsts. The long list includes the first post office and Protestant church, as well as the first brewery and jail. Contiguous plats were filed in 1851 and then joined in 1854 at Union Street by decree of the new Washington Territory. And thereby Steilacoom achieved its most important "first" as the oldest incorporated town in Washington. It now has 32 buildings and sites on the National Register of Historic Places, including the Keach/Davidson House, seen here with two chimneys on the right. Built in 1858, it is one of two surviving structures from this 1860s record of Commercial Street. —PD

Elma, circa 1910

Had a kindly postal authority not changed the town's spelling to a more euphonic name, Elma might have been called Elmer, in honor of Elmer E. Ellsworth, the first Union soldier to die in the Civil War. Elma's nicknames include the "Wild Blackberry Capital of the World" and the less sweet but also less thorny "Gateway to Grays Harbor." This circa-1910 scene looks west on Main Street across 2nd Avenue, with City Hall on the right. Elma community librarian Laura Young notes that the bell from the old bell tower survives on the stoop of the new fire station, located a half block north on 2nd Avenue and thus just to the right of this "now" view. —PD

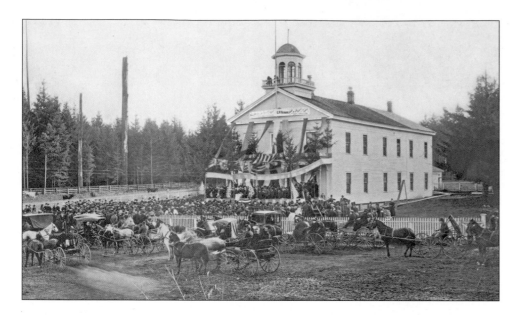

Capitol Buildings, Olympia, 1889, 1904, circa 1905, and 1926

Olympia was chosen as the territorial capital in 1853, and although fitfully threatened by rivals—notably Walla Walla, Steilacoom, Seattle, Ellensburg, and Yakima—this seat of Thurston County endures as the center of state government. The last of these failed capital kidnappings occurred in 1889, the first year of statehood. The scene at left records the statehood celebration on November 18, 1889, at the front of the territorial capitol building. Built in 1856, the frame structure survived until 1911.

Washington government later took residence in the Thurston County Courthouse building, completed in 1891 and taken over by the state Senate and House of Representatives in 1905. Its monumental tower is visible facing Sylvester Park in both the 1904 panorama (below) and historical shot by M. O'Connor (opposite, top left). Soon after the state moved its legislature to the new capitol in 1927, the 1891 tower was gutted by fire, then suffered injury again in the 1949 earthquake that also cracked the new capitol's dome. Both structures were repaired, although Jean's contemporary record (opposite, top right) shows that the old capitol did not retain its majestic central tower. Now the home to the Office of the Superintendent of Public Instruction, the impressive structure is still known as the "Old Capitol Building."

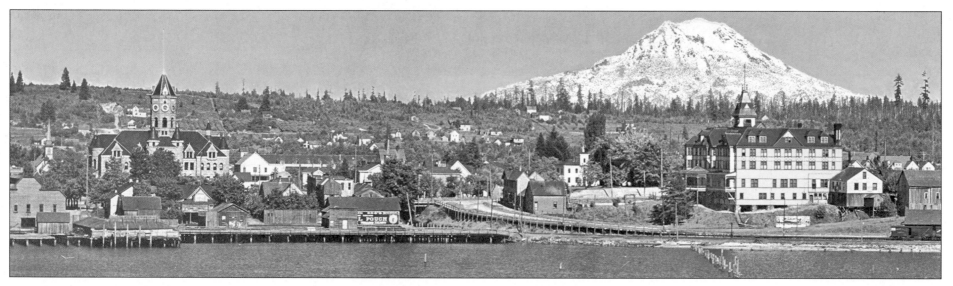

The state's governmental business is currently conducted in the Doric-colonnaded Washington State Capitol building (opposite page at bottom), its east wing shown here during construction in 1926. In 1927, five years of construction were capped with one of the highest domes in the world. —PD

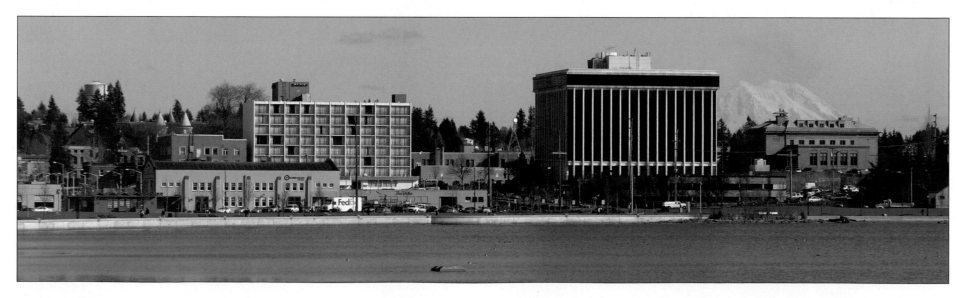

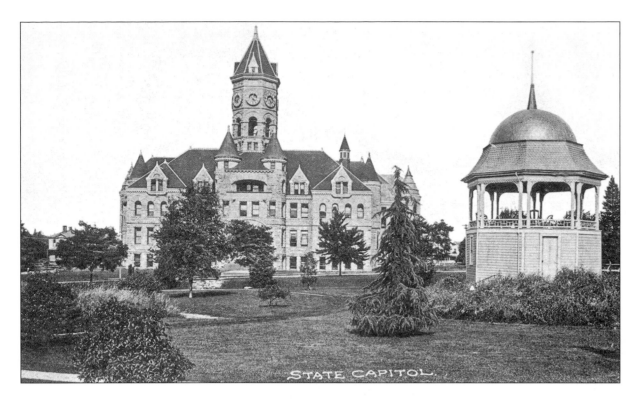

STATE CAPITOL.

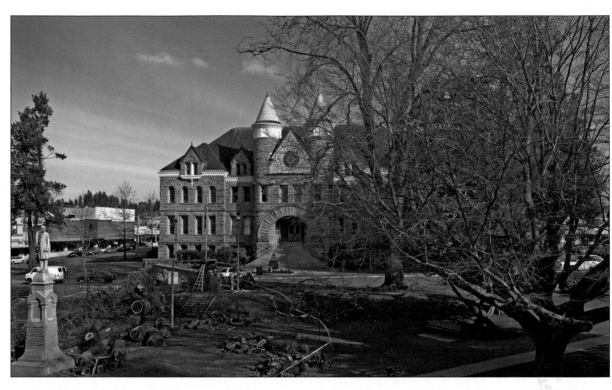

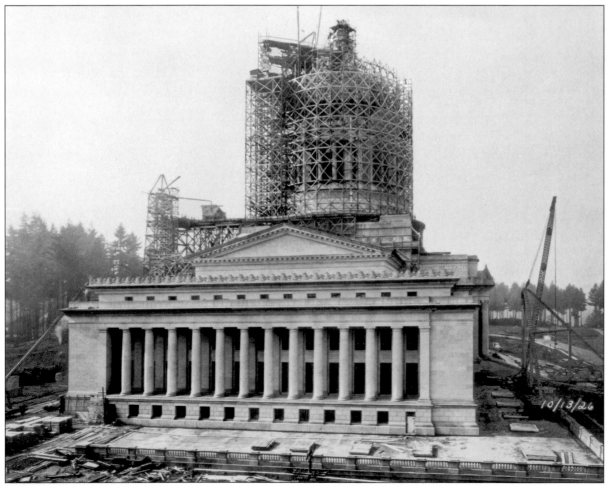

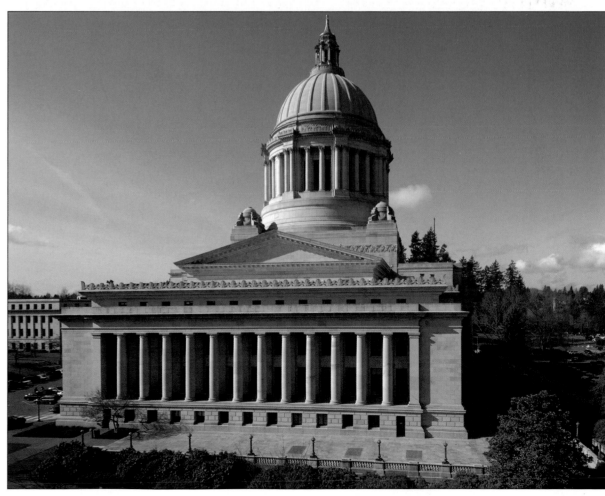

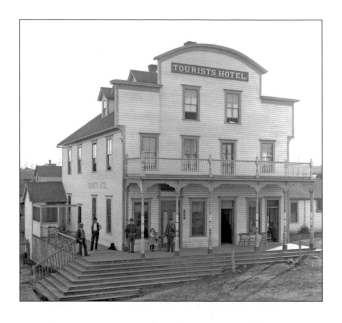

San Juan Island Landmarks, circa 1900 and circa 1909

The blockhouse (below) at English Camp on Garrison Bay still stands as a symbol of amiable resolution. In 1859, when an American settler shot a British pig, competing British and American claims of sovereignty over the San Juan Islands came to a head. After a bout of saber rattling, two opposing military camps were built on the island. After the chosen arbiter, Kaiser Wilhelm I of Germany, decided in favor of the United States in 1872, the forts soon disbanded and the picturesque archipelago of 172 islands settled into a pastoral peace that still attracts residents and visitors.

The decision to develop Joe Friday's sheep farm on the big island of San Juan into the county seat was slow to take, but by the 1890s Friday Harbor was the San Juans' biggest community, and it still is. Built in 1891, the Tourists Hotel (left) is typical of the many clapboard structures that survive with views of the harbor. It stands above the landing where Washington State Ferries regularly run to both Anacortes on the mainland and to Sidney on British Columbia's Vancouver Island. Today, the hotel (right) serves guests under a new name—Friday's Historic Inn. —JS

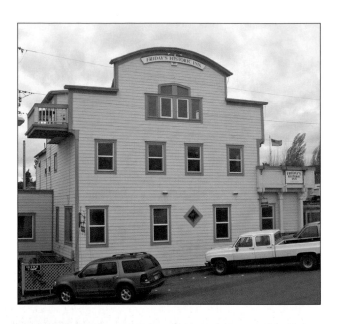

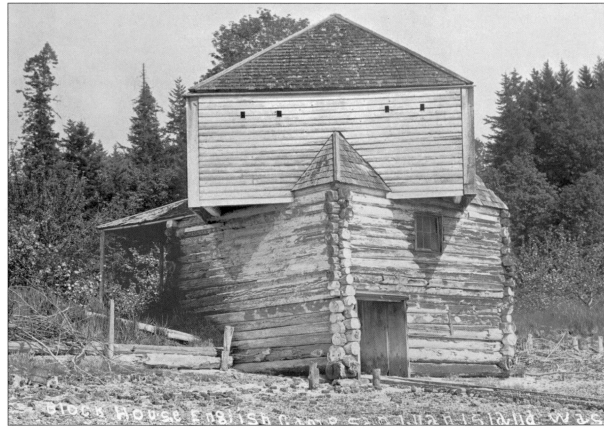

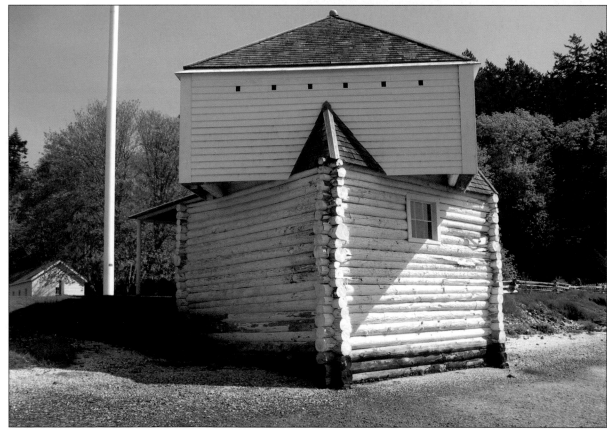

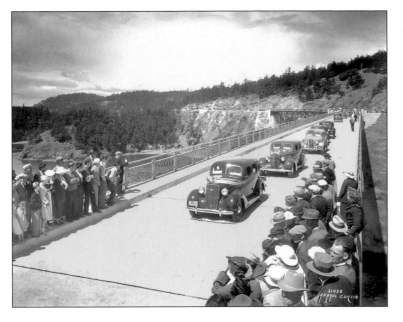

Deception Pass Bridge, Whidbey Island, 1935 and circa 1934

Captain George Vancouver named Deception Pass following his discovery that Whidbey Island, contrary to appearances, was *not* a peninsula. In 1935, after years of lobbying, Whidbey residents celebrated as the first cars crossed over this breathtaking link to the mainland (left). John Pope, the intrepid photographer of the "now" photo (right), scrambled a few hundred yards east of the bridge to find the proper prospect. Wife Michelle feared for his life as he bushwhacked down a steep, overgrown slope to get closer to the water, which was roiling at ebb tide through the narrow gorge. —JS

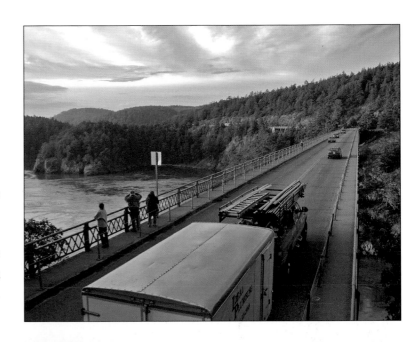

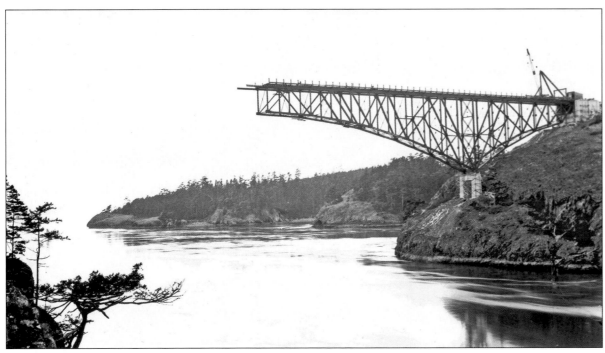

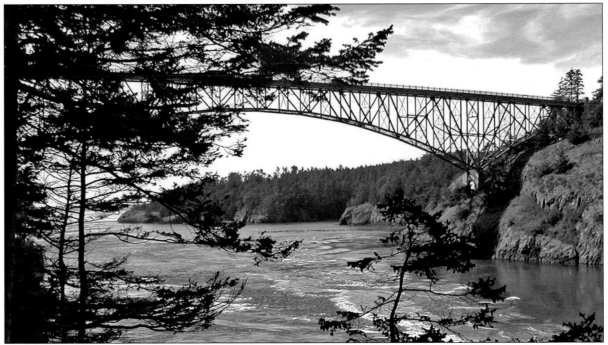

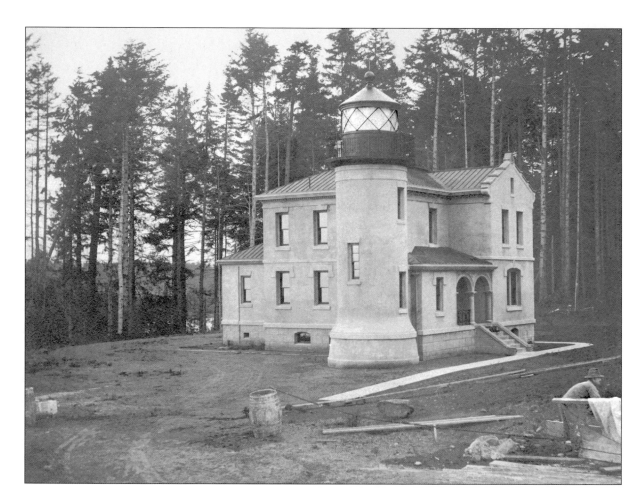 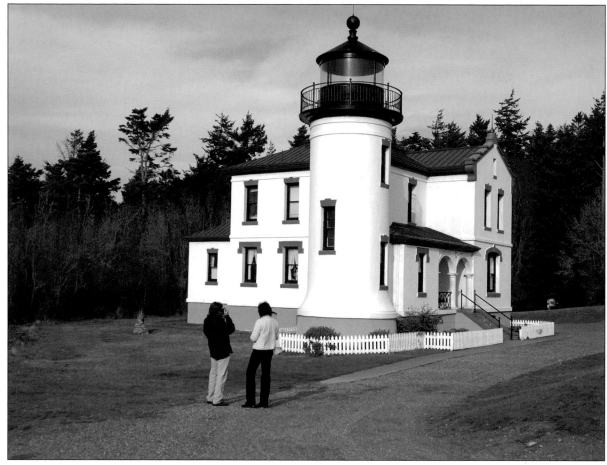

Admiralty Head Lighthouse, Whidbey Island, circa 1903

By now the Admiralty Head Lighthouse is an icon, though it is probably better known as the Fort Casey Lighthouse because of its proximity to the coastal outpost on Whidbey Island. Designed by the famed lighthouse architect Carl Leick, the 1903 lighthouse is less a beacon for ships heading into Puget Sound than a lure for globe-trotting lighthouse enthusiasts. Its classic shape has been honored with its own U.S. postal stamp. This early record was made by John Millis, when the tower was still getting its last touches. Millis took this and many other photographs when he was stationed at Fort Lawton in Seattle with the Army Corp of Engineers. —PD

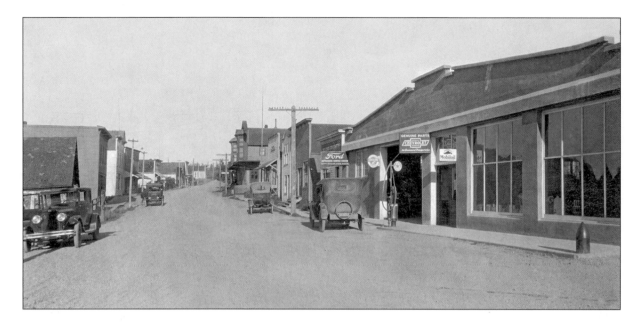

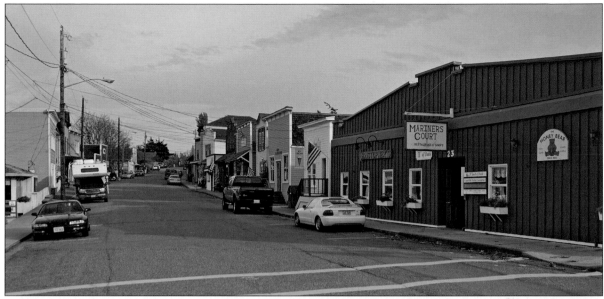

BARRINGTON AVE. OAK HARBOR. WHIDBY ISLAND WASH.

Coupeville and Oak Harbor, Whidbey Island, circa 1926 and circa 1930

First settled in the 1850s by sea captains, Coupeville was named after Captain Thomas Coupe, the only man to sail a square-rigged ship through Deception Pass. This shot of Main Street (top left) shows a number of Coupeville's early buildings still intact. Oak Harbor was first settled by a Norwegian but was made famous by Dutch farmers, who heard rumors of 5-pound potatoes and arrived en masse with agricultural know-how and tulips. Holland Happenings, and the "tulip trips" to both Whidbey Island and the nearby Skagit Valley, are spring rituals for many Seattle gardeners. —JS

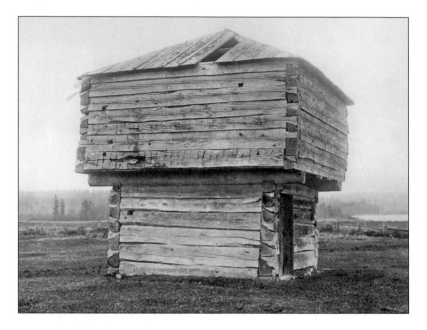

Ebey's Landing and Crockett Blockhouse, Whidbey Island, early 1900s

Jacob Ebey, along with Walter Crockett, was one of the first settlers on Whidbey Island. He built his house on the bluff just below the line of forest at the upper left of the photograph below. Ebey certainly wasn't among the island's earliest inhabitants: Salish people had lived here for at least a thousand years before his arrival.

On the northern edge of the Crockett Farm, south of Ebey's Landing, stands one of two blockhouses built by the Crocketts for their protection. It was restored and moved alongside Fort Casey Road by the Works Project Administration in 1938. Asahel Curtis took the "then" photo in the early 1900s. —JS

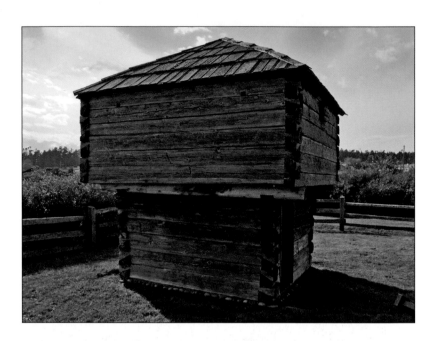

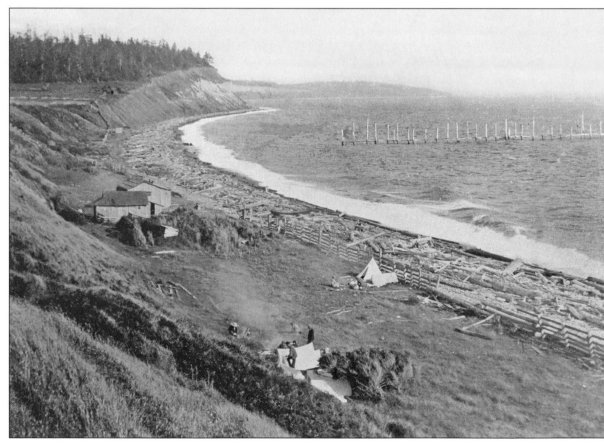

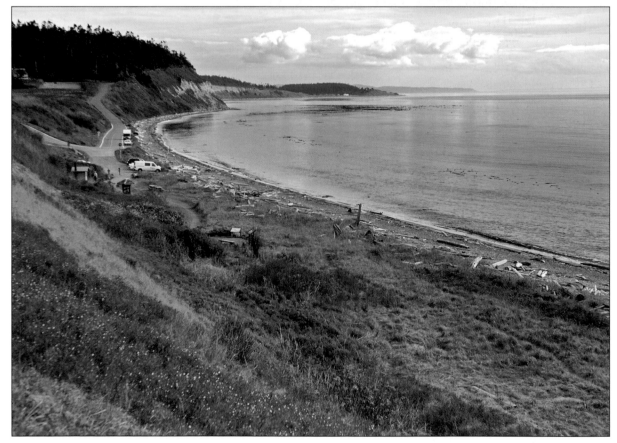

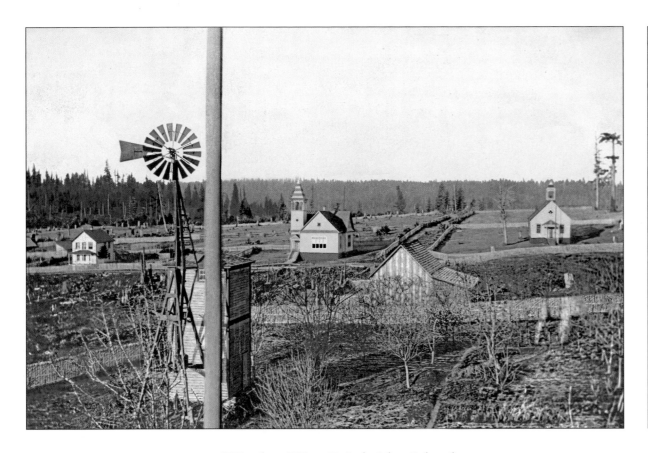

Winslow Way, Bainbridge Island, circa 1900

Every day for more than 20 years, Riley Hoskinson looked over his homestead from the family farmhouse to record the weather for the U.S. Weather Service. This circa-1900 view by his son, Stuart, looks west in winter through fruit trees. The prominent windmill was a Winslow landmark for visitors riding "Mosquito Fleet" steamers into Bainbridge Island's Eagle Harbor. Beyond the farm, at the future corner of Winslow Way and Madison Avenue, are the Eagle Harbor Congregational Church, built in 1896 (with the parsonage at far left), and what locals called the "Second School" on the right. Turned 90 degrees and moved one lot south in the 1960s, the church now survives with new neighbors—the modern shops on Winslow Way, the island's main commercial street. Early in the 20th century, Bainbridge Island began to show signs of what the Works Project Administration's Washington writers' guide described in 1941 as "the aristocratic among the islands of Puget Sound...home and vacation-place of the well-to-do, university instructors and artists." —PD

Front Street, Poulsbo, 1912 and circa 1920

It took a while, but members of the Poulsbo Historical Society were able to locate the right place for Jean to shoot this then-and-now photo of Front Street. They showed the historical images to residents who remember the street from the 1920s, explored on their own, and discovered a helpful clue linking the two photographs: The historical scenes share the two-story commercial structure with three second-floor windows, seen to the right of the flagpole in 1912 (below) and at the center of the circa-1920 view (right). The crowd in the street is standing in front of a three-story clapboard structure called the Hostmark Building, perhaps for a sale or to collect their mail. Hostmark, Poulsbo's first merchant, ran both a store and post office.

Had the crowd stuck around, Jean would have been standing with it in 2005. Hostmark's building survives but in shortened form. The top floor was cut away after the merchant-postman hanged himself there. In both the circa-1920 view and Jean's repeat, the presumably haunted storefront is just out of the frame to the left. —PD

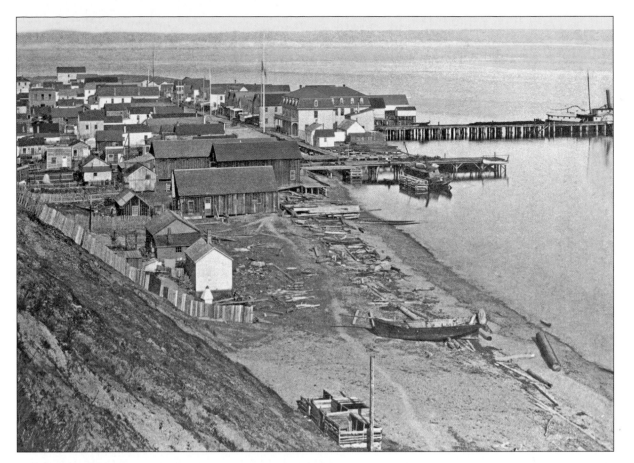

Port Townsend, late 1870s

The Huntington studio of Olympia recorded this bird's-eye shot of Port Townsend's business district, probably in the late 1870s. Streets are not particularly hard to prepare on a compacted sand spit, but they are risky—as the locals learned in 1866 when a tidal wave swept through town. In the early 1880s, this official Puget Sound port of entry raised the level of the streets in preparation for the coming of a long-hoped-for transcontinental railroad. While railroads remained reluctant to stop at Port Townsend, ships were not. In 1889, this "Key City" was described as "ranking only second to New York in the number of marine craft reported and cleared, in the whole U.S." But Port Townsend's nearness to the Strait of Juan de Fuca was an advantage only for windjammers. The rapid rise of steamships and the lack of a transcontinental connection meant that the port's moment of shipping glory was short-lived. Note that the bluff from which Jean took the "now" photo is steeper; this is because contributions from the bluff were used to extend the community's "Main Street," named Water Street, south from the central business district and over the tides. The before and after differences made by this regrade are revealed on the right in the two views. —PD

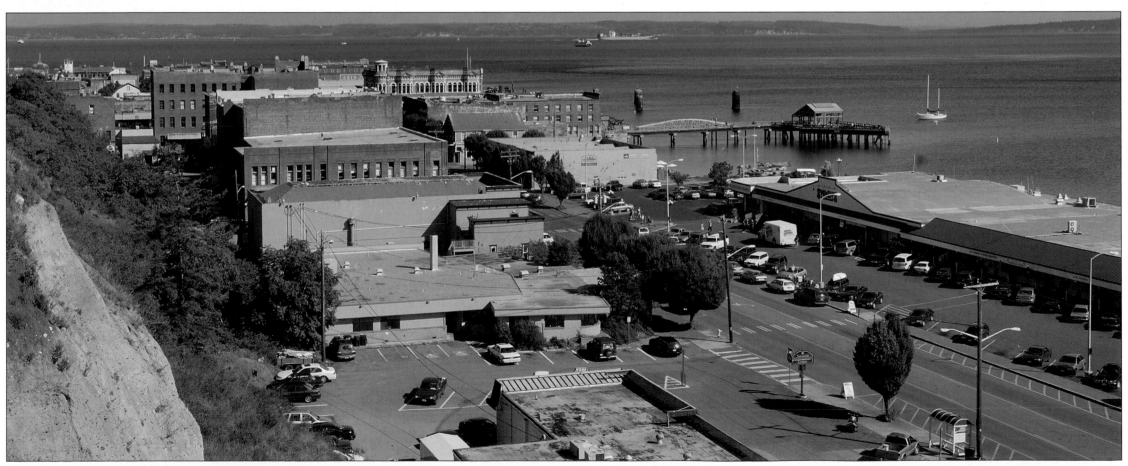

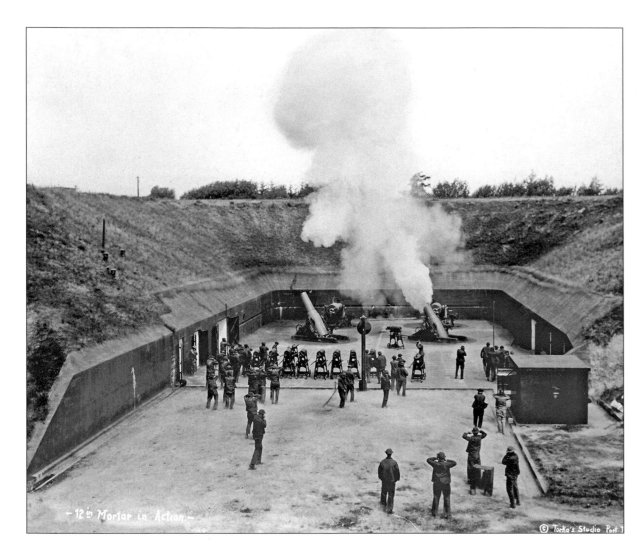

Fort Worden, circa 1915

These big guns at Port Townsend's Fort Worden were part of the triangle of forts built at Admiralty Inlet as a first line of defense against imagined enemy attack on the then relatively new Puget Sound Naval Shipyard at Bremerton. Conveniently, construction coincided with the Spanish-American War, and although there was not a remote chance that the Spanish would appear, their fleet could be imagined during test firing.

In truth, the cement from Belgium—or lack of it—was the real "foreign threat." When practice firing began in 1901, portions of the battlements cracked because the mixers had been too stingy with the cement. Fort Worden never fired on an enemy, and it eventually became a popular state park in 1978. Port Townsend's economy and culture have benefited considerably more from its playful uses than from those for which it was originally designed. —PD

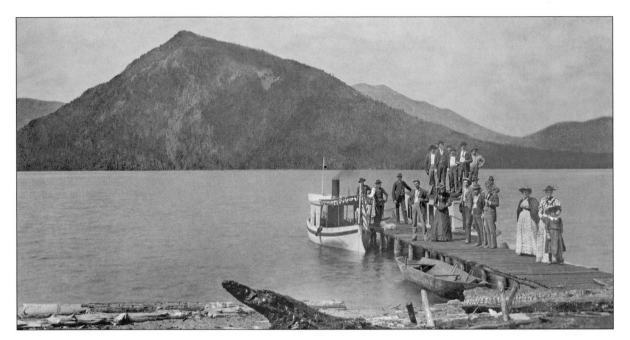

Lake Crescent, circa 1905

The shores of Lake Crescent were first settled in 1890, and it wasn't long before the tourists arrived. Cabins and resorts sprang up, burned down, and were quickly rebuilt to serve vacationers seeking refuge from urban life. One example is the Log Cabin Resort below. The steep mountain slopes cradling the lake delayed the construction of a road until 1922. Thus the early-20th-century passenger-only excursion boats, seen here against the backdrop of aptly named Pyramid Mountain, provided popular summer cruises.

Water sports have lost none of their popularity in the intervening decades. The repeat photograph above features paddlers (from left) Jim Benson, Bill Isenberger, Kenneth Casady, and Nan Benson, all from Port Angeles. —JS

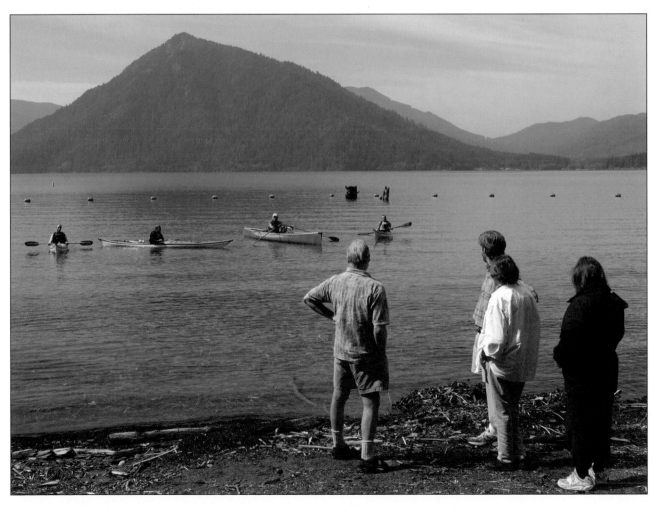

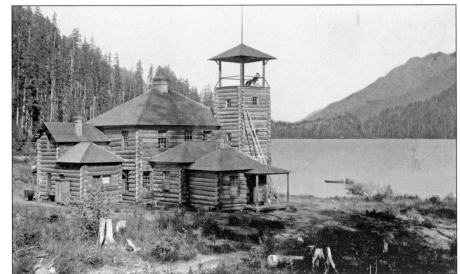

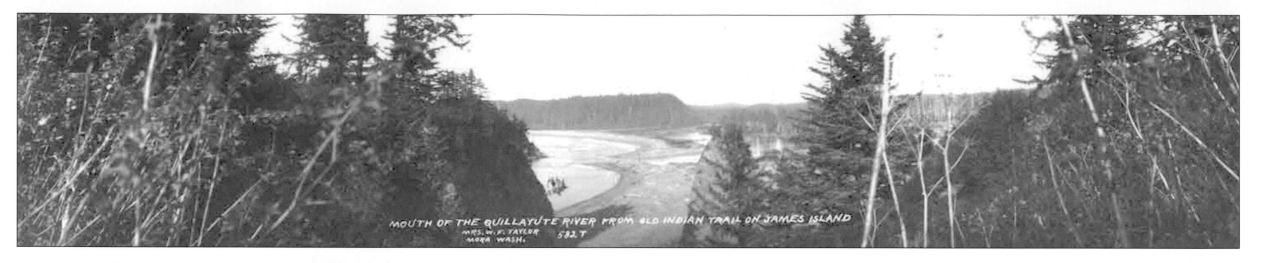

MOUTH OF THE QUILLAYUTE RIVER FROM OLD INDIAN TRAIL ON JAMES ISLAND
MRS. W. F. TAYLOR 582 T
MORA WASH.

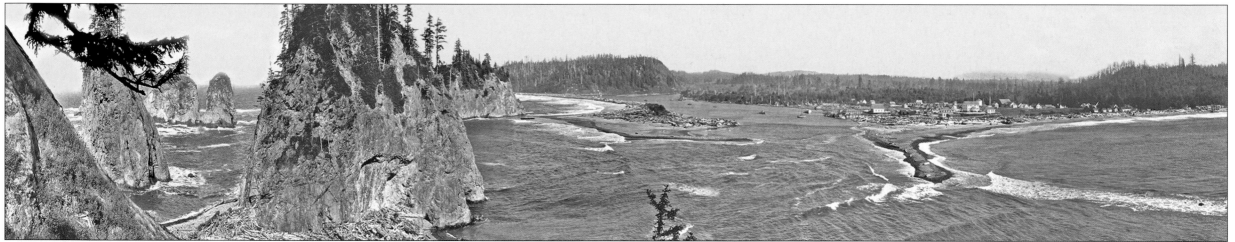

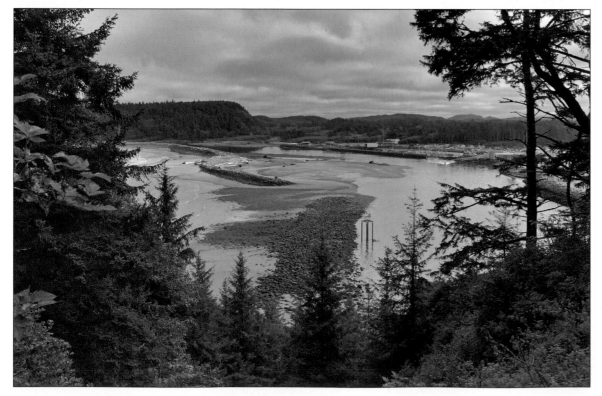

La Push, circa 1920s and 1945

Home to the Quileute people for untold generations, La Push, a tiny fishing village at the mouth of the Quillayute River, has endured a number of battles over culture, property, and fishing rights. Isolated and ignored until 1889, when the reservation was set aside, the Quileute continue to fight for their rights to this day. In a recent protest, they denied access to the parking lot of popular Second Beach until their demands to build on tsunami-safe higher ground were acknowledged by the National Parks Department.

Second Beach lies just south of La Push. The prosaic moniker belies the raw natural beauty revealed in Asahel Curtis' then-and-now photograph (opposite page). The mermaid in the foreground of the "now" shot is unidentified, but Kael Sherrard is the agile climber of the sea stack.

Many telling photographic records of La Push are the work of Fannie Taylor, who came from Deadwood, South Dakota, to settle in Mora, once a tiny town 1 mile upriver from the Quillayute's mouth. For the next 15 years, she served as postmistress and taught in the Indian school at La Push. Larry Burtness, historian and project manager of the web-based Olympic Peninsula Community Museum, tells us that Philip Wischmeyer (see his Neah Bay panorama on p. 74) met Taylor on one of his many Olympic Peninsula photo trips and inspired her, soon becoming her mentor. Her photographs include a lovely panorama of La Push (top photo) captured, Burtness posits, using Wischmeyer's wide-angle camera. Taken from sacred James Island, it looks down at La Push and its open harbor. The photo (middle) from October 1945 shows a denuded island. The sea stack prominent in Taylor's photo has been leveled to repair a protective sea wall. —JS

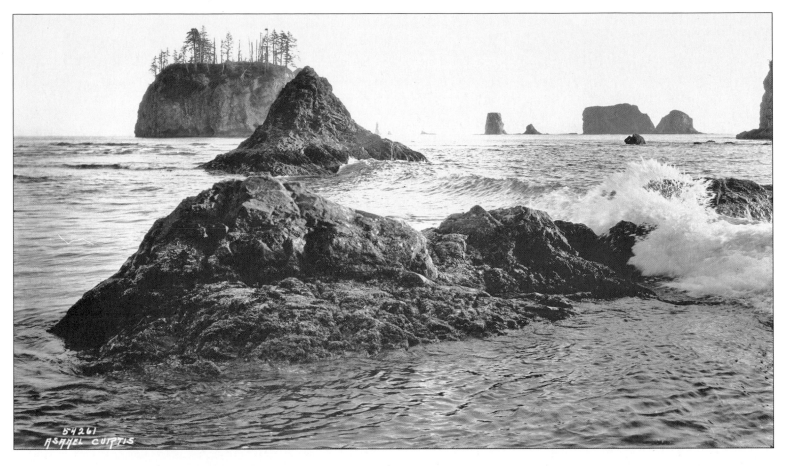

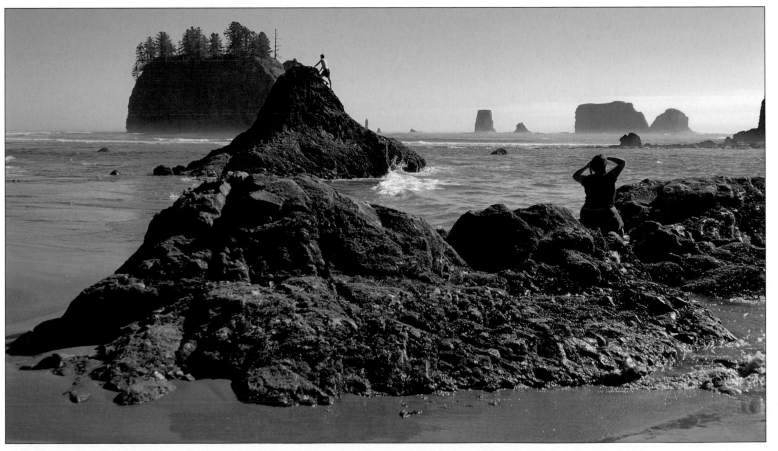

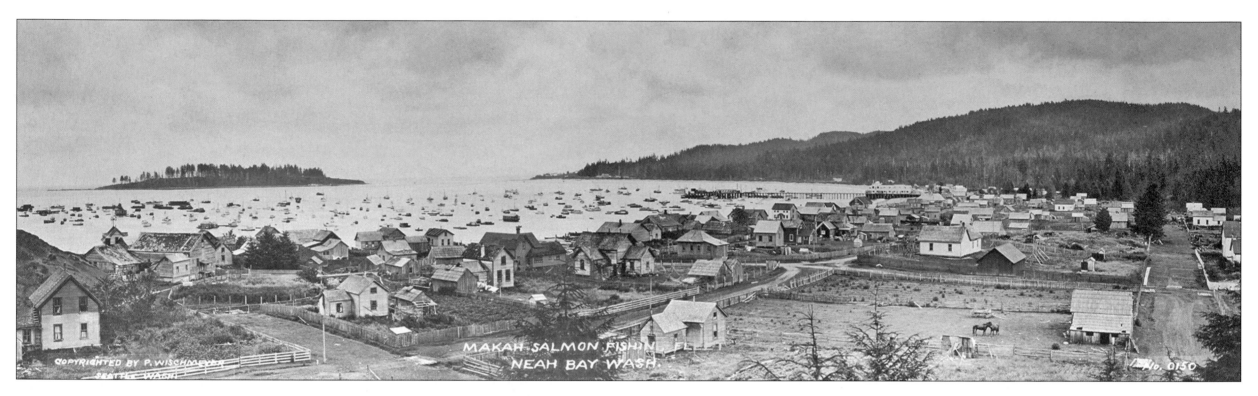

MAKAH SALMON FISHING FLEET
NEAH BAY WASH.

COPYRIGHTED BY P. WISCHMEYER
SEATTLE WASH.

No. 0150

Neah Bay, circa 1910

Photographer Philip Wischmeyer took this superb panorama from Diaht Hill. Kirk Wachendorf of the Makah Museum identified the prospect and contacted Brian and Roxanne Parker, from whose backyard I took the "now" photo. Wischmeyer had originally perched about 25 feet to my left in an area now obstructed by a stand of firs. His portrait of a bay crowded with the Makah salmon fleet provides a startling contrast to today's deserted waters and hints at a way of life nearly lost to European contact. Today, there are seeds of hope—the Makah Cultural and Research Center, a hub of civic life, reports a resurgent interest in language and heritage among young Makah. Neah Bay was also a site of one of the earliest non-Native settlements north of San Francisco and west of the Rockies. A Spanish colonial expedition erected a small fort here in 1792, but abandoned it after six months. —JS

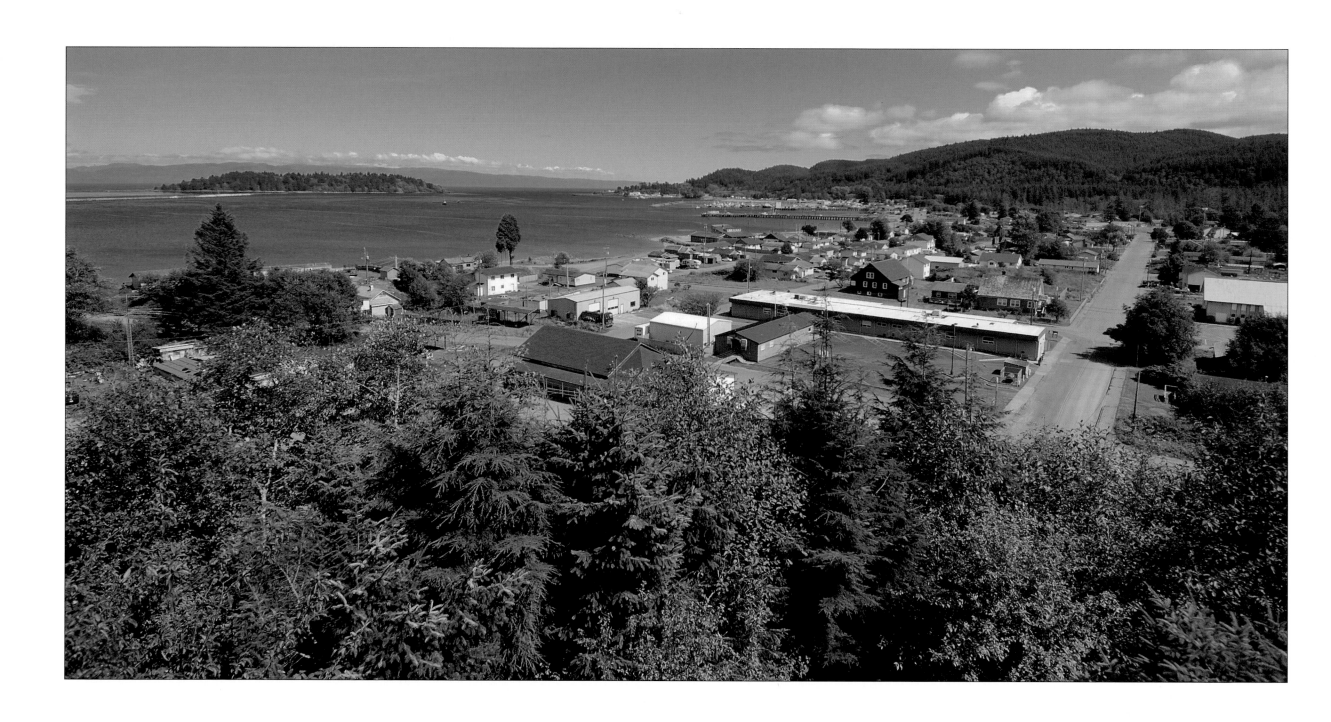

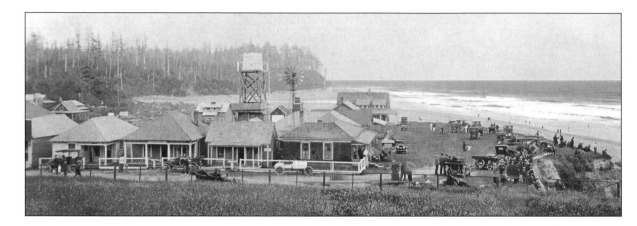

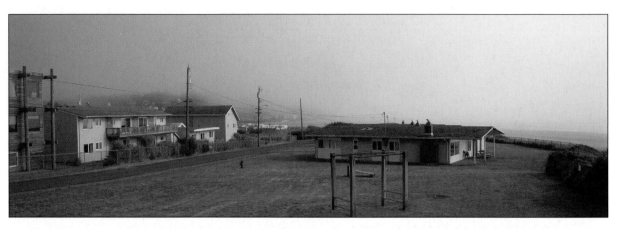

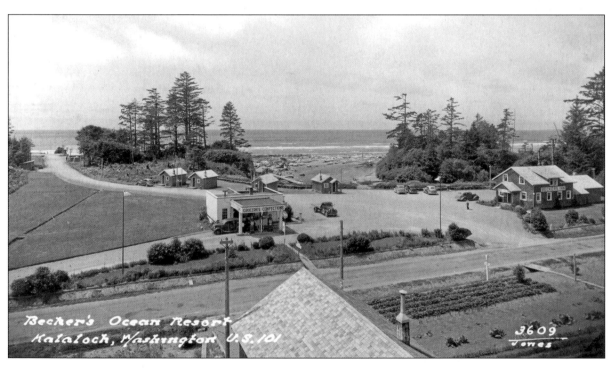

Coastline Retreats, circa 1915 and circa 1931

Pacific Beach Resort (top left) was more than a half-century old when the site was taken during World War II for a gunnery site and then a secret Navy research facility that was closed in 1987. It is now a state park.

Even before the 1931 dedication of the Olympic Loop Highway, today's Highway 101, Kalaloch (bottom left) was drawing resort-bound tourists. The cabins by the beach remain a popular destination for urbane Puget Sound residents looking to indulge their wilder yearnings.

—PD

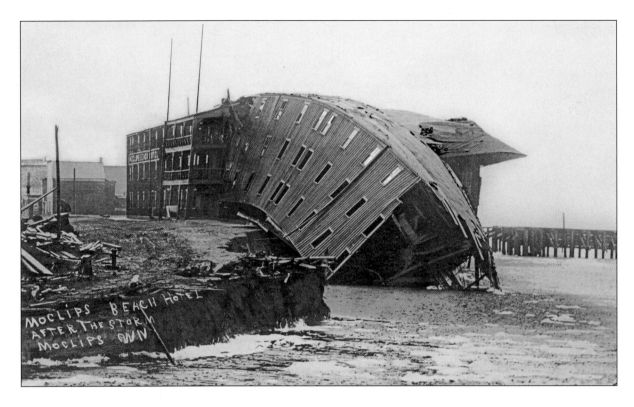

Moclips Beach Hotel, 1911 and 1913

The sensational story of the oversized Moclips Beach Hotel is one of human ambition facing off against the force of the ocean. Gene Woodwick, curator of the Ocean Shores Interpretive Center, lends us this short history: "Wanting some income while it waited for the nearby Quinault Reservation to be opened for logging, the Northern Pacific Railway helped Edward Lycan, an Aberdeen doctor, build the 283-room Moclips Beach Hotel in 1907. At its zenith, as many as 2,000 people a weekend rode the Northern Pacific from the Puget Sound area to the hotel. For Independence Day 1910, the Seattle Auto Club packed their motorcars to the beach for a big rally, and a few machines were lost because their owners did not understand that the tide goes both out and in. Moclips' fateful visitor arrived the following February 12, 1911, on a Sunday afternoon: the wildest storm on the coast since settlement. The big blow shattered the bulkhead and used the timbers as battering rams to undermine and break up the long north and south wings of the hotel. Through the night it also swept away several houses while, in the dark, citizens clung to each other or whatever." Dr. Lycan tried to salvage what remained of the hotel's center section but that, too, was shaken by a storm in December of 1913 (right). —PD

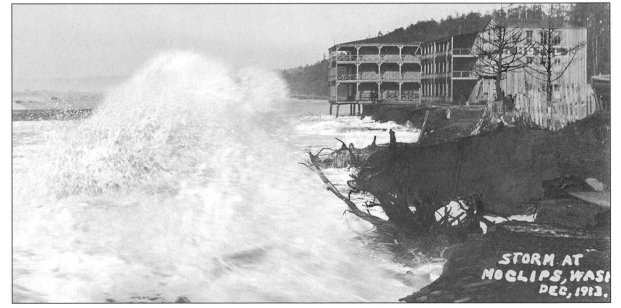

Southwest Corner

Hoquiam • Aberdeen • Montesano • Highway 101 • Raymond • South Bend • Claquato • Frances • Skamokawa
Ilwaco • Cape Disappointment • North Head • Longview • Chehalis • Vancouver • Mount Saint Helens

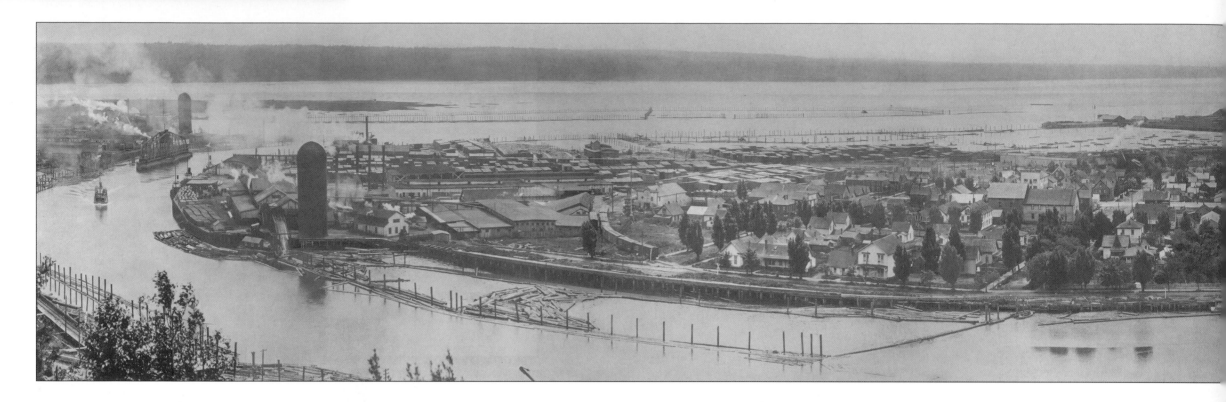

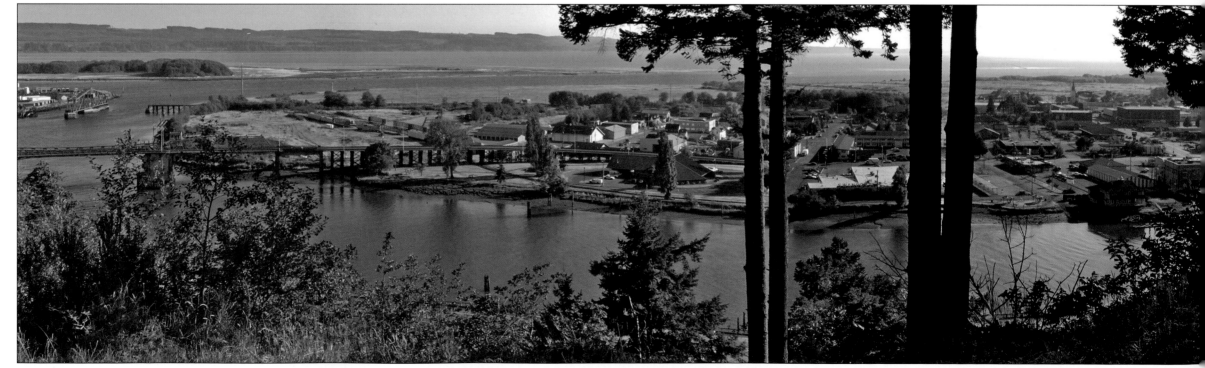

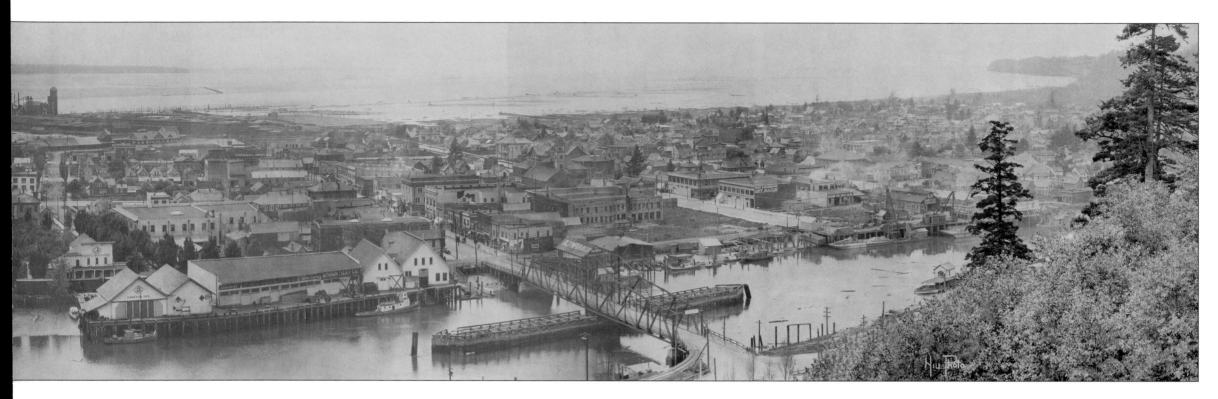

Hoquiam From Beacon Hill, 1914

Hoquiam, the Chehalis Indian name for this river, means "hungry for wood." It is a moniker appropriate for both the driftwood-strewn tideflats and the community that transformed them into what historic photographer Charles F. Hill captured in this panorama so clearly that it invites endless inspection. (For a proper study of Hill's work, visit Hoquiam's splendid Polson Museum, where the panorama of industrial Hoquiam hangs on the wall.) The mill town's timber-driven boom eventually gave its 12,000 residents the highest per capita income of any city in the state.

The accompanying photo of mobilized strikers (left) also dates from 1914. They march north on 8th Street, heading for the steel swing bridge included on the right of the panorama. The wooden span that preceded it in 1900 provided the first pedestrian connection to the east and west sides of a formerly divided city. The 8th Street Bridge was abandoned for a new bridge on Riverside Avenue in 1971. In Jean's contemporary repeat (opposite page), a screen of trees obscures this section. —PD

Heron Street, Aberdeen, circa 1908

Both historic photos shown here are of Aberdeen's Heron Street taken from opposite ends of the same block. The panorama of Aberdeen's brick-paved Heron Street (below) was taken from G Street. Before bricks were introduced in 1908 on Heron Street—Aberdeen's "Main Street"—the rotting sawdust foundation of the original wood paving had to be replaced with about 1,700 dump trucks' worth of earth. —PD

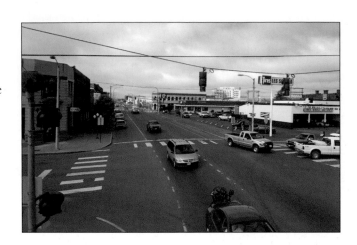

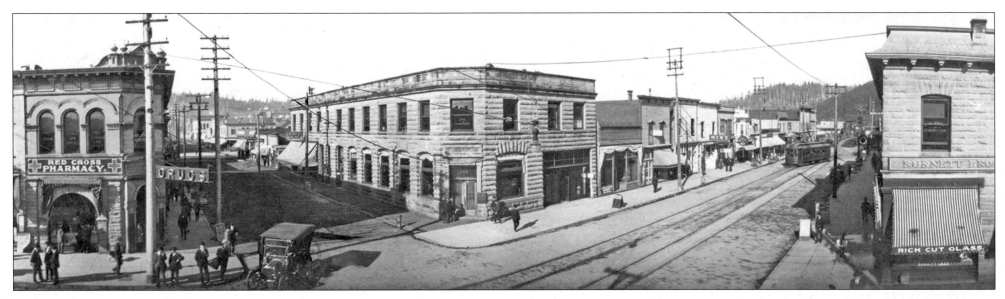

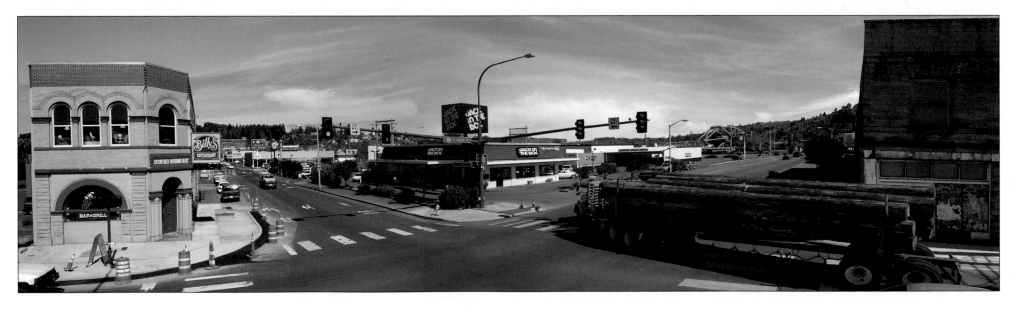

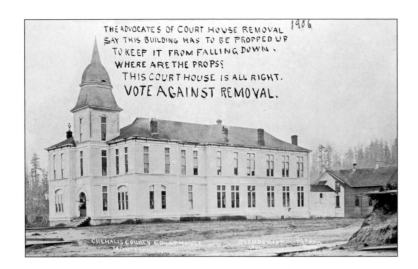

THE ADVOCATES OF COURT HOUSE REMOVAL
SAY THIS BUILDING HAS TO BE PROPPED UP
TO KEEP IT FROM FALLING DOWN.
WHERE ARE THE PROPS?
THIS COURT HOUSE IS ALL RIGHT.
VOTE AGAINST REMOVAL.

CHEHALIS COUNTY COURT HOUSE

Montesano, 1906 and circa 1931

Twice the "twin cities" of Aberdeen and Hoquiam attempted to wrest their county's courthouse from Montesano. But in 1905 this conspiracy lost in a countywide election. Montesano had run and won on its efficiency, and with the 1906 postcard of the extant 1890 clapboard courthouse, shown at left, the county seat continued to flaunt its enduring modesty.

However, Montesano soon switched from restraint to pride and prepared to distinguish its seat with a new stone edifice adorned with ornament and packed with heroic murals. In response, the offended twin cities petitioned the state to create a new county with Hoquiam as the seat. Both statehouses agreed, and the governor, too, but not the state's Supreme Court. Montesano kept its seat and in 1912 opened its enduring sandstone-faced landmark, topped with a copper dome. That the architect, Watson Vernon, hailed from Aberdeen was little consolation for the twin cities. —PD

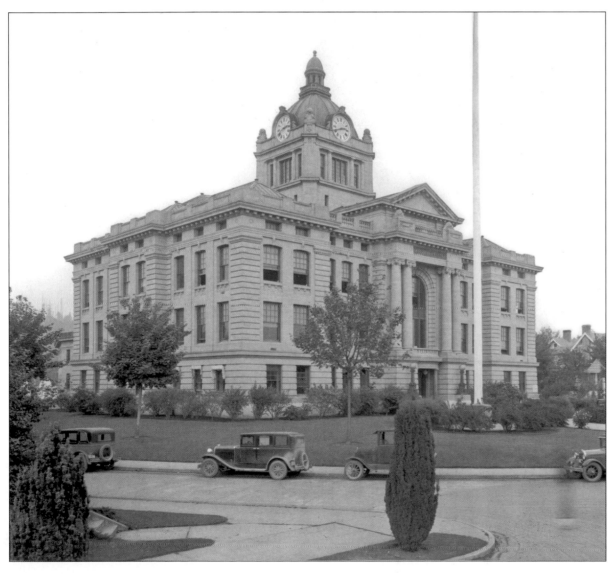

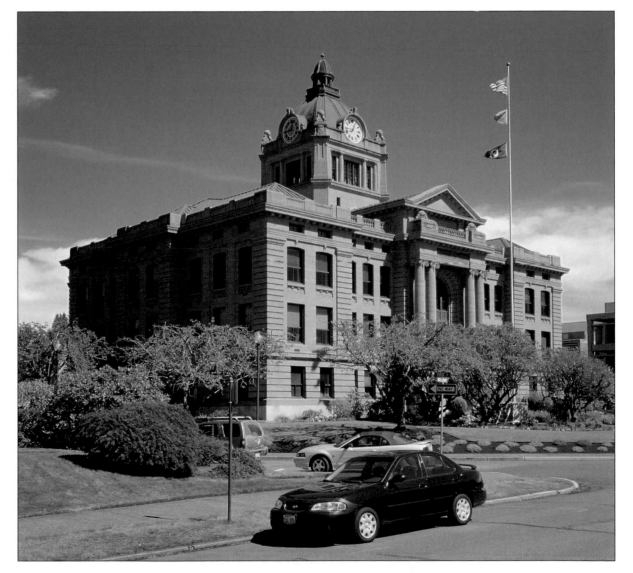

Highway 101, Pacific–Grays Harbor County Line, 1930

On October 8, 1930, enormous crowds arrived at the county line dividing Pacific and Grays Harbor Counties, lining up along the portion of Highway 101 that links Aberdeen and Raymond. Entertained by grandiloquent dignitaries and a uniformed brass band, they had gathered to mark the opening of the 25-mile stretch between Willapa Bay and Grays Harbor. The road's construction had been a nightmare, taking five long years of difficult excavation through dense undergrowth and unstable soil. When the speechifying concluded and the long caravan continued south to Willapa Bay, the cars in the lead reached Raymond at about the moment the cars at the rear passed this improvised stage at the county line. In a nod to the newly shortened commute, the old sign in Aberdeen that read "Willapa Bay 119 miles" was replaced by one reading "Willapa Bay 28 miles." Note the dense stand of old-growth forest shadowing the festivities, which contrasts with today's light-drenched clear-cut. —JS

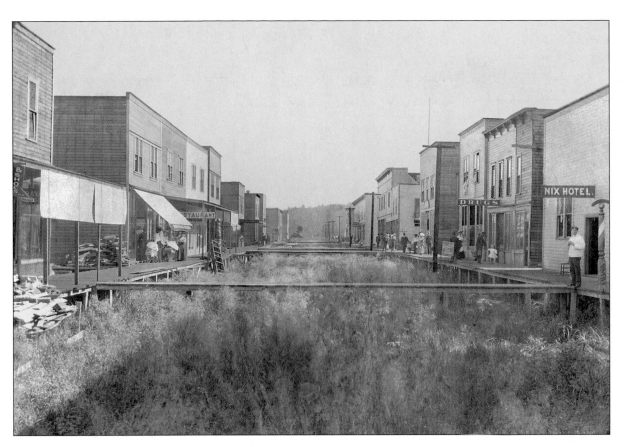

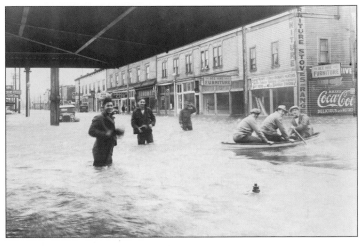

1st Street, Raymond

circa 1905, circa 1910, and circa 1933

When Raymond was first platted in 1904, its streets and sidewalks were 5 and 6 feet above the Willapa River floodplain. Bruce Weilepp, director of the Pacific County Historical Museum, explains that, "1st Street was notorious for flooding during especially high tides. The fire department would call the merchants when the water started moving and everyone arranged their stock up a couple shelves until the tide went out." With the completion of Highway 101 in 1930, the business district moved east toward it and 3rd Street. Now residential, 1st Street is still the first to flood. The 1st Street scenes featured here that are not flooded all look south from Ellis Street. —PD

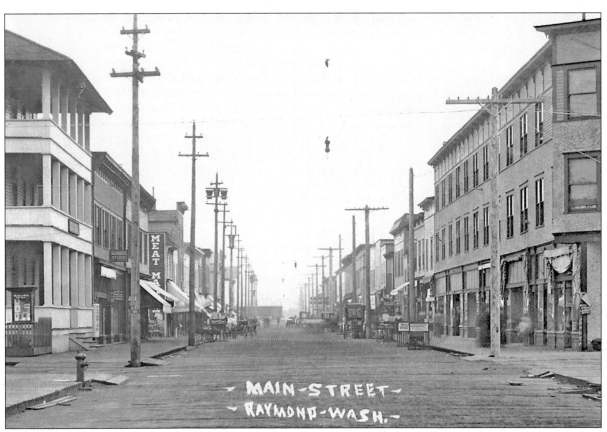

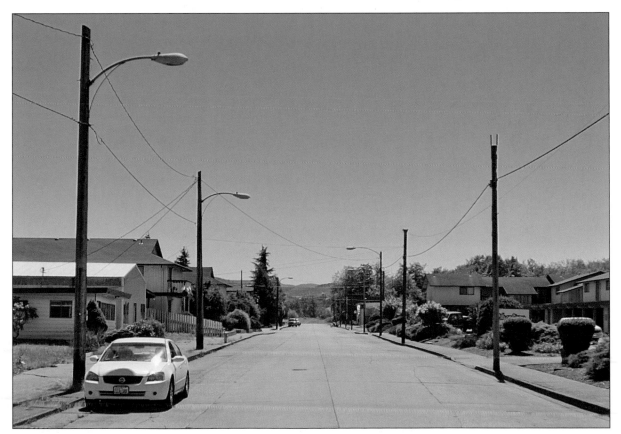

Pacific County Courthouse, South Bend, circa 1926

A long village green climbs to Pacific County's dazzling cream-colored courthouse. The mixed coloring continues inside the Classical Revival building with a beautiful stained-glass dome that scatters a calming light throughout the rotunda. It is an influence often needed by persons visiting the 1910 landmark as litigants. —PD

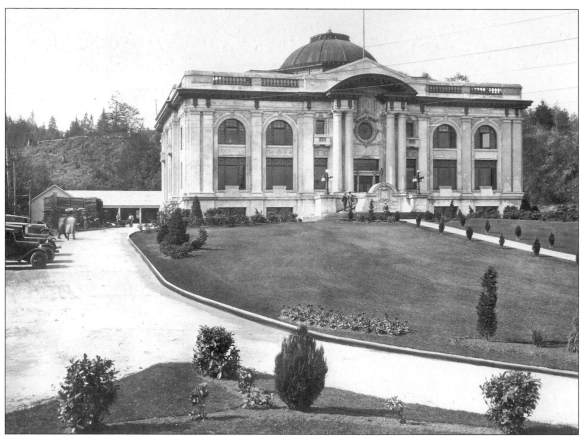

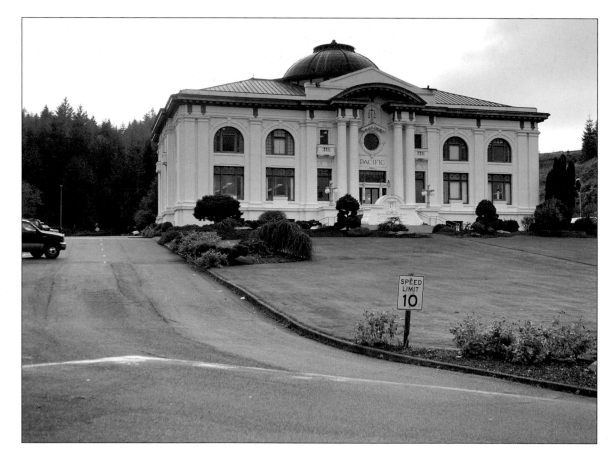

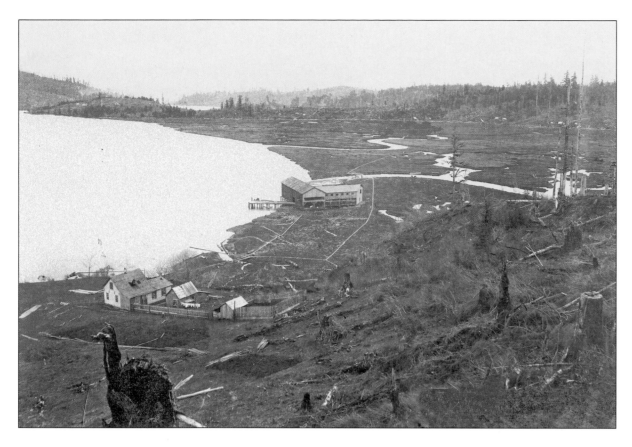

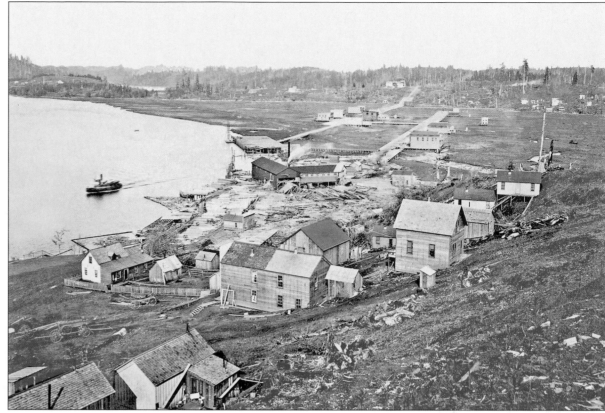

South Bend, 1890–1891

At least twice—here in 1890 and 1891—John W. Tollman climbed the hill that divides the east and west ends of South Bend and focused east to a sawmill and a home. His two photographs reveal how in one year a landscape had become a growing townscape. At that time, all of South Bend anticipated the coming railroad. In the five years from 1889, when generally savvy investors enlivened rumors of a railroad, to 1893, when the Northern Pacific arrived, South Bend grew from a button population of 150 to a burly 3,500. The other big arrival in 1893 was the national "panic," or depression, that held on through the mid-1890s and turned Pacific County fortunes from boom to bust. Because of the trees, Jean recorded his repeat from an opening lower on the hill than where Tollman stood. —PD

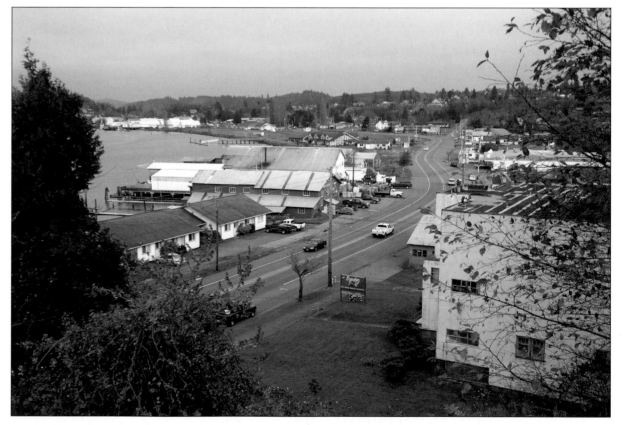

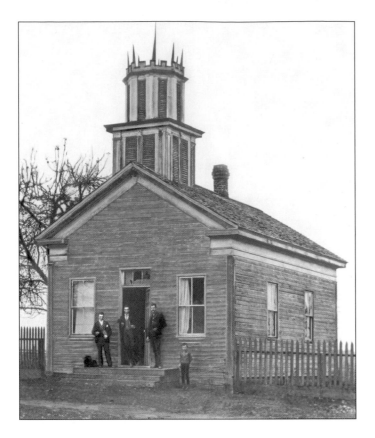

Highway 6, Claquato and Frances, 1891 and circa 1905

Two landmark pioneer churches, at Frances and Claquato, stand above Highway 6 between Chehalis and South Bend. Built in 1858 with a crown of thorns topping its tower, the Claquato church (left), about 3 miles west of Chehalis, is also distinguished as the oldest standing church in the state. The parish lost its parishioners after Chehalis took the Lewis County seat from Claquato in the 1870s. Although empty when it was photographed in 1891, it survived for a full restoration in the 1950s. Holy Family Catholic Church in Frances (below) dates from 1892, when the Northern Pacific Railway was approaching this largely Swiss settlement. —PD

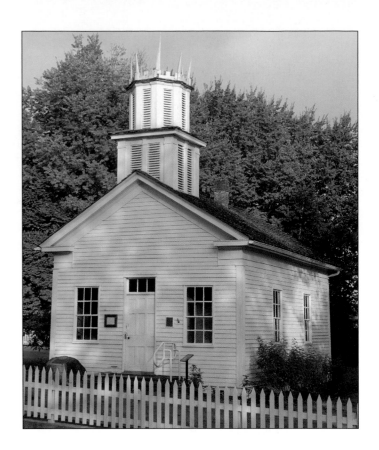

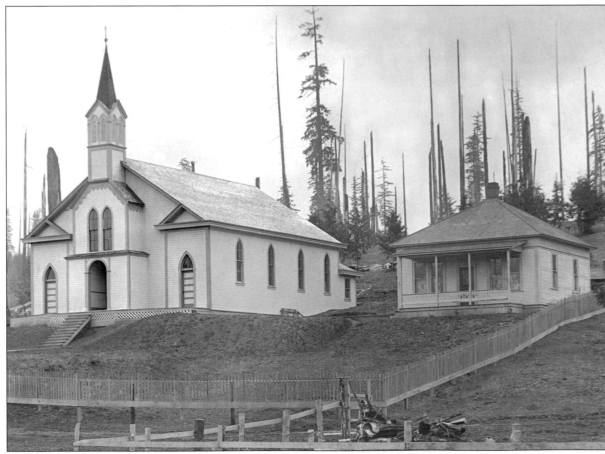

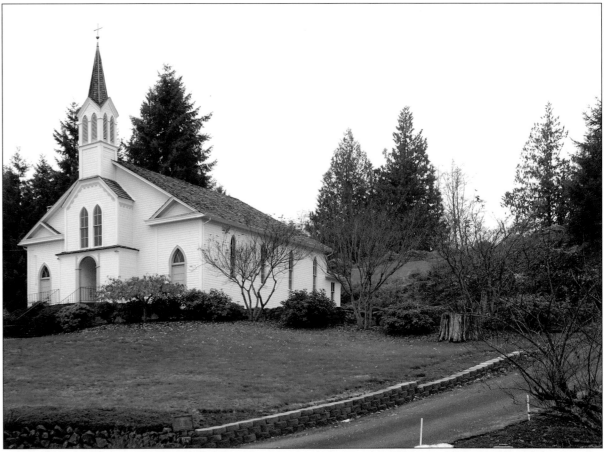

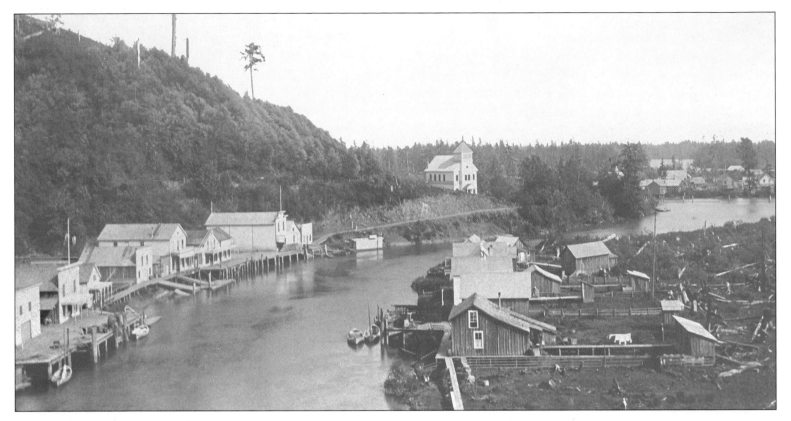

Skamokawa, circa 1903

Skamokawa was a Chinook fishing village on the Columbia River centuries before any roads reached this "Little Venice." In the early 20th century, it prospered as a center for lumber, fishing, and dairies, and still had only water connections. The recently restored Redman Hall (on the hill in the center of each photograph) was built in 1894 as Central School. Shown below, it is now home to the River Life Interpretive Center. The overgrown ridge from which the historical photograph was recorded can no longer be penetrated, requiring Jean to make his repeat photo from a bridge across Skamokawa Creek. —PD

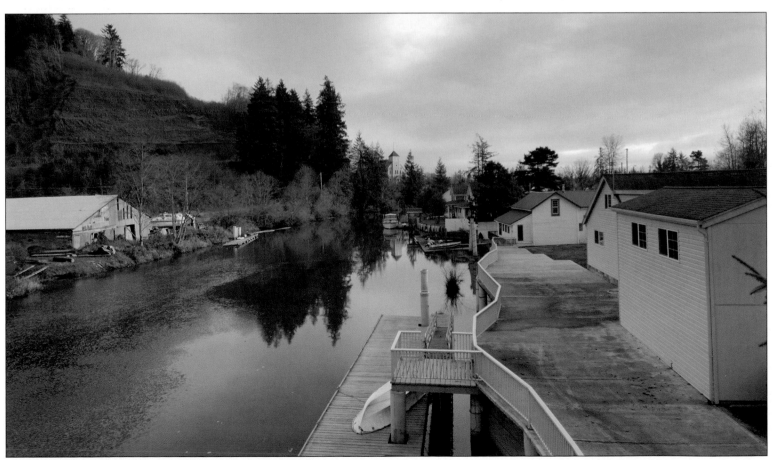

Ilwaco, circa 1909

For 41 years, beginning in 1888, the Ilwaco Railroad and Navigation Company carried passengers the 13-plus miles between Ilwaco on the Columbia River and Nahcotta on the Long Beach Peninsula. Since steamers could only reach Ilwaco, the port closest to the dangerous Columbia Bar and the Pacific Ocean, when the tide was up, the "Clamshell Railroad" had a schedule that flexed with the tides. In the "now" scene, members of the Ilwaco Historical Society pose on 1st Avenue near Main Street, near the site of the old depot. Soon after heading north on 1st Avenue, the rails ran parallel to what locals still promote as "The Longest Beach in the World." Driving on the beach is still a popular adventure and several arches have been erected to give beach driving a grand start. In late 2005, an errant Pepsi truck clipped the arch on Bolstad Avenue, the principal gateway to the beach. Locals restored their landmark arch in June 2006. —PD

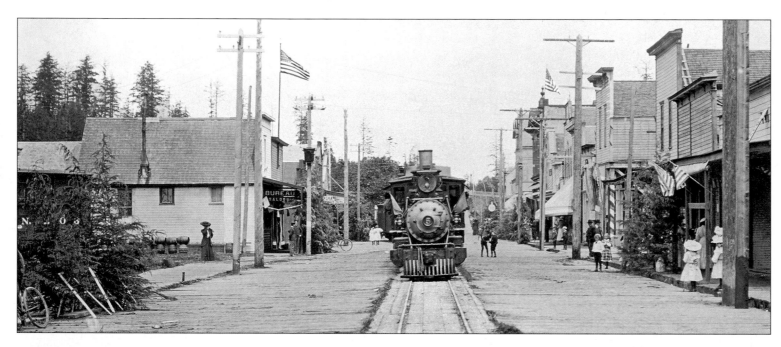

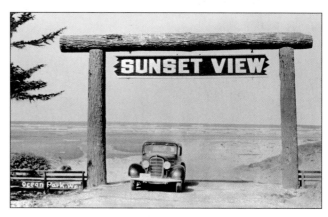

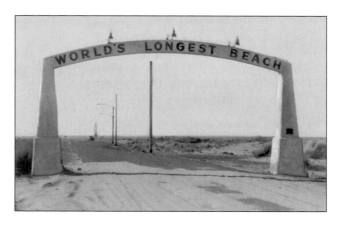

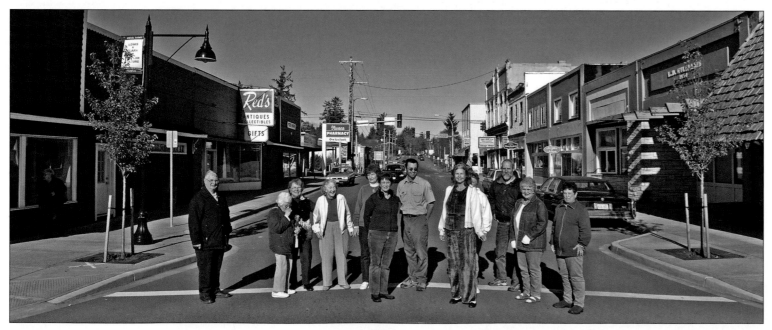

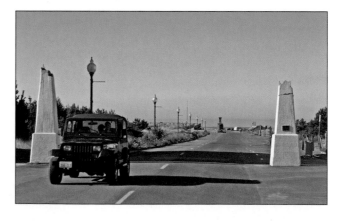

Cape Disappointment, circa 1913

Better known by sailors for its confounding fog, Cape Disappointment rewarded Jean with clear weather on the day he visited. After steadying his camera, Jean positioned himself with Aaron Webster (in uniform) of Washington State Parks' Lewis and Clark Interpretive Center, to repeat a view that dates at least from before 1914, when work began on the North Jetty at the mouth of the Columbia River. The jetty extends more than 2 miles from McKenzie Head, the distant mound seen in both views. It was from that mound that William Clark noted in his journal for November 18, 1805—with his typically creative spelling intact—"men appear much Satisfied with their trip beholding with estonishment the high waves dashing against the rocks & this emence ocian." Note the erosion of the cliffs that appear between Aaron and Jean and just below the Lewis and Clark Interpretive Center. —PD

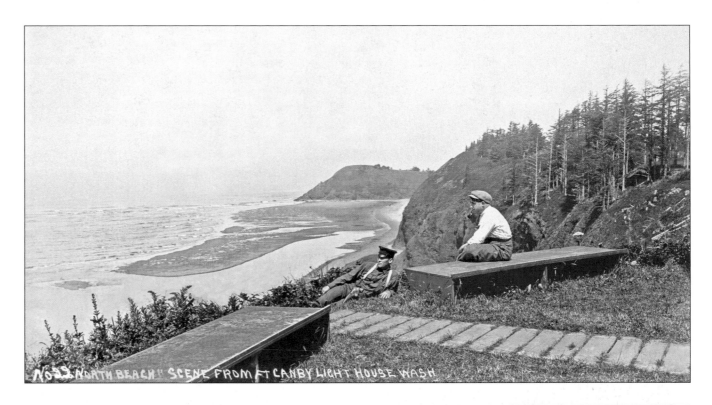

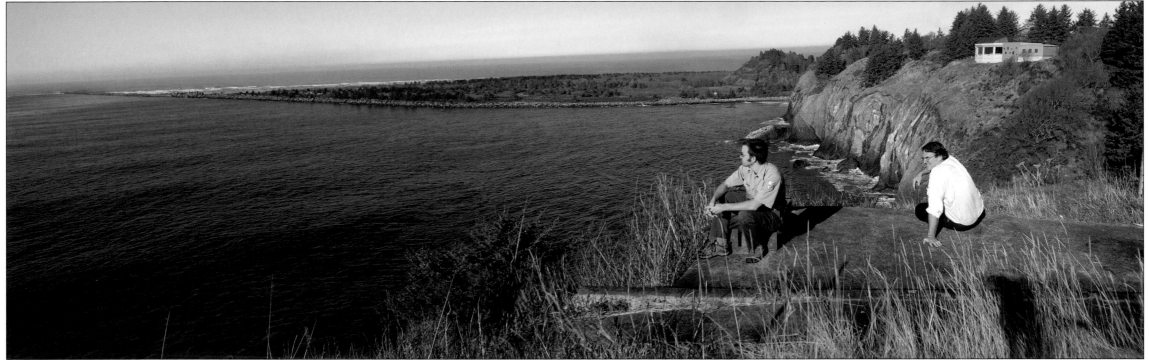

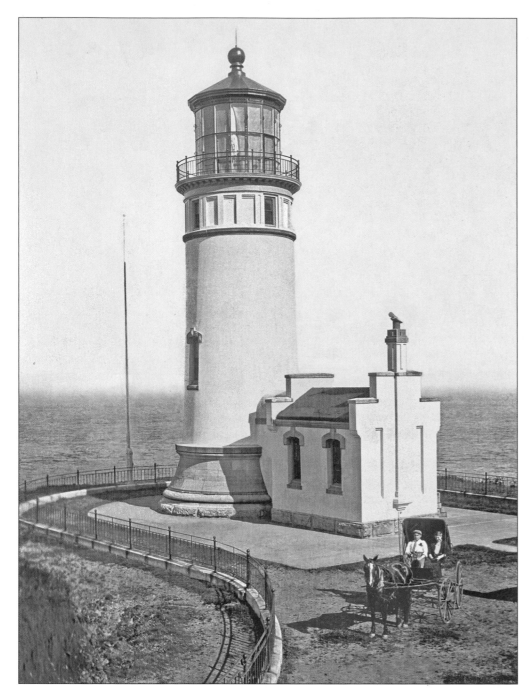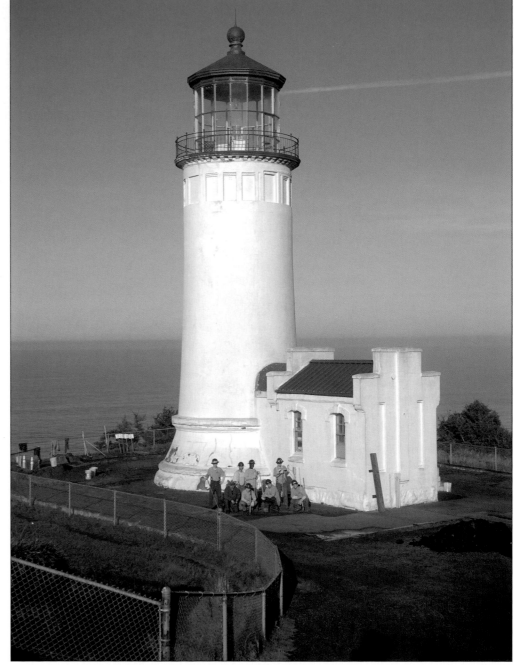

North Head Lighthouse, North Head, circa 1905

A mere 2 miles north of the lighthouse at Cape Disappointment, the graceful tower at North Head marks the southern end of the 22-mile-long North Beach Peninsula, "The Graveyard of the Pacific." In October 2005, a crew of young men worked to repair erosion on the bluff's weather side, part of a state program to teach incarcerated teens work skills and a sense of responsibility. Sadly, at the time of this writing in 2006, this program was scheduled to close—a victim of budget cuts. —JS

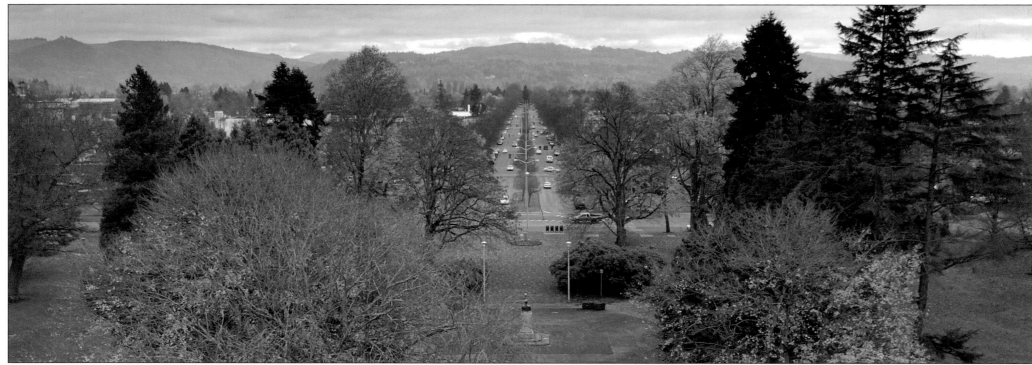

Longview, circa 1923

During the construction of his model mill town, R.A. Long had several panoramic photographs taken from the Monticello Hotel, the town's first distinguished structure, which was completed in 1923, a likely date for this early record from its roof. Both views look east-southeast down Broadway and over Longview's popular City Center Park, now known as R.A. Long Park. Jean used a wide-angle lens to show off more of Longview's greenery while it was dappled with fall colors in 2005. —PD

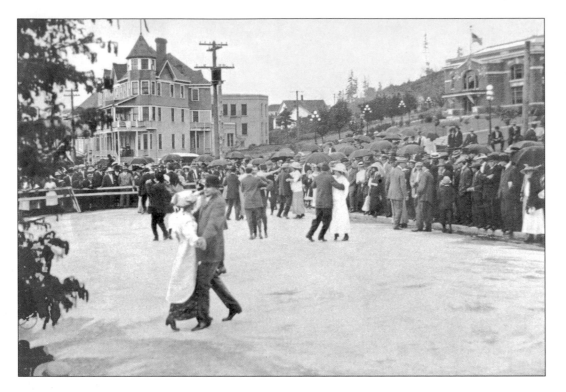

Chehalis, circa 1914

The popular Chautauqua movement began in the East in the 1870s with a mixture of Bible studies and lectures on self-improvement. Here on Market Boulevard in Chehalis, the movement had people dancing in the street. The Lewis County Historical Museum estimates that this invigorated scene dates from about 1914; the Chautauqua dances were held at this location until 1918, when the turreted St. Helens Hotel in the background was replaced with the current masonry building. In the background at right is the Chehalis City Hall, built in 1912 and still in service, although minus its ornate trim, damaged in the 1949 earthquake that was generally cruel to the region's cornices. In Jean's repeat, City Hall is barely visible through the trees. —PD

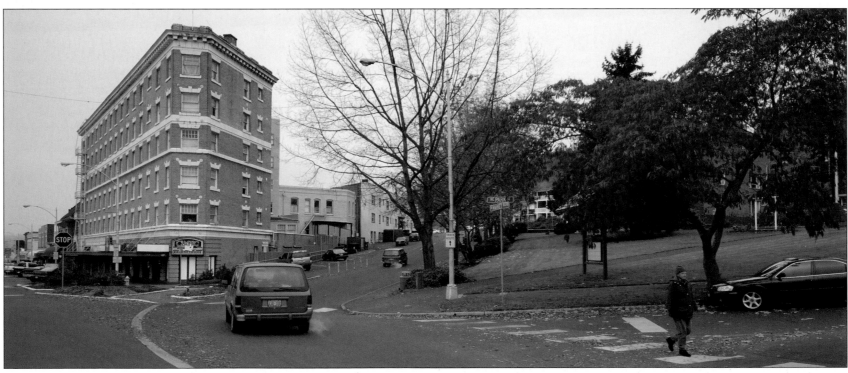

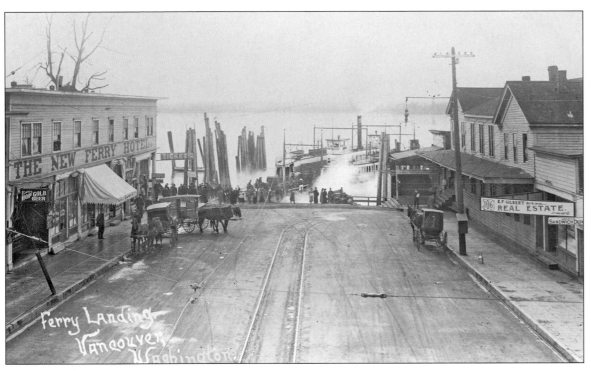

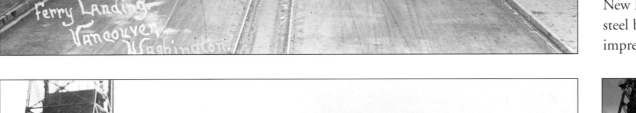

Interstate Bridge, Vancouver, circa 1905 and 1917

Open to ships but not yet vehicles, the 250-foot-long vertical lift of the Columbia River bridge between Portland and Vancouver was tested (bottom left). Below it the old ferry approaches the Vancouver dock on perhaps one of its last runs. In the accompanying photo (left), the ferry landed at the foot of Vancouver's Main Street and a hostelry either happily or hopefully named "The New Ferry Hotel." When completed in the spring of 1917, the bridge was lauded as "the longest steel bridge in the world"—and at 23,000 feet, including the approaches, the span was a most impressive feature for the Pacific Highway, then a work-in-progress. —PD

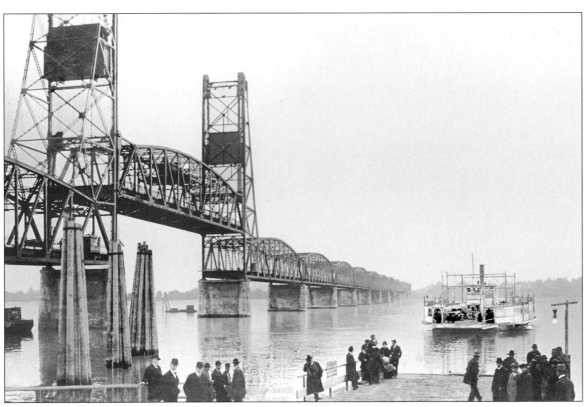

Mount Saint Helens, circa 1945

Hiking down toward Spirit Lake in late October 2005, I found the sheer scale of destruction on May 18, 1980, incomprehensible. The shell of a recently revived Mount Saint Helens puffed out steam across the water. In the eerie stillness, because there were no visual cues to lend any sense of distance or size, I might have been looking at a model of the real thing. This distorted perspective was resolved when I pulled out the Boyd Ellis postcard that I carried to make the repeat. In Ellis's photo of an austere morning with the 9,677-foot mountain reflected in all its glory, the serrated edges of tree-lined ridges provided a yardstick by which to measure. And then I understood.

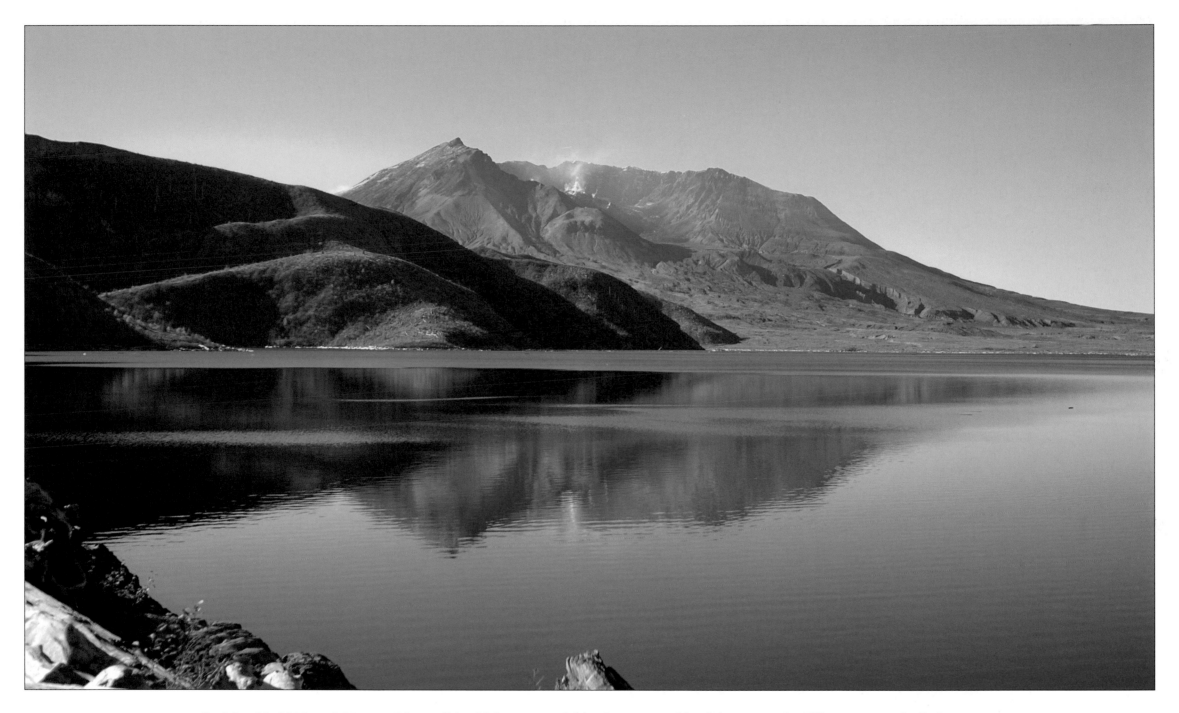

On May 18, 1980, at 8:32 a.m., Mount Saint Helens erupted, blowing away a side of the mountain. Fifty-seven people died, 200 square miles of forest were destroyed, and the mountain instantly lost 1,300 feet of elevation from its south side and 2,900 feet from its north. A thousand miles of state roads had to be closed and a layer of ash blanketed much of the state. Ellis stood closer to the south end of Spirit Lake at a spot no longer accessible today. —JS

Yakima Valley

*Ellensburg • Snoqualmie Pass • Keechelus Lake • Yakima River • Yakima • Union Gap • Toppenish
Wapato • Prosser • Richland • Pasco-Kennewick Bridge • Goldendale • Sunnyside • Maryhill*

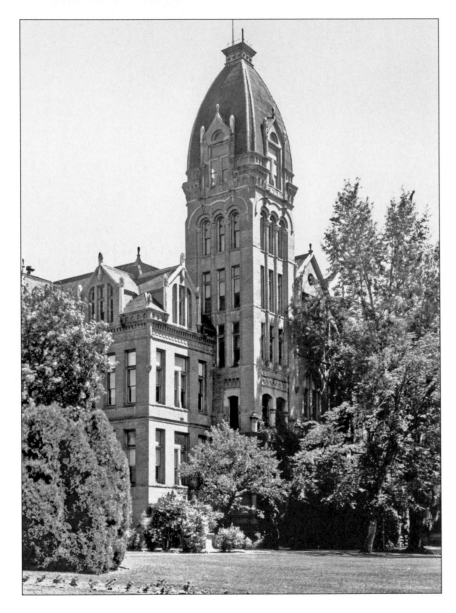

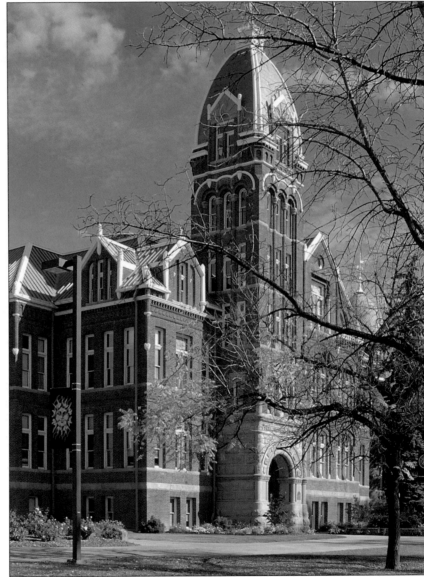

Barge Hall, Central Washington University, Ellensburg, 1940s

Built in 1893–1894 to hold everything—classrooms, offices, library, laboratories—Barge Hall remained the only structure on the Ellensburg campus until 1908. Built as a "normal school," a school to teach teachers, it grew into Central Washington University. With its 120-foot tower, Barge Hall was constructed from load-bearing masonry and wood, and so was vulnerable to tremors like the big one in 1949. Condemned, the weakened tower was removed in 1955. The landmark was missed, so in the early 1990s the reinforced tower was rebuilt and restored to its former grandeur. —PD

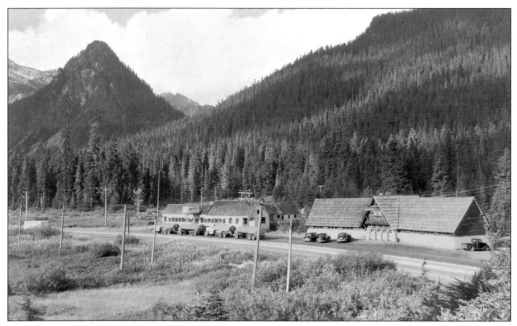

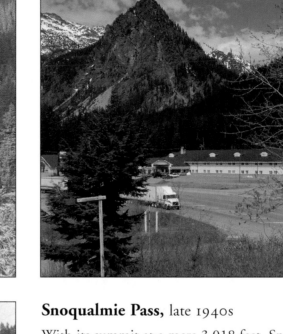

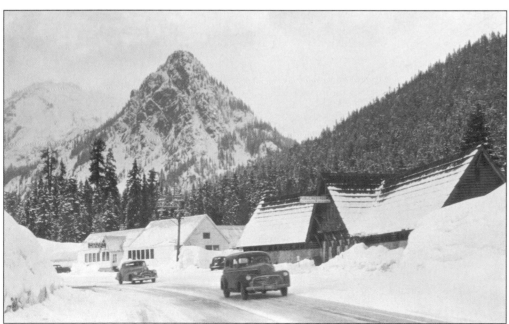

Snoqualmie Pass, late 1940s

With its summit at a mere 3,018 feet, Snoqualmie Pass was for Native Americans an ancient path and for the settlers an inviting way to tap the stock of eastern Washington and encourage immigration. But a wagon road that was blazed and built in the mid-1860s was soon made impassable by nature and neglect. In 1899, the state took some interest in what one report referred to as the "famous lost wagon road," and in 1909, when the Milwaukee Railroad first crossed the pass, so did motorcars in a transcontinental race. The pass was opened officially in 1915. Now an average of 28,000 vehicles use the pass each day.

Guye Peak is the familiar landmark pyramid just north of the pass. A fit climber can make it to the summit in less than two hours. —PD

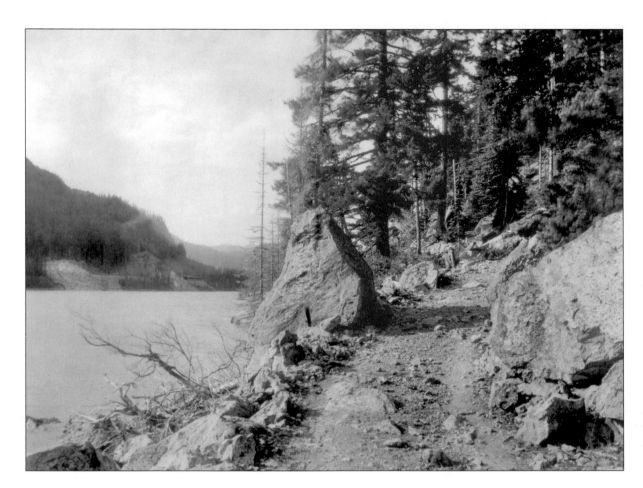 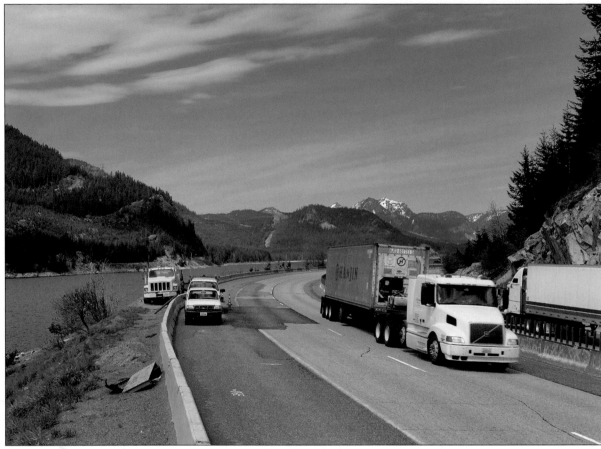

Keechelus Lake, 1911

In 1911, Asahel Curtis took this rare photo of the rough-and-ready wagon road first cut through Snoqualmie Pass in the 1860s and then improved in the first years of the 20th century. In the "now" shot, note how the hills across the lake and just above the yellow highway department truck are identical to those in the "then" shot. In the section pictured here, Interstate 90 is built on fill over the lake, and rockslides close the highway often enough to be a real danger. At the time of this writing, the Washington State Department of Transportation was preparing for a nearly complete rebuilding here with a wider highway that will be covered in many places. —PD

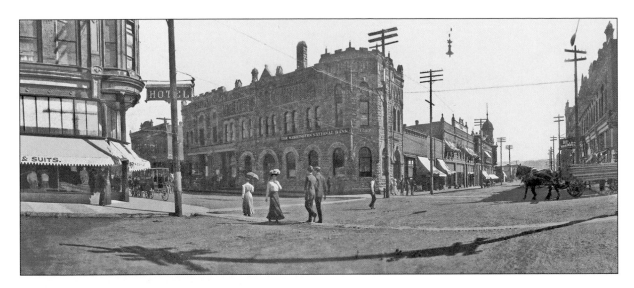

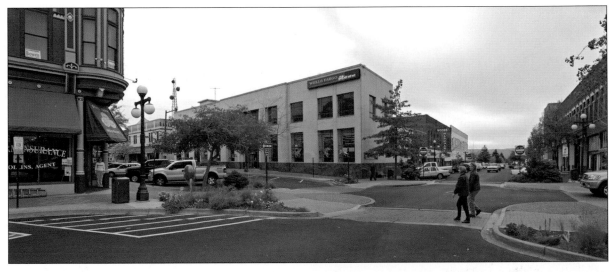

Pearl Street, Ellensburg, circa 1903

In 1889, the business districts of Seattle, Spokane, and Ellensburg were all burned to the planks on the streets. Ellensburg responded to its Independence Day blaze with many late Victorian delights, especially on Pearl Street. The panorama shown here looks south on Pearl across 4th Street to the block of ornate sandstone that was The Washington National Bank. When modernism reached this bank for a 1950s remodel, much of the architectural details were kept behind the slabs of marble that now cover the Wells Fargo bank. On the left of the panorama is the Davidson Building, which in the 1980s was restored to its original Victorian shine. —PD

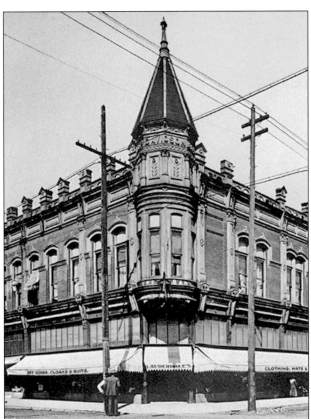

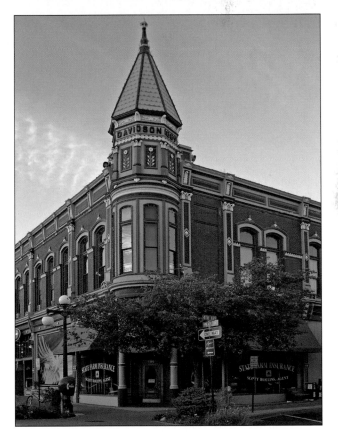

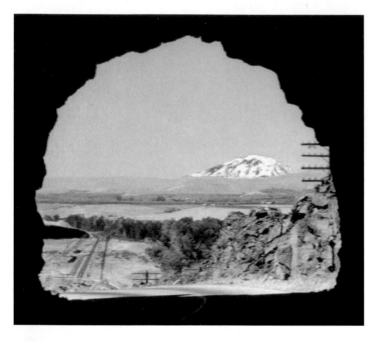

Highway 821, Yakima River, late 1940s and 1932

The stunningly beautiful Yakima River canyon has been a magnet for generations of photographers, and one of the best is represented here. Asahel Curtis took his photo (below left) from a crumbling hillside looking south down the river along present-day Highway 821 (Canyon Road) north of Yakima proper. As the "now" photo illustrates, the road has been rerouted and widened to allow the ubiquitous apple trucks free reign. Three days in a row, I visited Curtis' perch, waiting to no avail for a train to complete the tableau. Until the early 1960s, traffic passed through a long narrow tunnel that was constructed in 1924 (left). The tunnel is now unused and partially caved in. Dappled with colorful graffiti, it provided a cool shelter from the July heat for Howard Lev (right), seen here swigging water against the backdrop of Mt. Adams. —JS

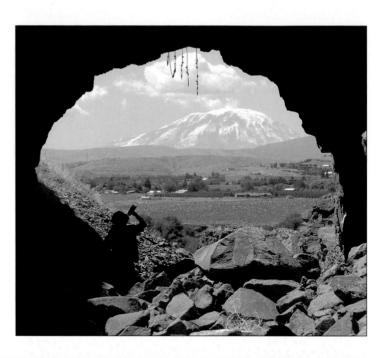

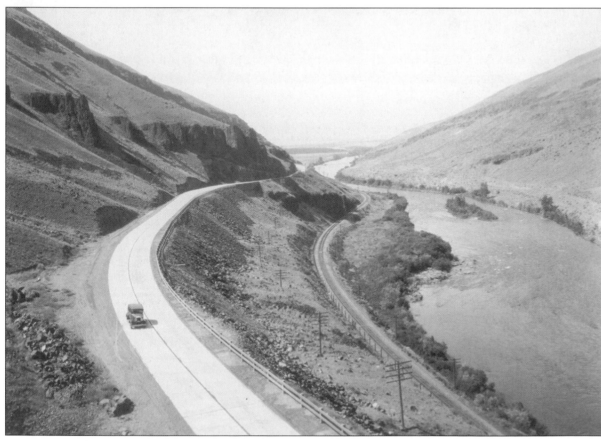

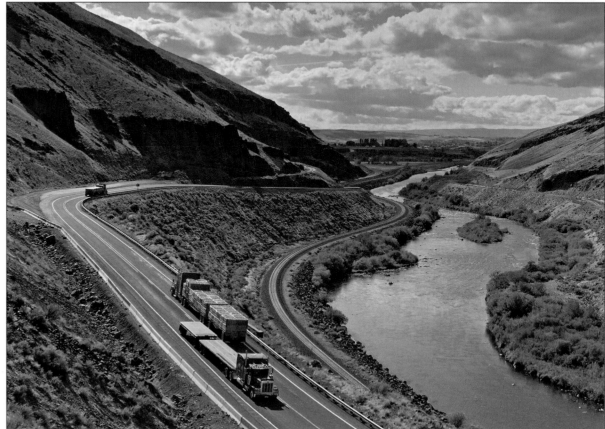

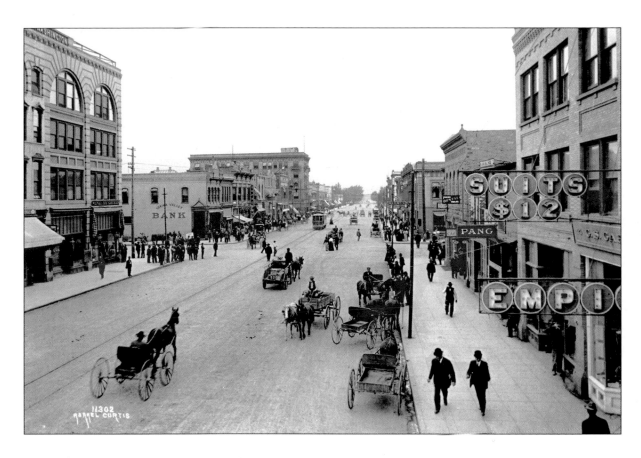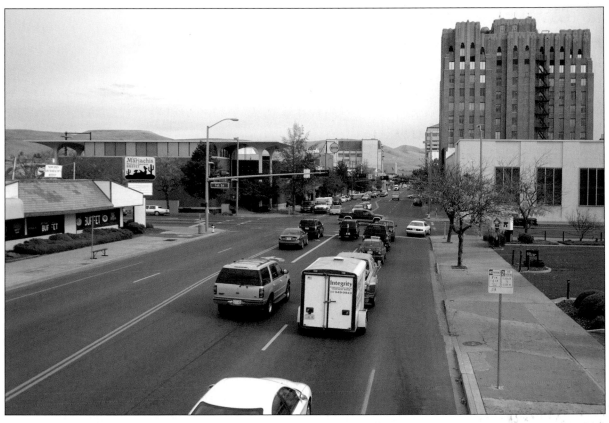

Yakima Avenue, Yakima, circa 1909

Repeating its performance in Tacoma of bypassing an established town in order to lay out its own, the Northern Pacific Railway first created North Yakima and then invited the residents and businesses of Yakima City (near Union Gap) to follow the lure of free lots. And they came. One North Yakima periodical crowed, "There appears to be a regular stampede of buildings from old Yakima northward." The old town's largest hotel, the Guilland House, continued to bed guests as it was rolled north to new North Yakima on logs. With its 100-foot width, Yakima Avenue—the new town's "Main Street"—mimicked the choices of town planners in Salt Lake City.

It would seem that none of the frontier structures moved from one Yakima to the next appear in this cityscape of East Yakima Avenue that looks east across North 1st Street. But then, apparently, neither has any of the 1908 architecture survived 20th-century modernity to appear in Jean's 2005 repeat. —PD

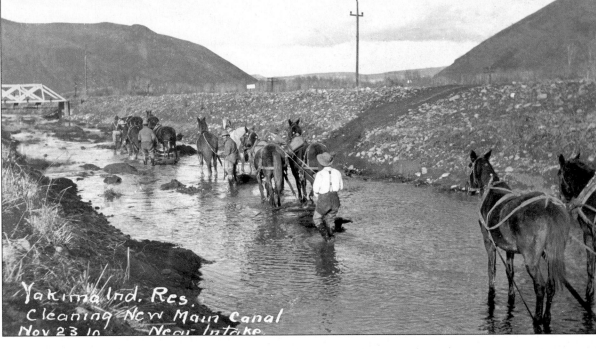

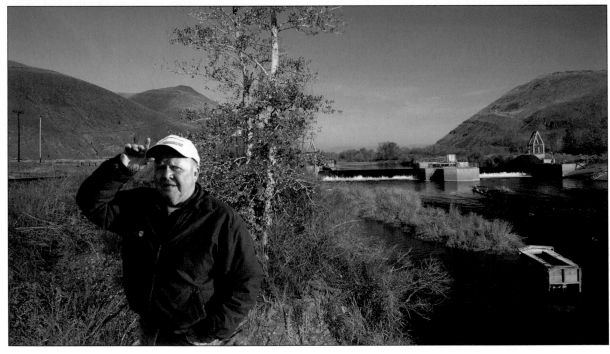

Union Gap, 1884 and 1910

Orchardist Forrest Baugher stands on his land alongside the Yakima River, just below the Union Gap dam. In 1884, a photographer surnamed Partridge took a photo of a teepee erected near the site of the Yakima Indian War of 1855, says David Lynx, Yakima Valley Museum photo archivist. The "war" comprised two battles (a month apart) and eight deaths. Yakama chief Kamiakin had resisted signing a treaty that ceded millions of acres to the U.S. government, but by 1858, the tribe had been forced to give up 90 percent of its land. The crews cleaning the Yakima Canal (shown above), which runs parallel to the river at this point, might have included Baugher's Grandpa George, who earlier helped dredge the canal. —JS

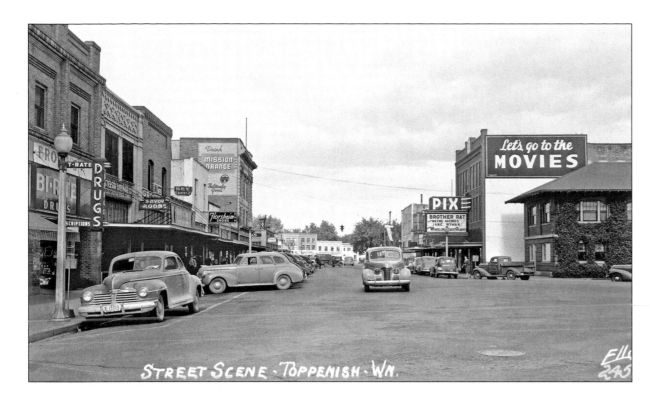

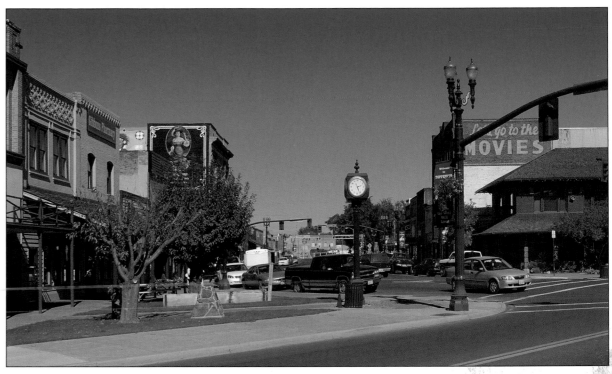

Toppenish and Wapato, mid-1940s and 1918

In the mid-1940s, the Pix Movie Theatre was playing *Brother Rat* starring Jane Wyman and Ronald Reagan, as recorded in this Boyd Ellis postcard. Little else has changed on Toppenish's Main Street. In Wapato, Asahel Curtis photographed the town's 1918 American Commercial Bank, reputedly the first in the nation to be owned and operated by Native Americans. —JS

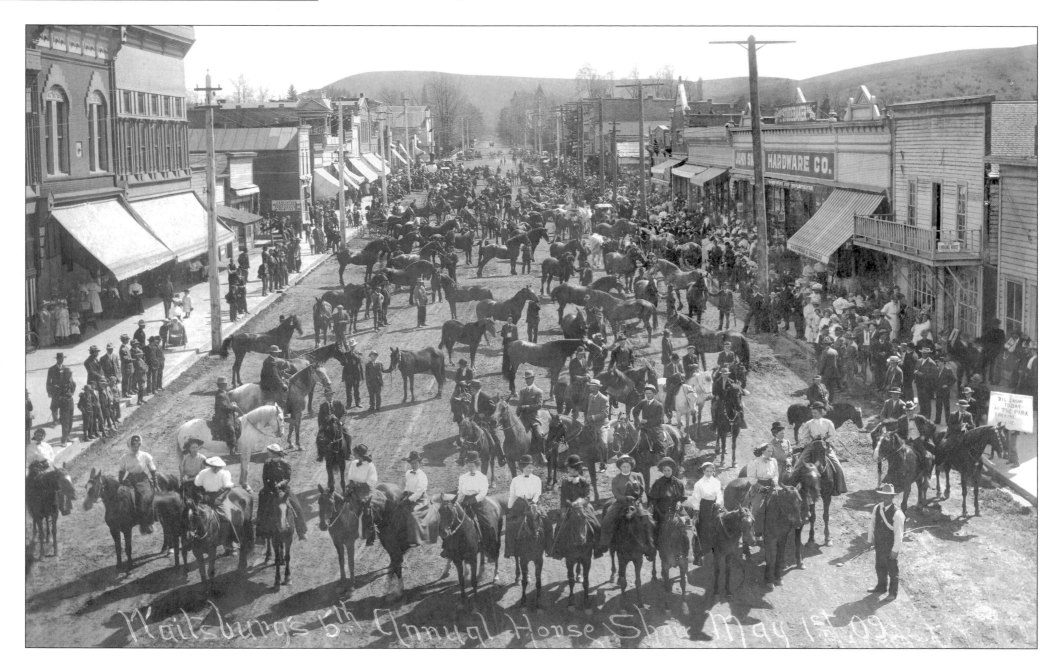

Waitsburg's 5th Annual Horse Show May 1st 09

Main Street, Waitsburg, 1909

Loyal Baker, publisher of the *Waitsburg Times,* with parents Anita and Tom Baker, engineered our repeat of the early Main Street tradition of recording the annual horse show. An announcement in the paper and a strong sense of community lured nearly a hundred hardy souls, including seven horses, to attempt the repeat at 11 a.m. on New Year's Eve 2005. The town fire engine, ambulance, squad car, and dump truck complete

the scene. In its early days, Waitsburg rivaled Walla Walla for its energy and spirit. Today, many original buildings house new and vibrant ventures. On the right, the Whoopemup Café, a local hotspot, serves fine but unpretentious cuisine. On the far left, the 1904 Oddfellows Hall opened as the Ammo Art gallery and Jim German Bar in 2006. —JS

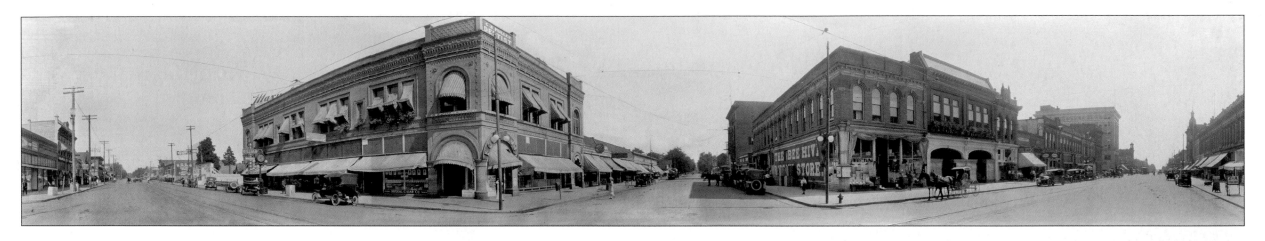

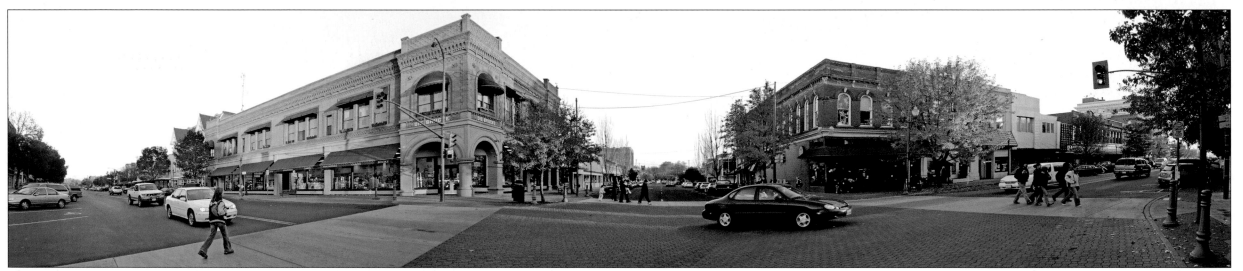

Main Street, Walla Walla, circa 1915

History and architecture come alive in Walla Walla, particularly along Main Street, composed of buildings not so much restored as polished to their original fine luster. Plaques commemorating contributions to state history abound. Main Street is built along the ancient Nez Perce Trail. Territorial Governor Isaac Stevens convened the First Walla Walla Council here in 1855, in which millions of acres of land were taken from Indian tribes in exchange for reservation life. A year later, Colonel Edward Steptoe built Fort Walla Walla. As a supply hub for the Idaho gold rush, the city boomed and soon was the largest in the territory. In 1878, territorial legislators convened here to draft a state constitution, but the U.S. Congress applied the brakes, rejecting statehood for another 11 years.

While the provenance of the Main Street panorama is unknown, its date lies between 1910 and 1917. The seven-story Baker-Boyer Building from 1910 exists at the far right, while the American Theatre (see its peaked twin roofs at left in the repeat), completed in 1917, had yet to crack its first tin of greasepaint. Colonel Steptoe built his fort where the theater now stands. —JS

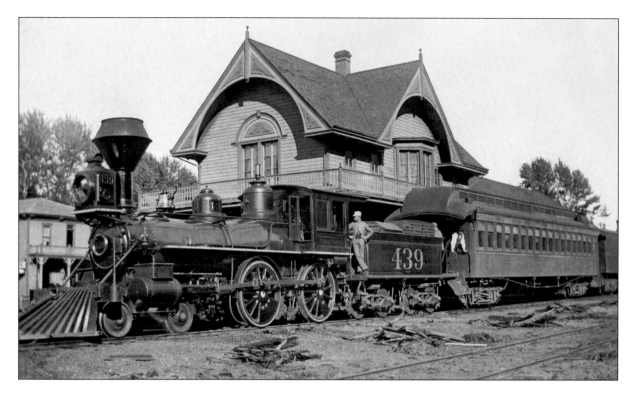

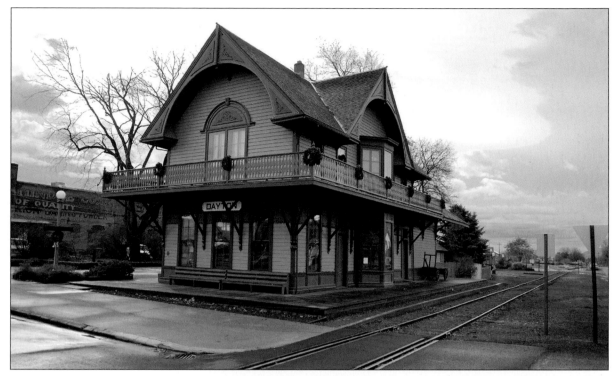

Dayton, 1880s

"Historic Dayton" is how Dayton likes to be known—and rightfully, for Dayton includes the oldest active courthouse and the oldest train depot in Washington state (both at left). At last count, historic Dayton could claim 117 structures listed on the National Register of Historic Places. Built and photographed here in 1887, the Columbia County Courthouse was designed by William Burrows, a Dayton architect. The Italianate landmark lost its ornate cupola in 1938, but in 1992 it was restored. In 1975, the Union Pacific railroad gave the 1881 train depot to the Dayton Historical Depot Society, and it is now a home for local heritage. —PD

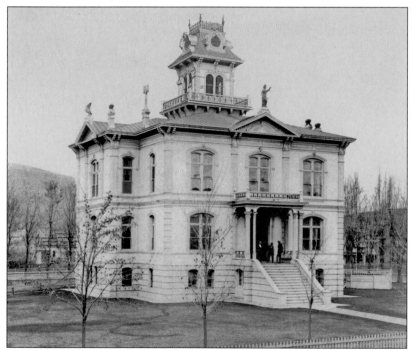

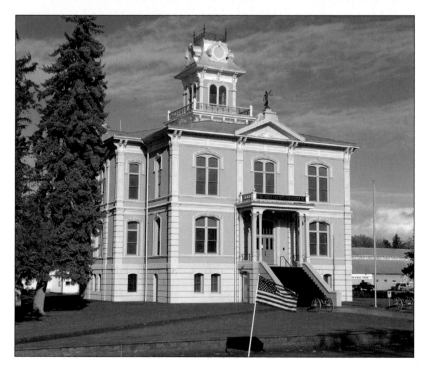

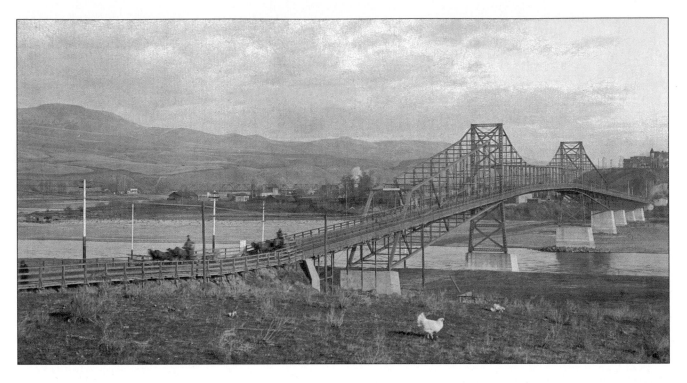

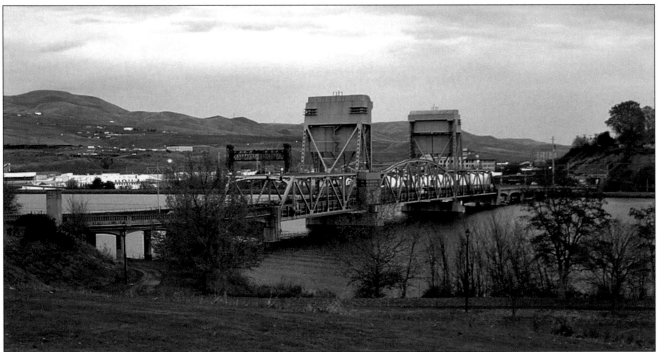

Lewiston-Clarkston Bridge, Clarkston, circa 1899

The 1899 Lewiston-Clarkston Bridge over the Snake River is still remembered as one of the most graceful steel cantilevers in the northwest. The contemporary blue bridge replaced it only 40 years later, and so is by now an old-timer itself. Both views look east from Clarkston into Lewiston, Idaho. —PD

St. Boniface Catholic Church, Uniontown, 1910

"You will see the church at the top of the hill," is how the Idaho-Washington Concert Chorale advises visitors to find St. Boniface Catholic Church in Uniontown. Twice a year, the group—mostly composed of musicians from the nearby college towns of Pullman and Moscow—enjoys excellent acoustics and light filtered through stained glass inside the Baroque sanctuary that was built in 1904 by German Catholic immigrants who wanted a reminder of the Tyrol. —PD

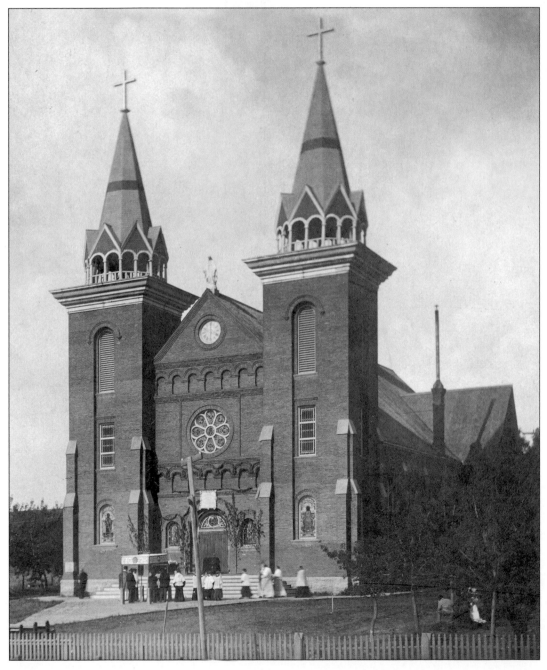

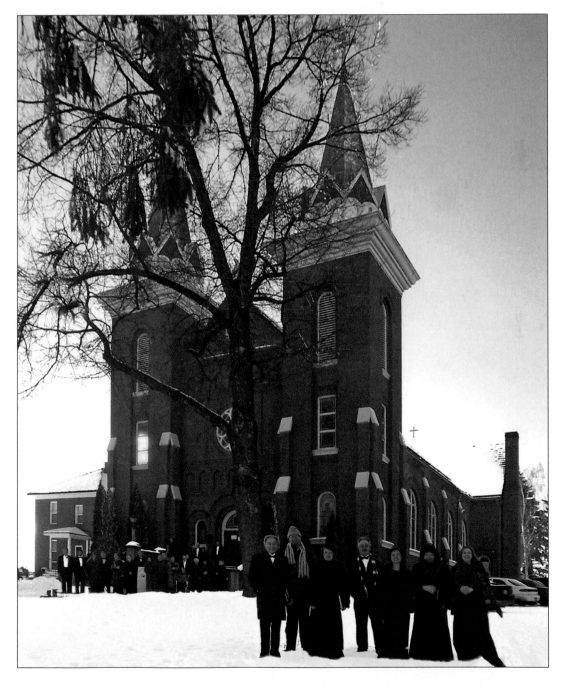

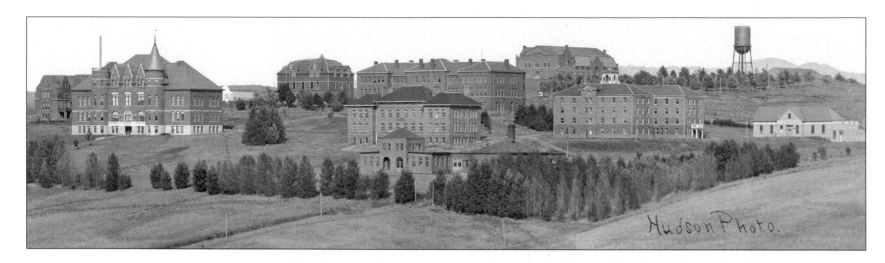

Hudson Photo.

Washington State University, Pullman
circa 1907

Founded in 1890 as an agricultural college, today Washington State University is ranked among the top 50 public research universities nationwide. Two of four extant buildings can still be seen: Stevens Hall at far left and turreted Thompson Hall. The clock tower of Bryant Hall, at upper left in our wide-angle repeat, was built in 1908, which puts Will Hudson's panorama somewhat earlier. —JS

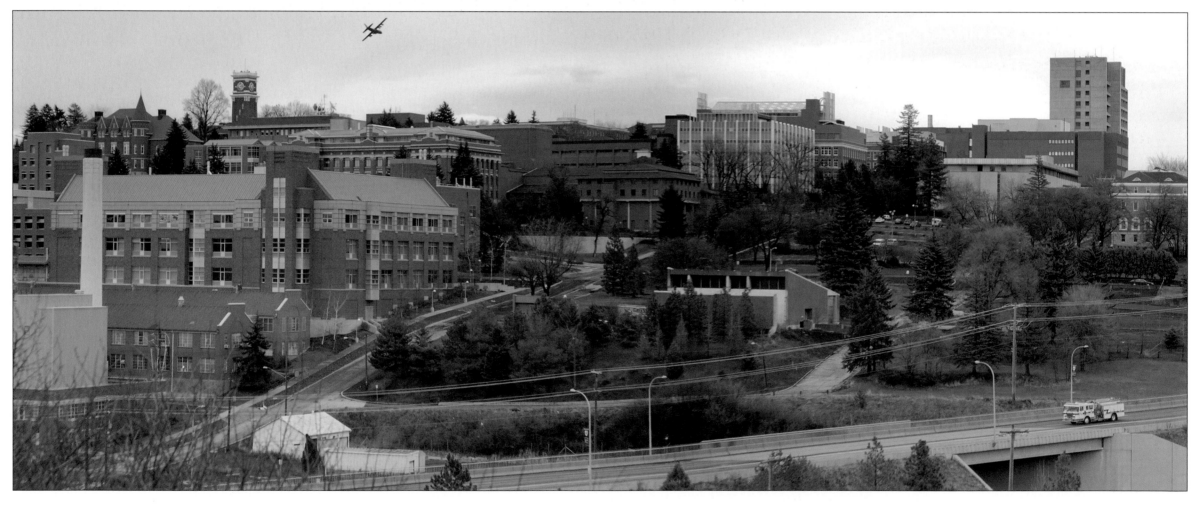

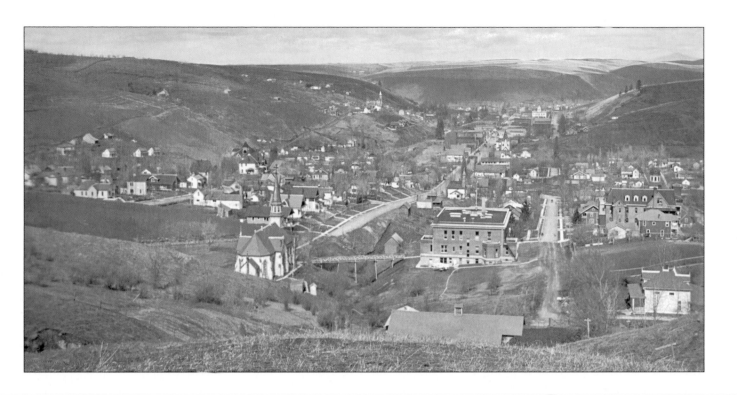

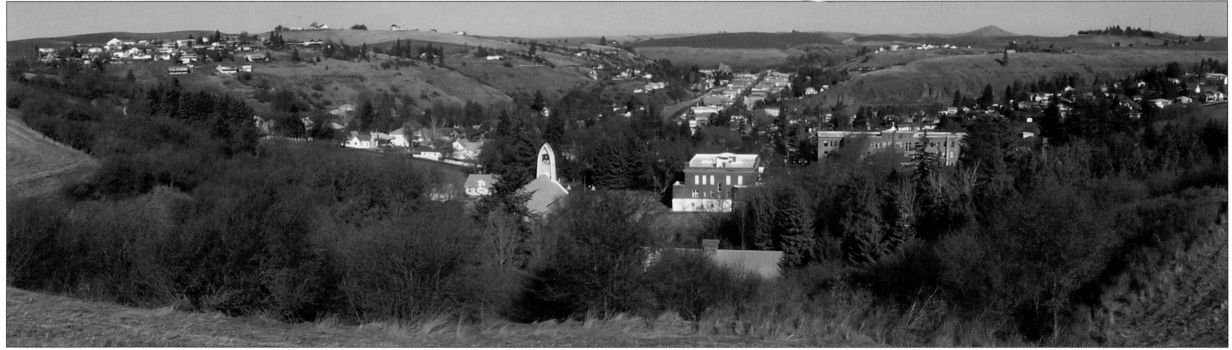

Colfax, circa 1917

Colfax, the seat for Whitman County, is nestled in the tapered valley of the Palouse River. The circa 1917 bird's-eye view looks north over the shoulder of St. Patrick's Church (1894) to a business district that is about two blocks wide. A new St. Patrick's (1959) has taken the place of the old in Jill Price Freuden's contemporary panorama. The 1915 St. John's Academy appears to the right of St. Patrick's in both scenes. The pointed profile of Steptoe Butte rises on the distant horizon of both views. —PD

Steptoe Butte, 1888, 1896 and the 1940s

At 3,612 feet, Steptoe Butte is a very unique observatory from which to delight in the real art of the Palouse: how prosperous farms mark its rolling hills. James "Cashup" Davis (right) was the Steptoe farmer-promoter most identified with the quartzite butte. Cashup always gave cash for the goods he needed to stock his popular stagecoach stop on the western slope of the butte. The English immigrant wed Mary Ann Shoemaker of Columbus, Ohio, and before they moved west in 1871, the couple raised 11 children in Wisconsin. Once settled into serving stagecoaches in the Palouse, the family became known for its hospitality and the dance floor above the store.

When the railroads arrived nearby in 1883, the stages stopped running and Cashup looked to Steptoe Butte to further his conviviality. After building a switchback road to the top, he raised the two-story hotel high atop the butte, shown here in the 1888 photo at right. The observatory on top held a powerful telescope that could look into four states. The hotel was hard to climb to and its early popularity soon fell off. Mary Ann died in 1894 and, alone in his hotel, Cashup died two years later. His instruction that he be buried in a hole he'd dug for himself beside the hotel was not followed. However, his internment in the Steptoe Cemetery was a grand affair and the

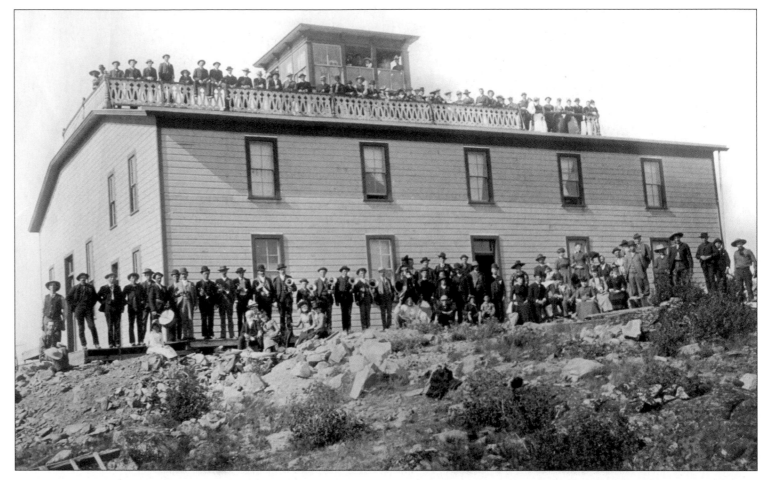

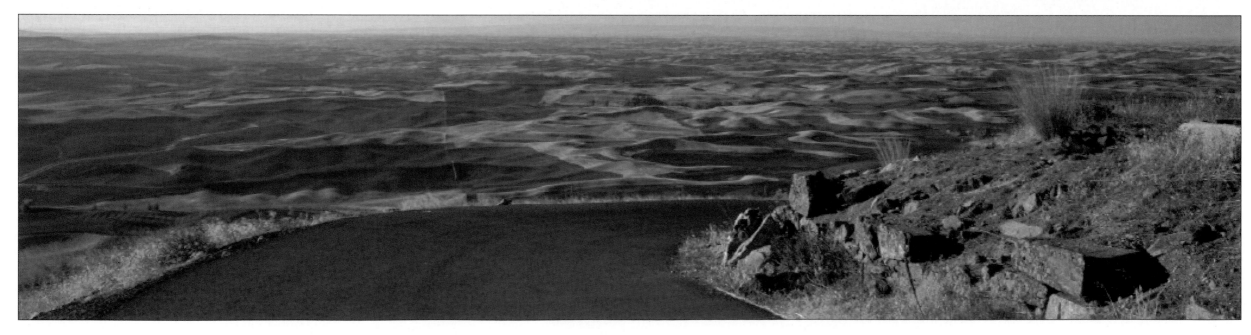

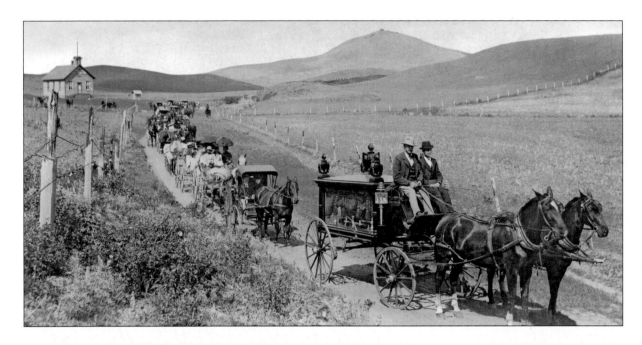

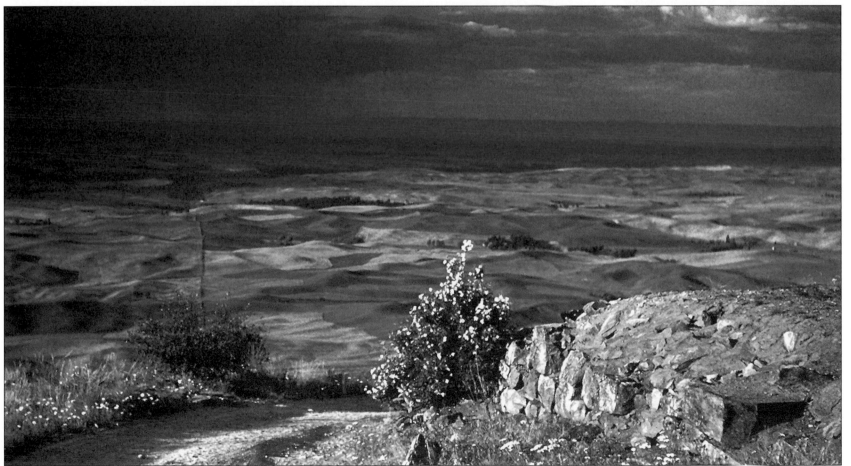

procession following an ornate hearse brought south from Oakesdale was also impressive. Cashup's hotel can be seen at the top of the butte in the funeral photo (above left), although not so vividly as on the night of March 15, 1911, when it was destroyed by fire.

Steptoe farmer Glenn Alderman poses with his pickup for the repeat of Cashup's procession. It was Alderman who identified the rocks bordering the road at the very top of the butte as remnants from the hotel foundation. Both views from the top look south. The older one (left) dates from the 1940s, when the road that loops up the butte was new. Tekoa mayor Rich Weatherly and his brother Jim made the repeat (opposite page) in 2005, proving that the rocks are still in place as a weathered reminder of Cashup Davis, a thousand feet above the rolling Palouse. —PD

Spokane and Vicinity

Monroe Street Bridge · City Waterworks · Howard Street Bridge · Davenport Hotel · Spokane High School
Spokesman-Review Building · Spokane County Courthouse · Northern Pacific Depot · Liberty Lake
Davenport · Medical Lake · Cheney · Sprague · Tekoa · Ritzville

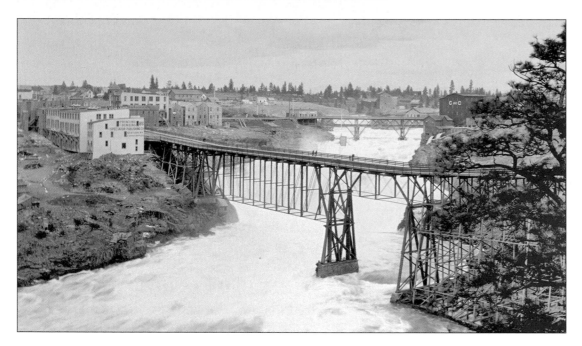

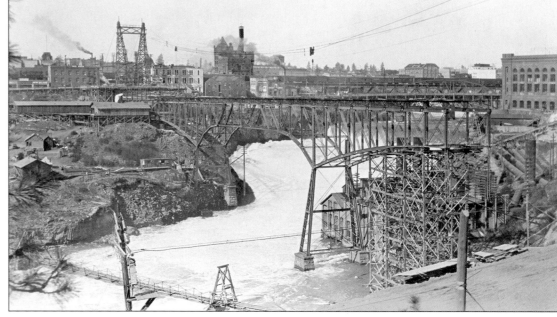

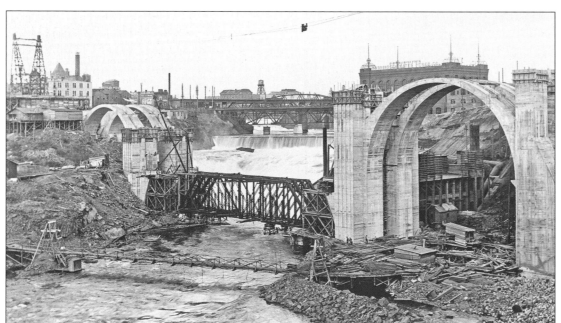

Monroe Street Bridge, Spokane, circa 1889, circa 1909, and 1911

Four Monroe Street bridges have been built with engineering pluck high above the Spokane River and below Spokane Falls. With the third bridge, the original three-arch concrete span of 1911 (left), Spokane got itself a second symbol to frame its first: Spokane Falls.

The first bridge (above left) was a shaky wood structure jointly constructed in 1888 by the city and the local power company for its cable railway. It was mercifully destroyed by fire two years later. Shown above, the second bridge was made of steel—although still shaky. Officially, "the deck members had excessive vertical deflections." Wise circus elephants refused to cross it. The third bridge, shown here under construction in 1911, looks identical to the fourth, because when a symbol wears out, you replace it with a replica, if you can. Jean's repeat dates from January 1, 2006, less than four months after the dedication. —PD

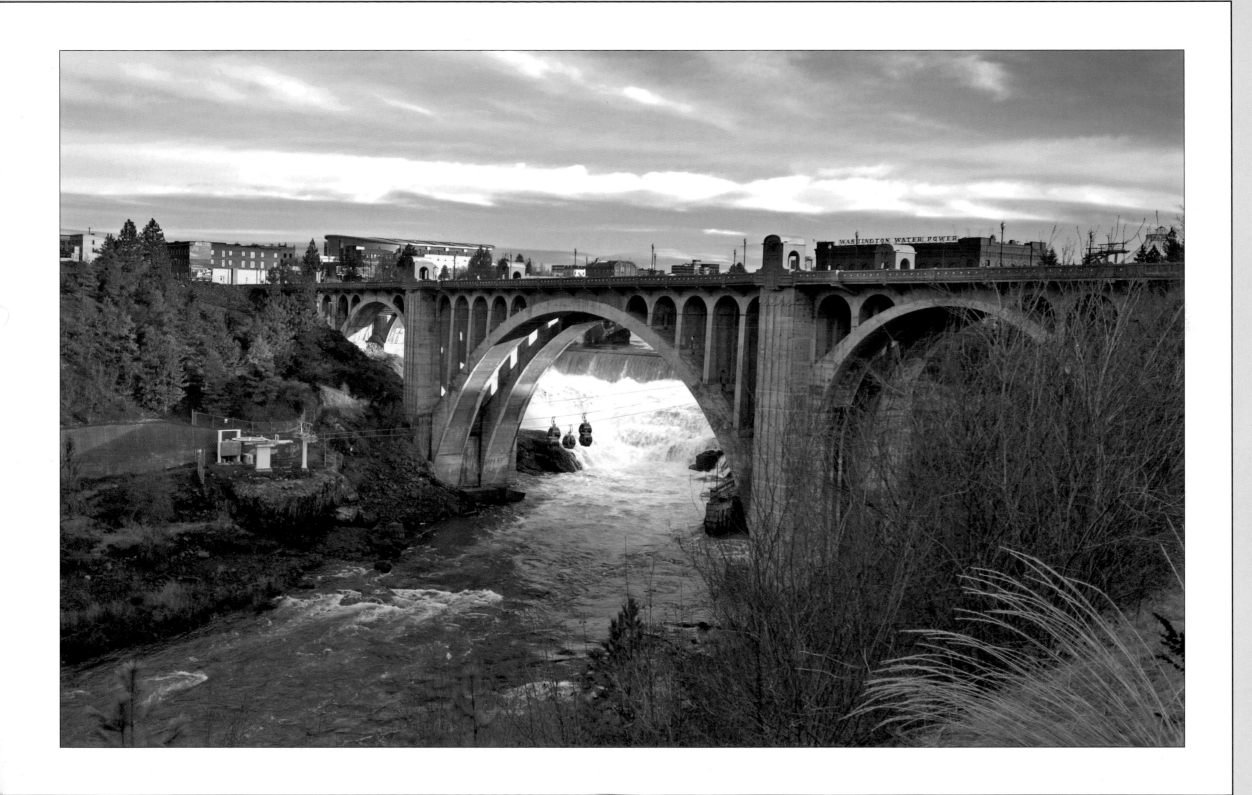

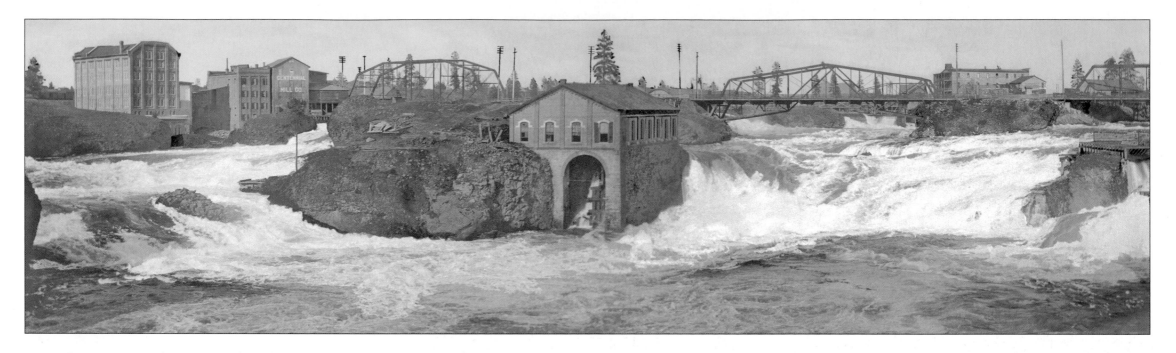

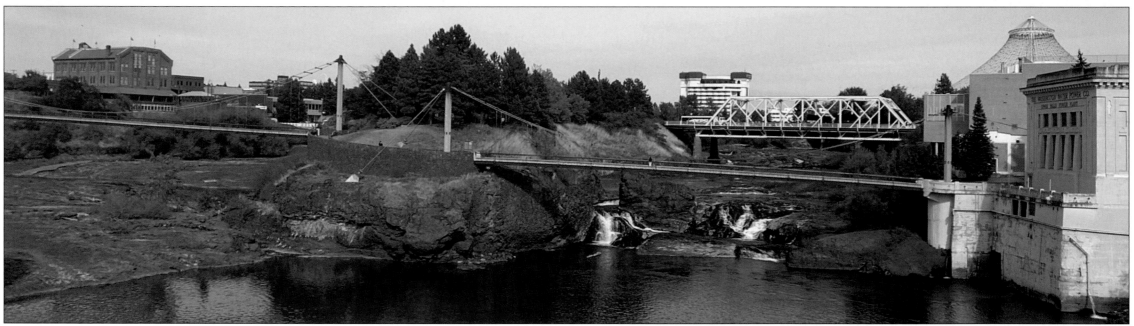

City Waterworks, Spokane, circa 1895

In 1888, Spokane stopped collecting its water from the Spokane River in barrels and built the City Waterworks at the western tip of Cannon (now Canada) Island. The pump was driven by a waterwheel, but not on August 4, 1889, when the plant was being upgraded and the water superintendent was out of town. That day, most of the business district burned to the ground, at least in part for want of water pressure to fight the blaze. The plant was abandoned in 1896 for an upriver site beyond the pollution of the business district.

A section of the works foundation endures and can be seen when the river runs low—as in Jean's sunset repeat. To locate the remains, look directly below the right-center of the "now" photograph. A slender remnant of the concrete foundation shows itself below the pedestrian bridge and a few feet this side of the whitewater falls. —PD

Howard Street Bridge, Spokane, circa 1887

Northern Pacific official photographer F. Jay Haynes stood atop a flourmill to capture this circa 1887 photo of downtown Spokane from Havermale Island. The attempt to repeat it was aided by the staff of Pig Out in the Park, an end-of-summer festival. A 15-foot ladder and a long pole elevated my camera to about 30 feet. In the historic photograph, the California House stands at the northeast corner of Trent and Madison; it is the first building on the left just across the old Howard Street Bridge. Partially burned in 1888, it reopened as the Windsor Hotel, which, with much of Spokane, burned to the ground in the fire of 1889. South Hill is on the horizon. —JS

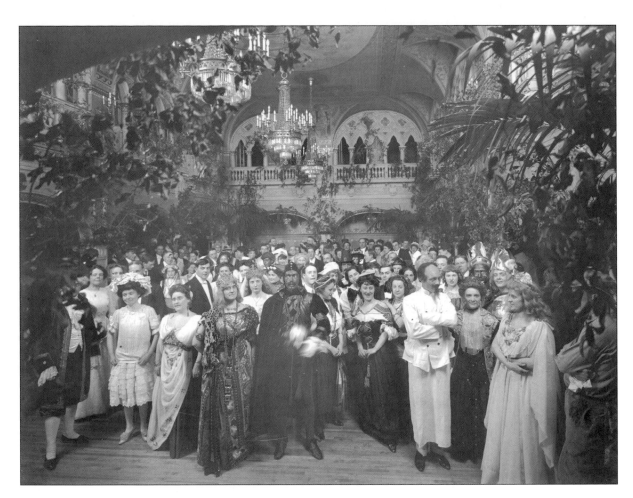
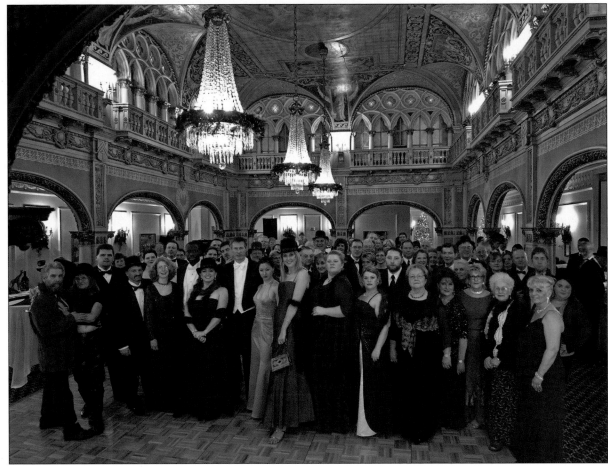

Davenport Hotel, Hall of the Doges, Spokane, 1911

Before Lewellyn Davenport opened his landmark Davenport Hotel in 1914, he was already celebrated for his elegant namesake restaurant. With a Mission Revival makeover by Spokane's famous architect and aesthete Kirtland Cutter, Davenport's Restaurant expanded in 1904 to include this extravagant second-floor ballroom modeled after the ducal palaces of Venice. Here in 1911, Spokane's artistic community decorated this Hall of the Doges with its own elegance for an artist's costume ball.

During the Davenport Hotel's recent rescue and restoration, to quote the hotel's own good-humored history, "The Hall of the Doges, Spokane's oldest and finest ballroom, was removed from the oldest part of the structure and reinstalled in the new east addition. The removal was accomplished by lifting the ballroom out intact—making it the only flying ballroom in the world." In the repeat photograph, today's celebrants were attending Spokane Coeur d'Alene Opera's Diamonds and Divas ball on New Year's Eve 2005. —JS

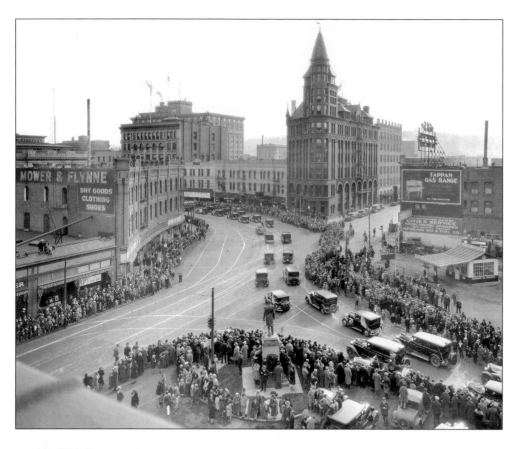

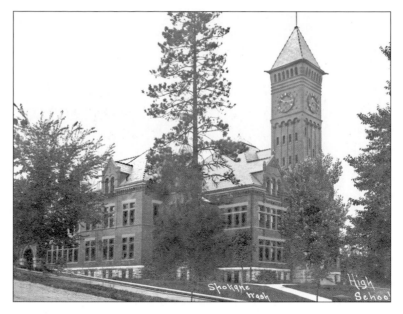

Spokane High School and Spokesman-Review Building, Spokane

circa 1905 and 1930

Spokane High School and the Spokesman-Review Building were both constructed in 1890–1891. Gutted by fire in 1910, the school (above) was replaced with the towerless but still elegant Tudor-Gothic Lewis and Clark High School below. The newspaper's landmark tower at Monroe and Riverside, Spokane's most distinguished intersection, survives, and impressively so. The historical photo by Spokane's Libby Studio (above left) was recorded on Armistice Day, November 11, 1930, and Jean's repeat on a fittingly still Sunday morning, New Year's Day 2006. —PD

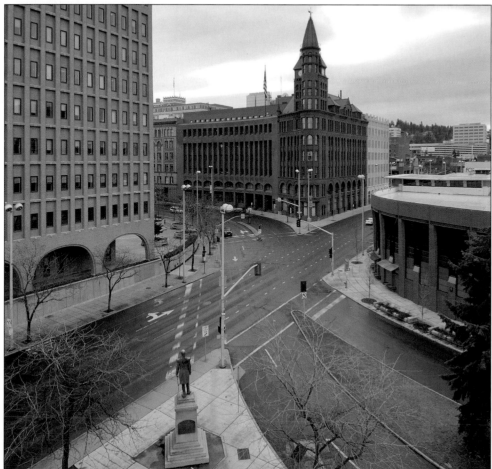

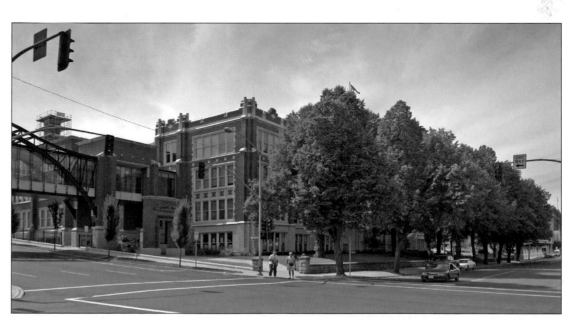

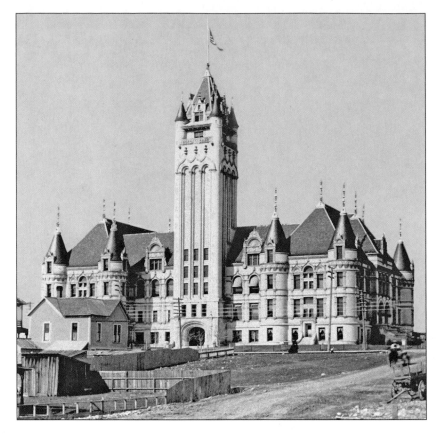

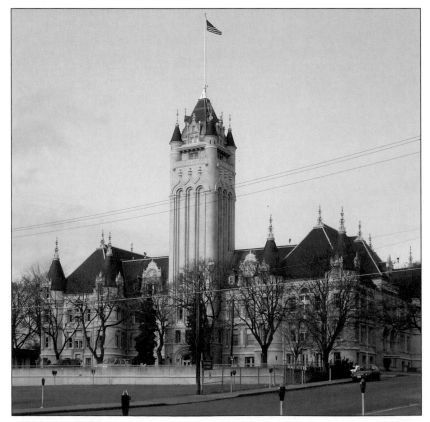

Spokane County Courthouse and Northern Pacific Depot, circa 1897 and circa 1890

Largely self-taught, architect Willis A. Ritchie was still in his 20s when work began on his Spokane County Courthouse in 1893 (left). Resembling a 16th-century French chateau, the courthouse is more than a seat of government; it is for some the most distinguished historical landmark in the state. However, it can only be appreciated from the outside, for very few traces of Ritchie's design survive within.

"City Father" James Glover came to Spokane Falls in 1872 looking for a site where the Northern Pacific Railway might land after crossing the Rockies. Not one but four transcontinentals came. Now only one of four landmark depots survives intact, the least distinguished of them all: the one built for the first railroad to enter Spokane, the Northern Pacific. (Except for its stately campanile tower, the Great Northern Depot was razed in the 1970s, as was the sturdy Union Station, for the construction of Expo '74, Spokane's World's Fair.) Built away from the river in 1890, the Northern Pacific Depot, as seen in this historic photograph by F. Jay Haynes (below), was nearly new. In the evening's rosy light of Jean's repeat, retired switchman Jack Arkills stands in profile while musing about his life on the rails. —PD

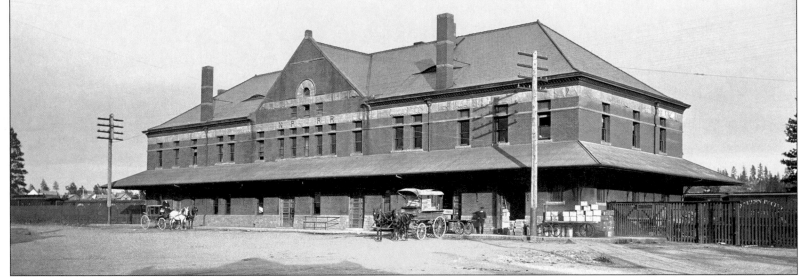

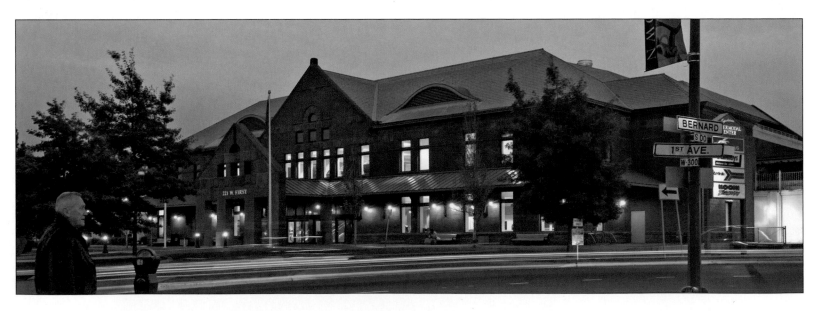

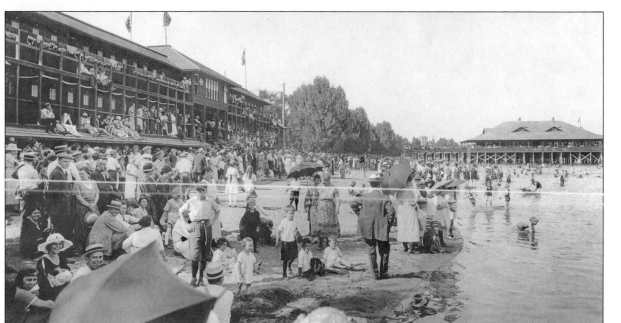

Liberty Lake, 1923

"Spokane's Inland Seashore" was a promoter's nickname for Liberty Lake, and the name fit, especially on weekends, when a sizable minority of Spokane visited its excellent beaches. While searching for the proper angle from which to repeat this Libby Studio beach scene, we soon and serendipitously came upon Liberty Lake resident and historian Ross Schneidmiller. He stands in the foreground of the contemporary beach scene near the lake's northwest corner. Familiar with this 1923 scene, its grand bathhouse on the left, and dance pavilion over the lake, he knows their stories—and showed us an additional historic photograph of a Liberty Lake rowboat race taken within moments of this one.

—PD

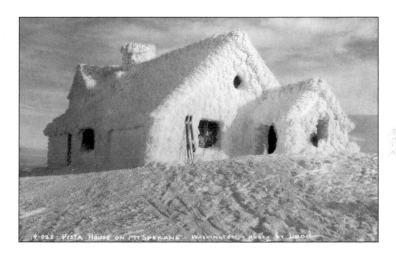

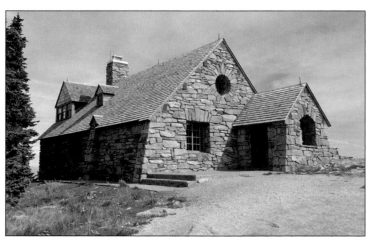

Vista House, circa 1940

In 1934, the Civilian Conservation Corps used stone found on-site to build Vista House at the summit of 5,889-foot Mount Spokane. Owned by the Washington State Parks and Recreation Commission, the stone shelter is now known by three generations of skiers. —PD

Davenport and Medical Lake, 1910 and circa 1910

In Tony Bamonte and Suzanne Schaeffer Bamonte's book *Spokane and the Inland Northwest: Historical Images,* where we first saw this photo of Davenport, a terse caption explains, "Looking north on Seventh Street after Cottonwood Creek flooded Davenport's main business section in 1910. The location of the footbridge is now the

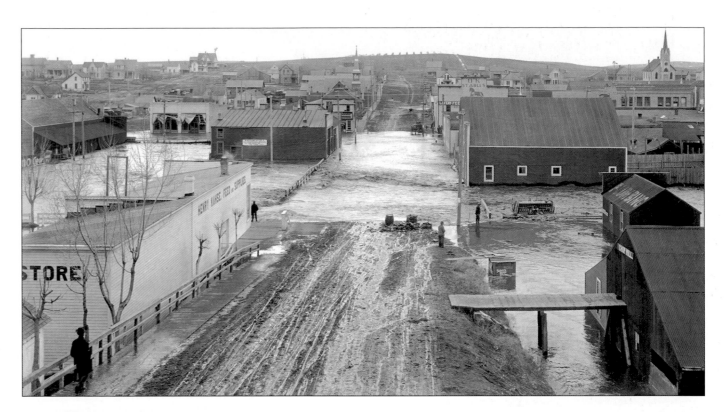

entrance to the Lincoln County Museum parking lot. The feed store on the left is still standing and is part of Kahse Park." We'll add that the well-nourished cottonwoods have grown so that Jean needed to move forward in order to avoid their branches while making his contemporary repeat.

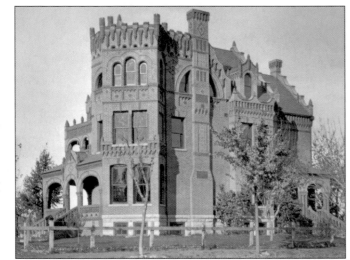

Long before the west shore of Medical Lake was picked for the Eastern State Hospital, the lake's mineral water was thought to have healing powers and the lake became a popular retreat for swimming, dancing, and —it was hoped—miracles. Now the lake is often silent and the hospital is hidden in the forest on the far shore from town. But what the locals call "The Castle," pictured here, still survives downtown. It was designed and built in 1900 by the

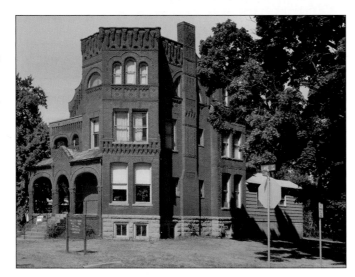

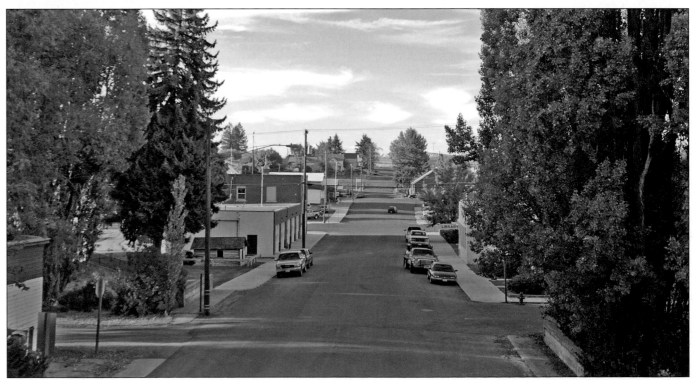

mayor, Stanley Hallett, an English import. While we came to photograph the lake, we left with our photographs of his honor's eccentric mansion, hoping to later solicit a historical picture that fit one of ours. We came within about 3 feet. This view is kept at City Hall, where it had been collected by Medical Lake historian Judy Abbot.

—PD

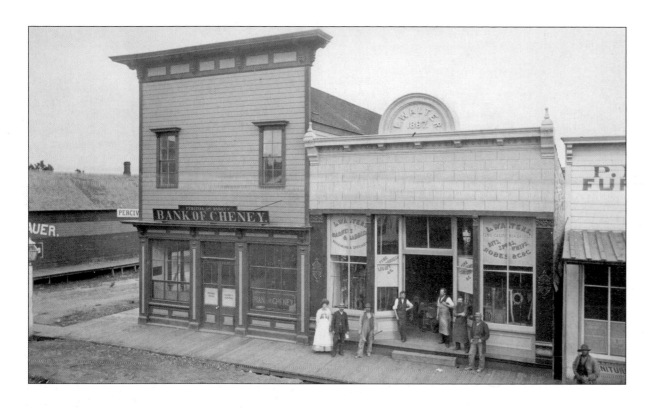

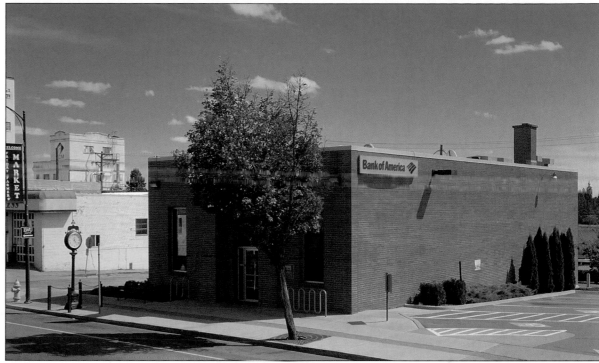

Cheney, circa 1888

In 1881, the railroad town of Cheney won the Spokane County seat from Spokane. A year later, the town started classes in an academy supported by the town's namesake, Northern Pacific Railway director Benjamin Cheney. Showing Louis Walter's harness shop side by side with Daniel Percival's Bank of Cheney, the historic photograph was likely made within two years of Cheney's 1886 loss—by election—of the county seat back to Spokane. This southeast corner of College Avenue and 1st Street still sports a bank, and four blocks up College is the main gate to the academy's successor, Eastern Washington University. —PD

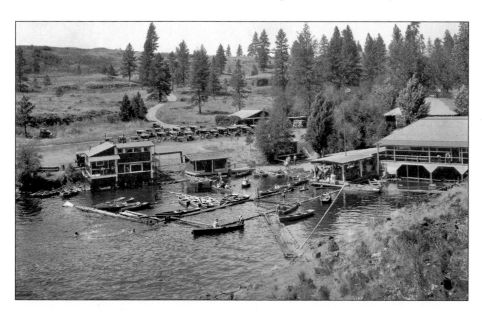

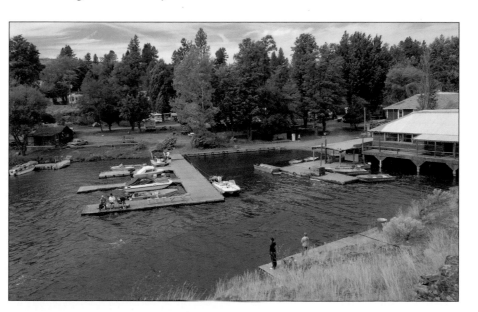

Fishtrap Lake, circa 1919

Fishtrap Lake Resort, a 30-minute drive from Spokane, has been a popular camping and fishing destination for more than a hundred years. Octogenarian Jimmy Scroggie, who recently sold the resort to Mike Barker, bought it in 1952 from R.D. Williams, who had bought it from Jimmy's granddad in 1902.

—JS

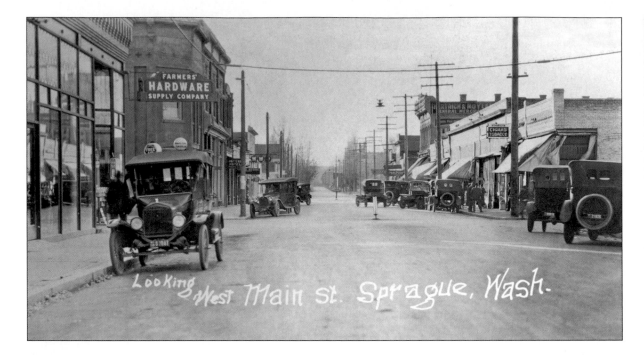

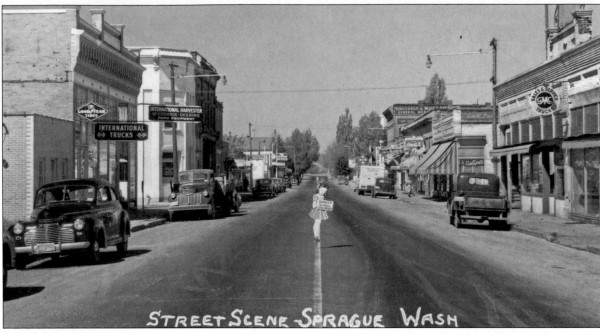

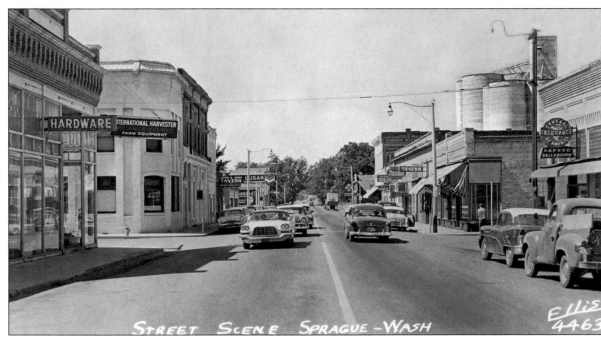

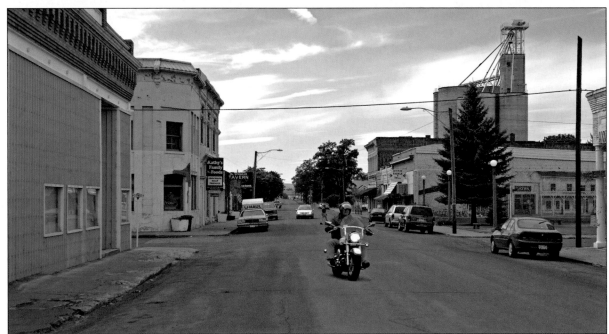

West 1st Street, Sprague, circa 1920, circa 1949, and circa 1955

Before Interstate 90 bypassed Sprague, motorists entered via the Old State Highway and directly onto West 1st Street. Heading west, this is what one saw, the town's main intersection at South C Street. Sprague was named for a director of the Northern Pacific Railroad, and the town was outfitted with sizeable railroad shops and an impressive roundhouse. After most of the town was destroyed by fire in 1895, the Northern Pacific pulled its shops and the town lost its biggest payroll. West 1st Street is still often called Main Street, as it was by the unnamed photographer of the circa 1920 view with the Model T (upper left photo). Dating the two remaining historical photographs requires some speculation. The grain elevator appearing on the right in the bottom left photo dates from the early 1950s. The elevator doesn't appear in the earlier scene at upper right, which most likely dates from the late 1940s. The ornate bank building, left of center in all four views, is now Sprague's general store. The hardware store on the left has lost most of its glass and is now storage for a car collector. —PD

Tekoa and Ritzville, 1908 and 1909

In 1908, an unnamed photographer climbed the ridge above Hangman Creek (top photo at left) to record what everyone in Tekoa was, no doubt, watching: early construction on the Milwaukee Railroad's landmark Tekoa trestle. Ninety-seven years later, Tekoa brothers Rich and Jim Weatherly took the wider-angle repeat of the 975-foot-long trestle that was barricaded after the railroad stopped operating in 1980. Rich, Tekoa's mayor, notes that this is the eastern terminus of the John Wayne Trail, which the city hopes to extend over the trestle and 12 miles more to Plummer, Idaho, for a link there with the Trail of the Coeur d'Alene.

Harland Eastwood, Ritzville resident and author, identified and dated this 1909 Independence Day parade looking northeast from North Adams Street on West Main Avenue (top right). It took three persons to record the 2005 Labor Day parade from the same corner. Christopher Clutter climbed Harland's ladder with a camera borrowed from Jennifer Larson of the Adams County Historical Society. —PD

Big Bend and Beyond

Rock Island Dam • Leavenworth • Wenatchee • Entiat • Lake Chelan • Vantage Bridge • Lyon's Gate Bridge
Soap Lake • Quincy • Coulee City • Steamboat Rock • Grand Coulee Dam • Dry Falls

Rock Island Dam, 1931

Completed in 1933, Rock Island Dam was the first dam on the Columbia River. It soared 40 feet high and included in its design a fish ladder to protect salmon and steelhead. In 1929, the Colville Tribe reported a harvest at Kettle Falls of 1,333 fish. By 1934, however, that number had dropped to only 159. More recently, the Chelan County Public Utility District has combined its existing fish bypass system with habitat restoration and hatchery programs in an effort to revitalize fish populations in the Columbia. —JS

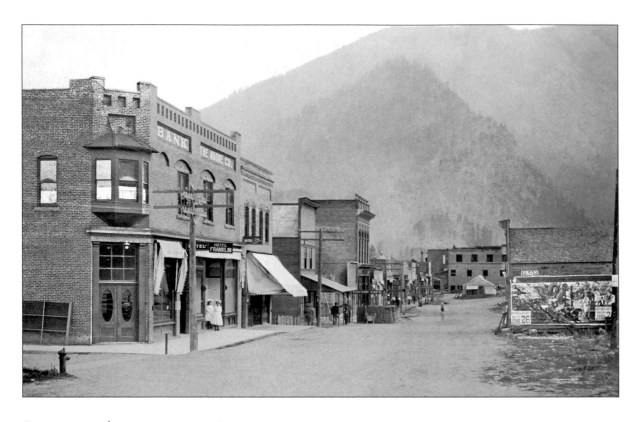

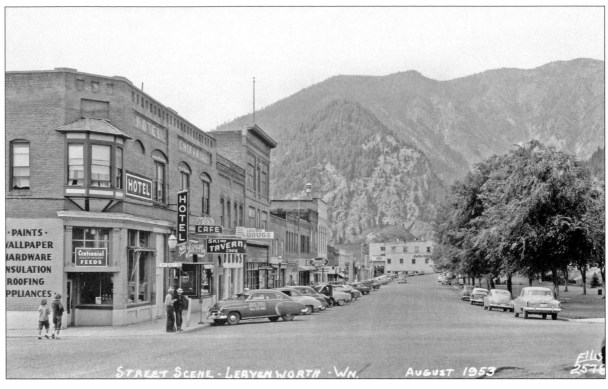

Leavenworth, 1910, 1953, and 2005

When local lumber mills closed in the mid-1960s, the town of Leavenworth neared extinction. Three views, beginning in 1910, document its conversion from a typical Western town to a Bavarian village. A controversial idea at first, more than a million tourists a year silenced the skeptics. Shopping, recreation, and festivals such as the popular Christmas lighting ceremony (below) draw crowds from across the state. —JS

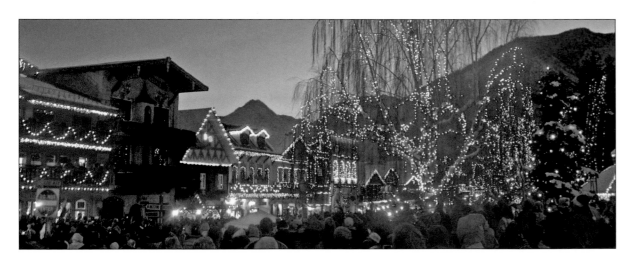

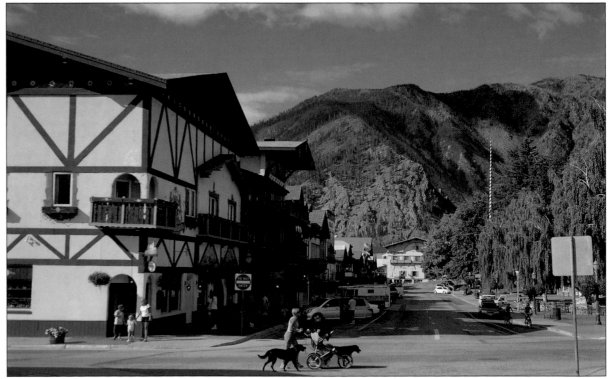

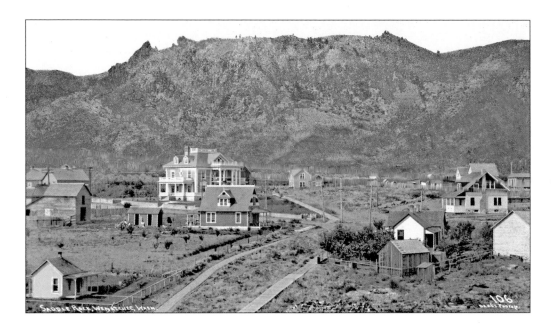

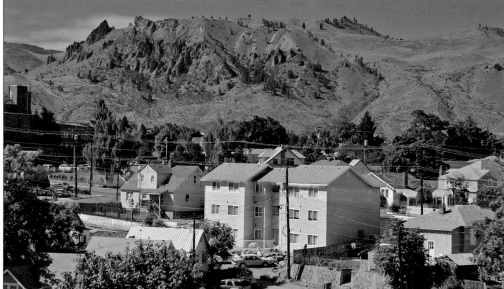

Saddle Rock, Wenatchee, 1909

By 1909, the year M.L. Oakes climbed atop the roof of Stevens School for this photo of Wenatchee's Saddle Rock, the Wenatchee Valley provided nearly half the nation's apple crop. A few houses remain from the early photo, but the imposing John Gellatly mansion, converted into the first Deaconess Hospital in 1915, is long gone. A parking lot replaces the school, so I climbed onto the nearby federal building for an approximate repeat. —JS

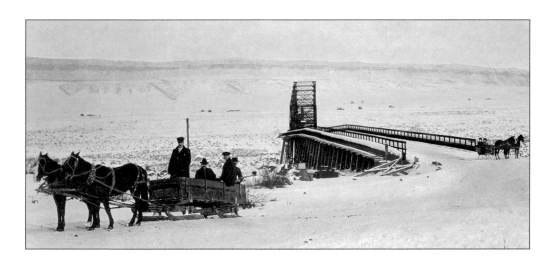

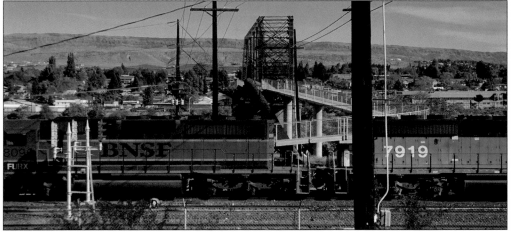

Wenatchee Bridge, circa 1910

More interested in piping irrigation water to East Wenatchee than in retiring the local ferry, W.T. Clark managed the financing and construction of the first bridge to span the Mighty Columbia at Wenatchee in 1908. It was an impressive 1,060 feet long. The enterprising farmer-builder ran his pipelines along both sides of the new bridge, leaving the deck open for the free passage of wagons and pedestrians. Clark expected that the demand for water on the drier Douglas County side of the bridge would pay for his investments and more. However, when the water fees he collected did not cover even his expenses, he proposed to collect tolls also. While the bridge was a great improvement over waiting for the ferry, the locals resisted Clark's new scheme, and instead persuaded the state to buy his new bridge, in spite of what the state inspector described as its "ugliness."

To get past the obstructions that now hide the bridge, Jean needed to move much closer to it. With the extensive regrading done for the railroads on the span's Wenatchee side, Jean stood lower than the unnamed historical photographer. When a second span was added upstream in 1950, the deck of Clark's bridge was given over to pedestrians and recreation, while also continuing to deliver water. —PD

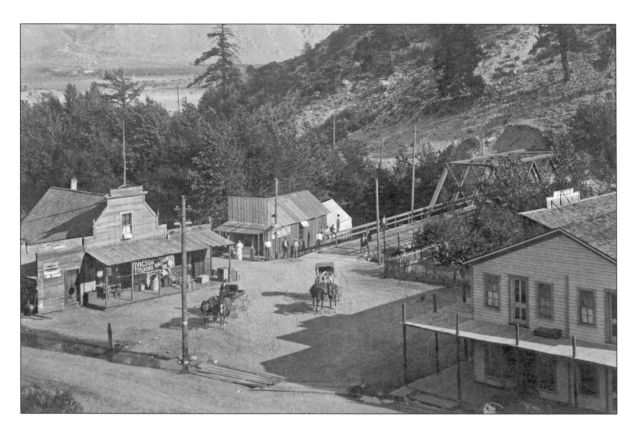 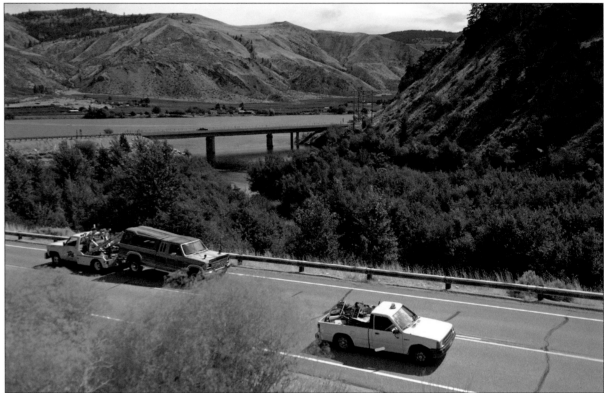

Entiat, circa 1905

Burned twice and moved twice as well, Entiat's turmoil begins with the rapids on the Columbia River for which the town was named. While these dreaded cataracts did not prevent shipping on the big river, they did often enough send it crashing. The first townsite, situated here at the mouth of the Entiat River, was at the gateway to that smaller river's narrow but fertile valley. Rightfully, locals call it a "sportsman's paradise." But when the railroad arrived in 1914, businesses began moving closer to the tracks. This relocation was advanced when large sections of the original townsite burned in 1915 and again in 1921. In 1960, the second townsite by the tracks was abandoned and then quickly inundated when the Columbia River was raised behind the new Rocky Reach Dam. —PD

Lake Chelan, circa 1914

Photographer Lawrence Denny Lindsley, grandson of Seattle pioneer David Denny, owned a house on Lake Chelan. His many photos, featured in the Lake Chelan Historical Museum, record the growing popularity of this lovely lake and surroundings in the early 1900s. The "then" photograph of Chelan was not difficult to repeat, despite the view being partly masked by trees. —JS

Vantage Bridge, circa 1940

Tom Stockdale's service station, motel, and restaurant stood on the west bank of the Columbia River at the approach to the Vantage Ferry Bridge (built in 1929). That was evident from our "then" photo, but it took a serendipitous trip to Vantage to fill in the blanks. Minutes after I handed the photo to a clerk at the Vantage General Store, Tom Stockdale's grandson, Bryan, arrived to escort me to the likeliest spot for a repeat. Bryan wears numerous hats—town manager, fire chief, EMT responder, and minister—but he found the time to show me an old road that dead-ended in the river, now without the bridge in the background. "Two hundred yards out," he estimated, "that's where grandpa's gas station was." Tom and Catherine Stockdale had arrived in 1935 on a 110-degree day to accept their wedding present—40 acres of land from Tom's father. There have been Stockdales in Vantage ever since.

—JS

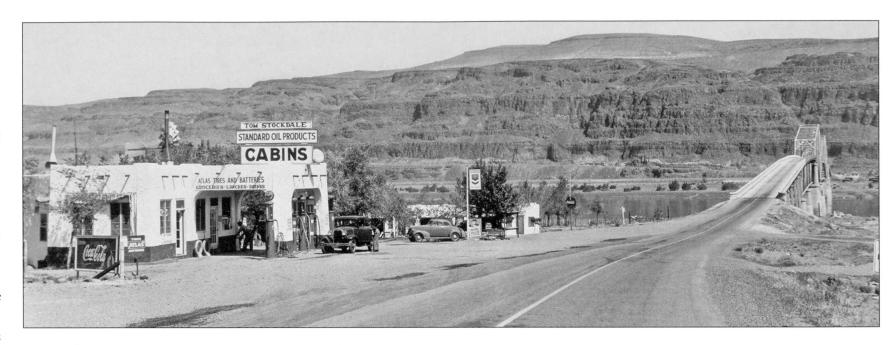

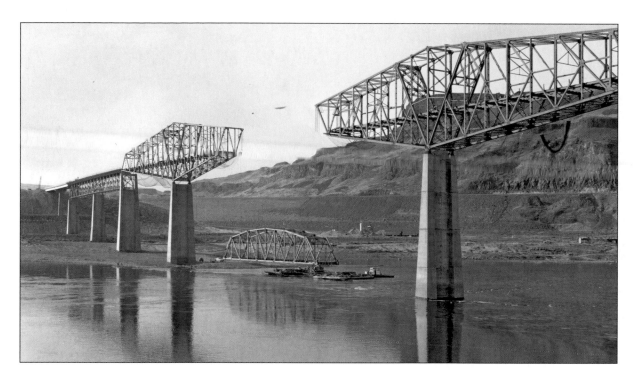

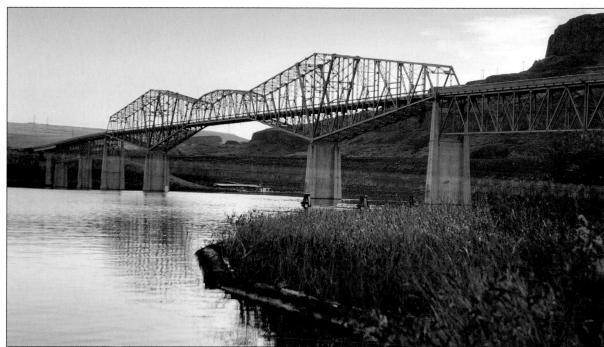

Lyon's Gate Bridge, 1968

In late 1962, the waters building up behind the Wanapum Dam threatened to overwhelm the old Vantage Bridge. It was replaced by the current Interstate 90 bridge at Vantage at a higher elevation a mile to the south. The older bridge, a marvel of engineering for its time, was dismantled and stored on a railroad siding in Beverly. In 1968, the original 1,640-foot cantilever truss was re-erected on new pylons over the Snake River in the heart of the Palouse, replacing the ancient ferry at Lyon's Gate. With the construction of the Lower Monumental Dam, the river backed up and created Lake Herbert G. West. The nearly-complete, recycled Vantage Bridge was photographed before the water levels rose and the pylons are still exposed. That the historical photographer stood considerably closer to the bridge can be proved by comparing the position of the bulbous bluff in the background of both views. —JS

Soap Lake, circa 1922

In another printing of the postcard featured here, the promise "It Will Cure You" has been handwritten over the rocks. The white-robed angel of therapy is leading a bandaged victim to the alkaline-rich waters of Soap Lake, named for the froth skimmed by the wind and deposited on the beaches. When the lake's popularity as a mineral-rich panacea gained momentum in the early 20th century, this southern shore was quickly stocked with hotels and all the attractions of a fetching health resort, including massage, mud baths, mineral soaks, and, of course, swimming in Soap Lake and drinking from it. The Siloam Sanitarium, seen on the horizon just below the angel's gesturing hand, was one of the town's grander retreats for treating both nervous afflictions and hypochondria. Soap Lake historian/filmmaker Kathy Kiefer is standing in for the angel in the "now" photo.

—PD

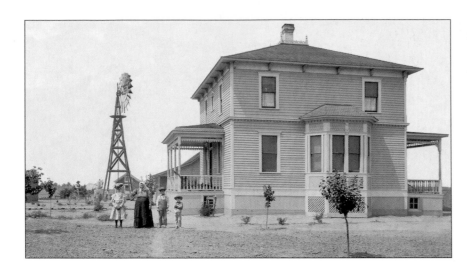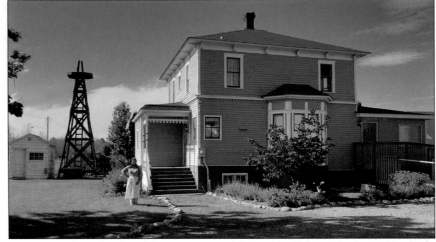

Quincy and Coulee City, 1908 and circa 1890

When the Reiman family posed with their classic box farmhouse in 1908 (above left), the agriculture around Quincy was years away from flourishing as it later would with dependable irrigation delivered by the Columbia Basin Project. Now more than a century after its 1904 construction, the Reiman-Simmons House is being restored by the Quincy Valley Historical Society. Since Jean photographed Society member Harriet Weber posing in period costume in the summer of 2005, the porch has been restored to its original architecture using the 1908 photograph as a guide.

It is about 40 miles from Quincy to Coulee City and Banks Lake, the Columbia Basin Project reservoir. Sited at the only place where the Grand Coulee could be easily crossed, Coulee City (below) developed as a pioneer transportation hub long before the Northern Pacific Railway reached it from Spokane in 1890. —PD

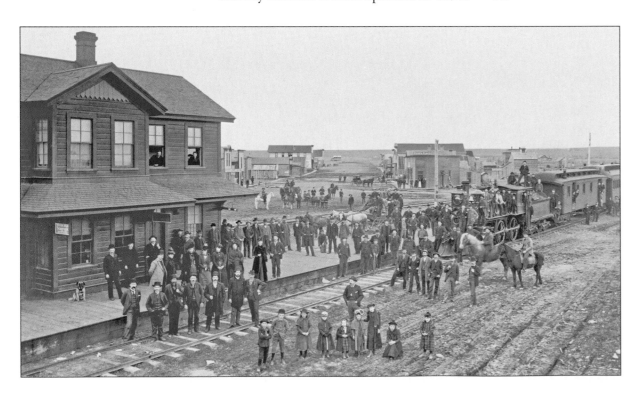

Steamboat Rock, circa 1940

The basalt behemoth of Steamboat Rock, several miles long and 800 feet high, is dramatic evidence of thousands of years of geological torment, seesawing between glaciers and cataclysmic floods. During the last Ice Age, a giant ice dam diverted the Columbia River from its current course. Steamboat Rock was an island in the diverted river. When the ice dam burst 13,000 years ago, it released the vast pent-up waters of glacial Lake Missoula, which extended hundreds of miles into western Montana. A 1,000-foot-high wall of water thundered towards the Pacific Ocean, returning the Columbia to its ancient bed. Steamboat Rock was left high and dry until 1951, when the Columbia Basin Project filled the coulee to store water for irrigation.

—JS

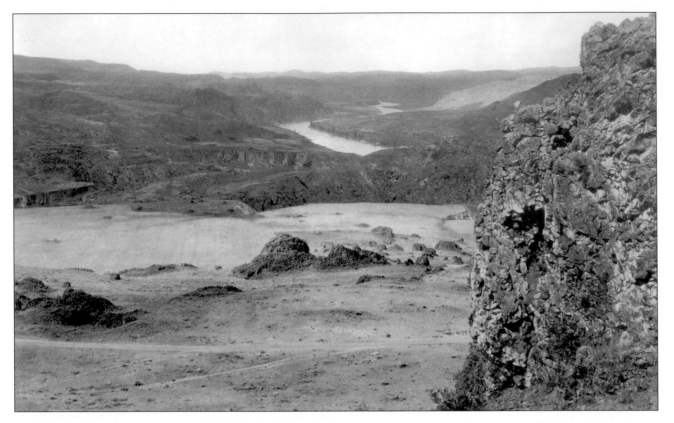

Grand Coulee Before the Dam, 1917

In 1917, Asahel Curtis climbed down to this precipice that overlooked the untamed Columbia. A $40 million levy to build the Grand Coulee Dam had been rejected by voters in 1914, but dam supporters, led by William "Billy" Clapp, an Ephrata lawyer, refused to give up. They commissioned a secret study to determine how high the dam would have to be to fill the coulee. The modern repeat gives a sense of the enormity of the project. Note the two boulders of indeterminate size in Curtis' photo. A sizeable two-story house nestles between them today. —JS

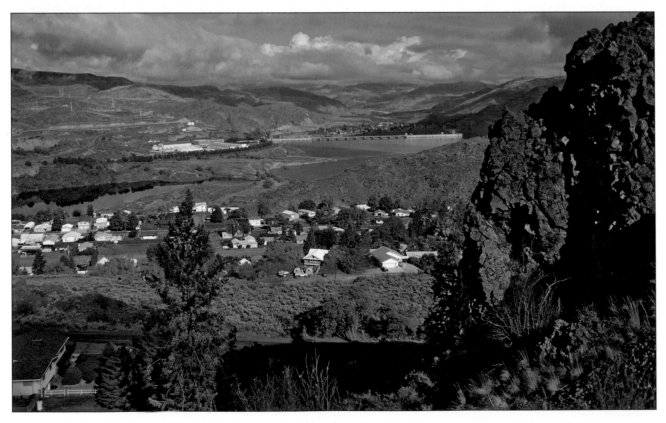

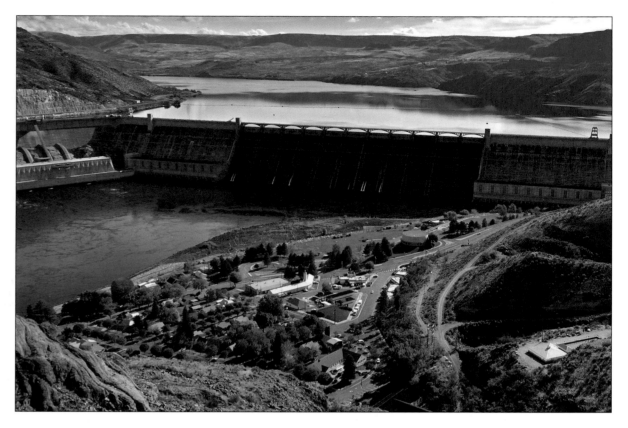

Grand Coulee Dam, circa 1945

When new, the Grand Coulee Dam was hailed as a triumph of human engineering. As a Woody Guthrie anthem proclaimed, it controlled a "wild and wasted stream" and inestimably improved our lot. Nearly a mile long, 550 feet high, and 200 feet thick at the base, it is the largest concrete structure in the country, helping to irrigate half a million acres of desert and generating 6,800 megawatts of clean electricity. Fortuitously completed in 1941, the dam's turbines supplied the vast quantities of electricity needed to manufacture aluminum for a nation at war. And yet, built without salmon runs, it also ended a Native American way of life on the upper Columbia forever. The repeat was taken from a precipitous 700-foot bluff overlooking "Engineers Town." My helpful guides to the top were a mountain goat and Grand Coulee representative Craig Brougher. —JS

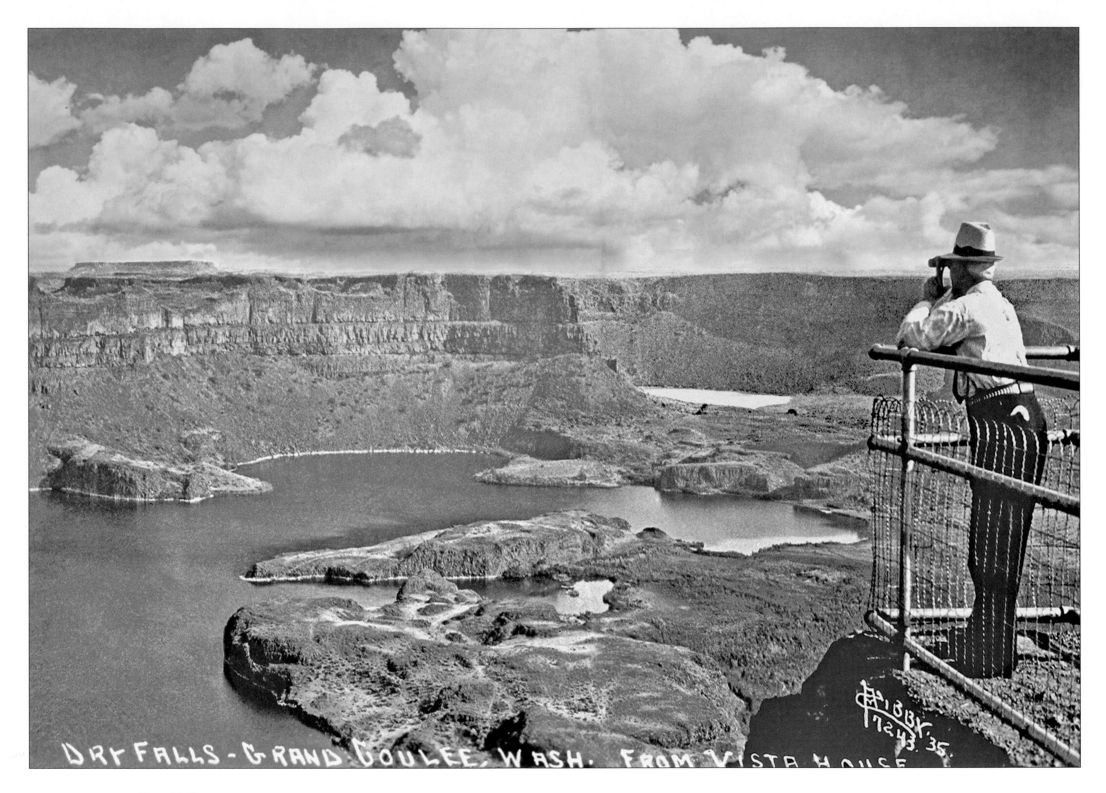

Dry Falls—Grand Coulee, Wash. From Vista House

Dry Falls, 1935

Since first built by the Civilian Conservation Corps during the Great Depression, the fenced bridge to the natural pulpit overlooking Perch and Deep Lakes to Dry Falls has seen countless visitors. Most have read the startling statistic, "Here once roared a cataract ten times greater than Niagara," and tried to imagine it. Of course, the full story of this torrent is a complicated lesson in geology and Ice-Age hydraulics that requires the help of rangers and enthusiastic volunteers to fully understand it; fortunately, the Sun Lakes–Dry Falls State Park has both.

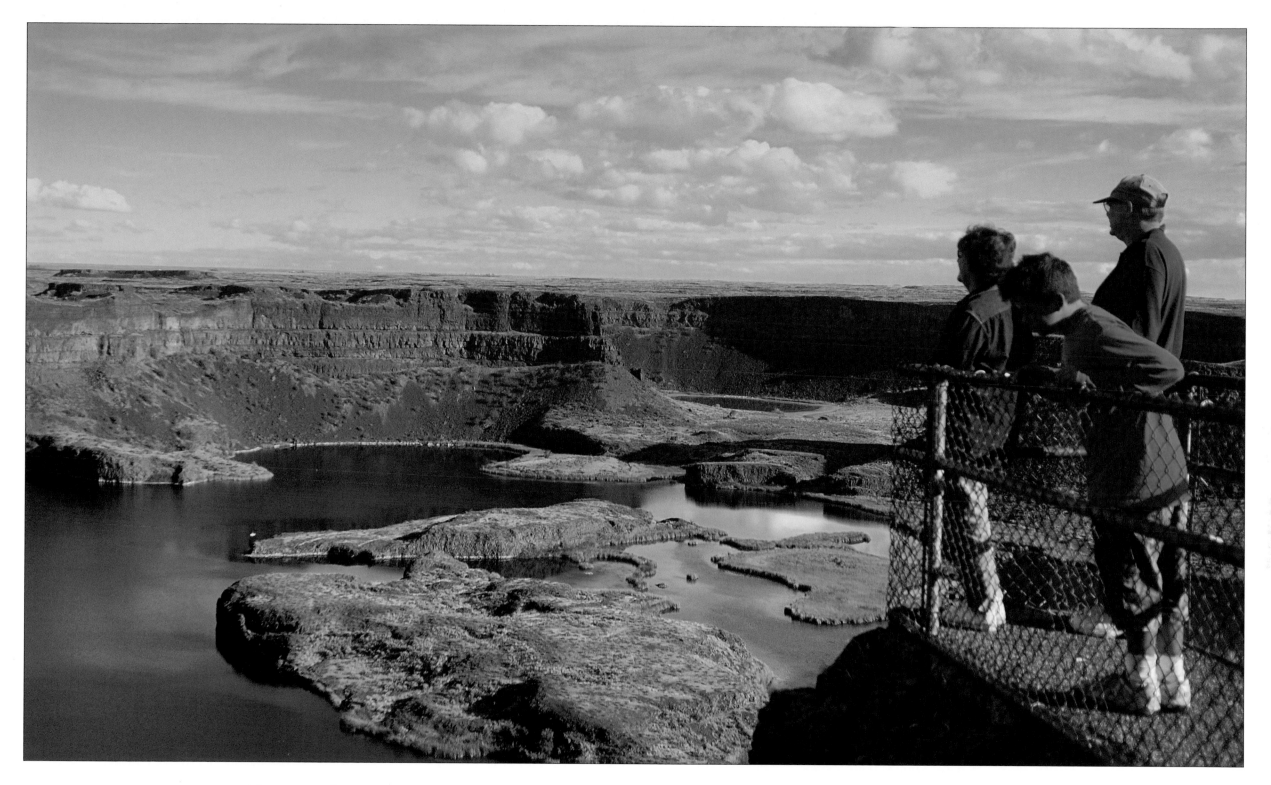

These Dry Falls are the result of massive Ice-Age flooding across much of present-day western Montana, Idaho, and Washington. It's difficult to envision the volume and force of water that could carve the Channeled Scablands of eastern Washington, leaving dramatic formations like the Dry Falls in the span of mere centuries rather than eons. But the release of glacial Lake Missoula, an inland sea as large as Lakes Erie and Ontario combined, accomplished precisely that, fundamentally altering the northwestern landscape and rerouting the Columbia River back to its original bed. —PD

Okanogan and Northeast Corner

Omak • Brewster • Okanogan • Republic • Northport • Kettle Falls
Confluence of the Sanpoil and Columbia Rivers • Colville • Metaline Falls

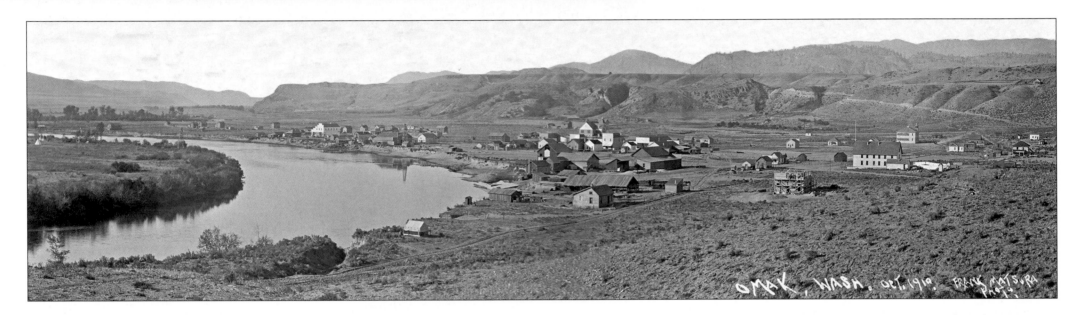

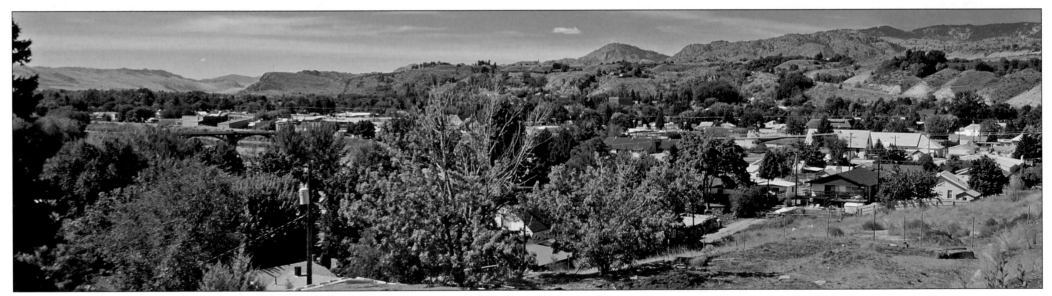

Omak, 1910

Frank S. Matsura, a pioneer Washington photographer, arrived in the Okanogan in 1907 and documented life there until his untimely death from tuberculosis in 1913. In Matsura's 1910 photo of Omak, taken from a bluff and looking southwest, the town nestles on a curve of the Okanogan River, before this part of the valley was extensively irrigated with lateral canals drawing from the river. From the present bluff, the river has disappeared behind thickets of trees. A recently constructed bridge peeps out just beyond the bend. —JS

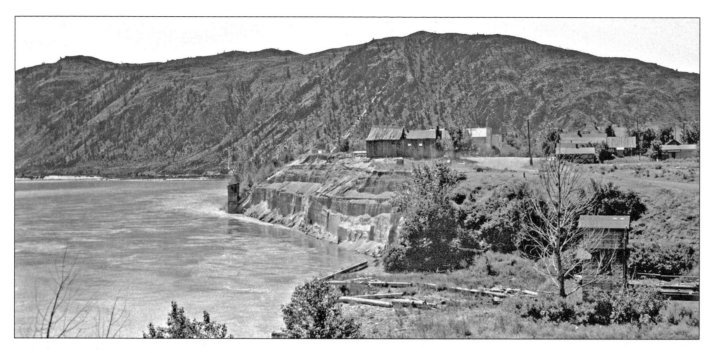

Brewster, circa 1905

Sensibly founded near where the Okanogan River joins the Columbia, Brewster was originally called Virginia City after "Virginia Bill" Covington, who owned a store at the steamer landing. But the name was changed when steamboats demanded a deeper water landing, requiring the town itself to move its location. Neighbor John Bruster supplied the landing, and the town was renamed in his honor, though it was intentionally misspelled by local decree. About a mile distant from the old, Bruster's new port of call drew store owners and many buildings were moved nearer to the new landing. Since the damming of the Columbia River, Brewster has lost land to the river, but acquired the untroubled reflection of Lake Pateros behind Wells Dam. —JS

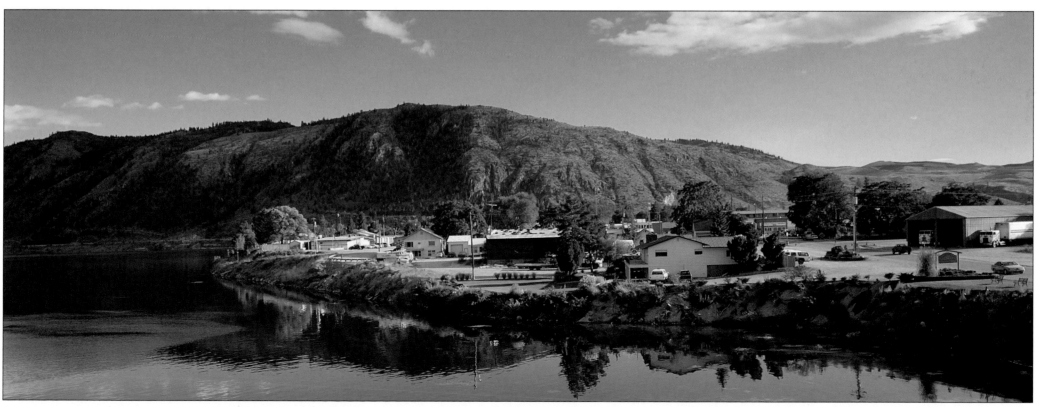

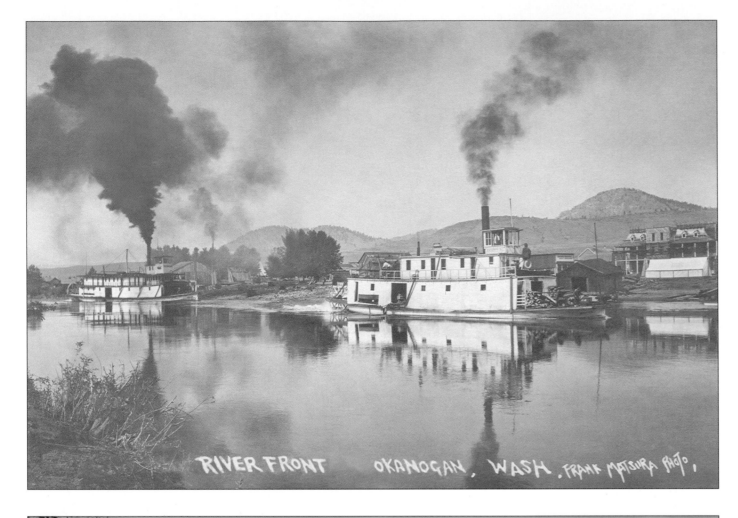

RIVER FRONT OKANOGAN, WASH. FRANK MATSURA PHOTO,

Okanogan, 1916 and 1908

Although outgrown by nearby Omak, Okanogan remains as the seat of Okanogan County government. The 1916 photo of its semi-Mission-style courthouse (below) would have been shot from the old firehouse's hose-drying tower, suggests Richard Rees of the Okanogan County Historical Society. Squeezing past ducts, up stepladders, and through windows, we reached the roof of the new City Hall for a retake that was still not as high as the historical photo from the firehouse tower. Steamers on the river (left) carried freight and passengers until the railroad arrived in 1913. Leader Mountain graces the horizon. —JS

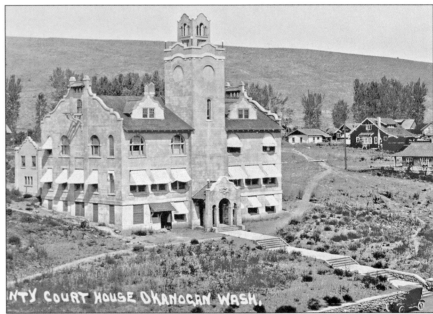

NTY COURT HOUSE OKANOGAN WASH.

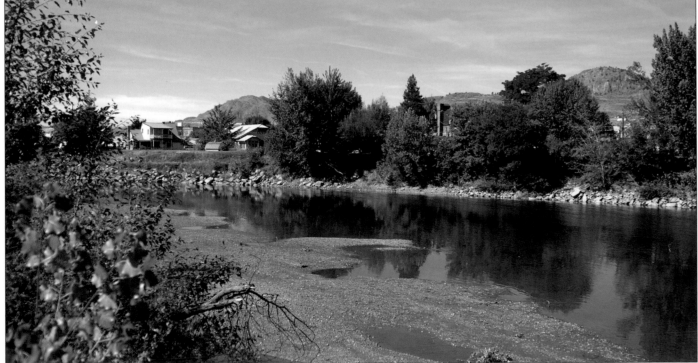

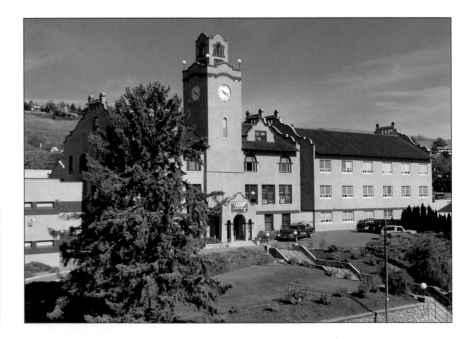

Davis Farm, 1912

In August 1888, William and Lucinda Davis and their five children arrived in the Okanogan valley and built a home. After losing the family's cattle to the bitter winter of 1889, William began operating a stage line between Bridgeport and Conconully, carrying mail, freight, and passengers. The Davis home became a welcome noon stop, renowned for its hospitality. William planted one of the valley's earliest apple orchards in 1891. Frank Matsura's 1912 photo shows the homesite; the building at left was for fruit packing and storage. Lucinda's eldest son, Edward, sits at far left; her brother, Bill, stands at center. In the repeat, Davis descendants gather beneath Lucinda's aging catalpa tree. Great-grandson David Fitzgerald (red jacket) lives with his family in the old ranch house. —JS

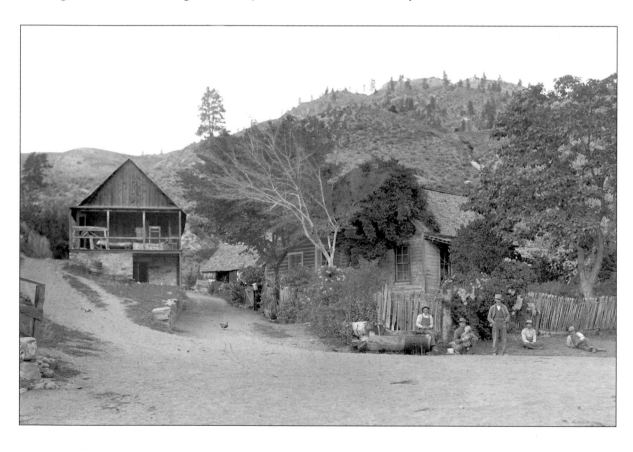

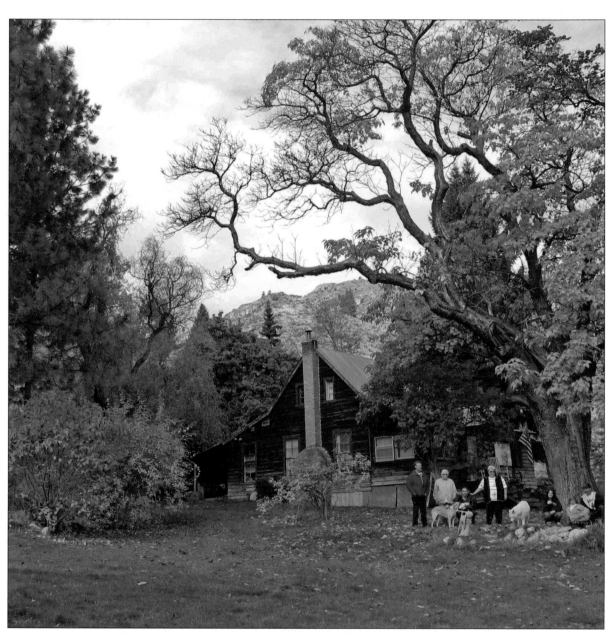

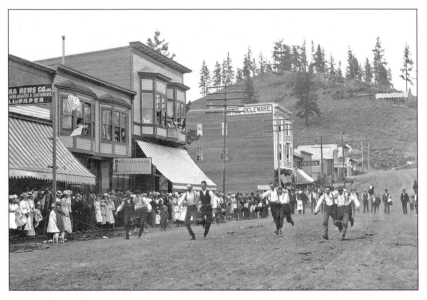

Republic, 1898 and circa 1903

Two years after its founding in 1896, the mining boomtown of Republic still had a lone fir tree left standing in the middle of Clark Avenue, a single horse hitched to its trunk (below left). A patchwork of competing gold claims evidently superseded street design. In 2005, another fir tree on Knob Hill prevented an exact repeat. The three-legged race shows Republic in the early 1900s (left); contestants are hobbling down Clark Avenue with Knob Hill in the background.

In the 1980s, town officials restored a number of Republic's historic buildings, hoping to attract tourists. Today, many storefronts look as they did 100 years ago.

—JS

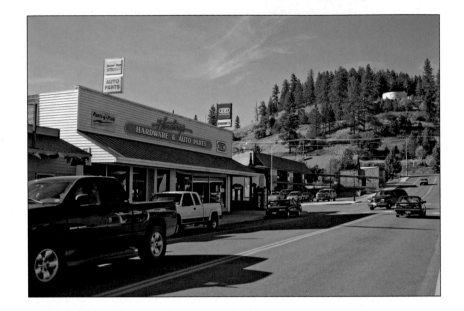

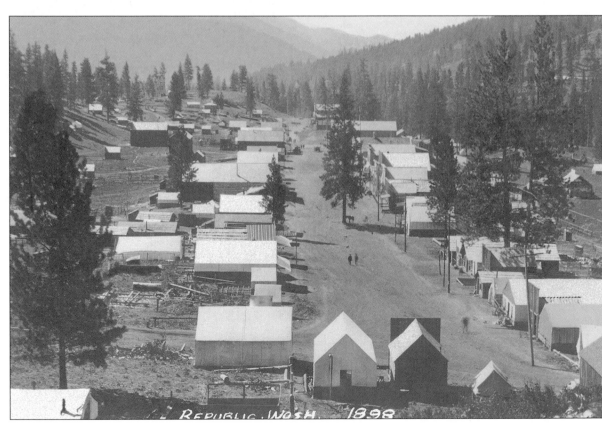

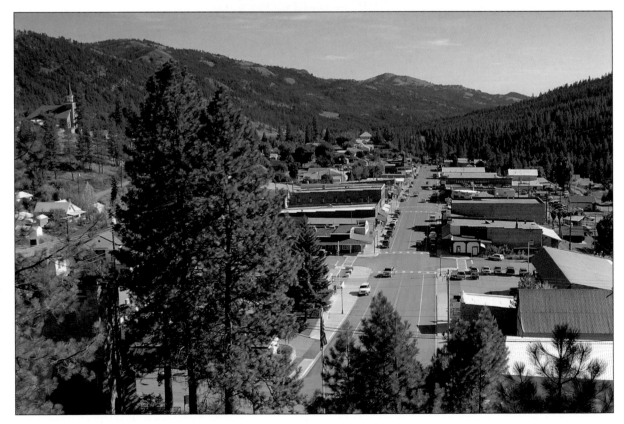

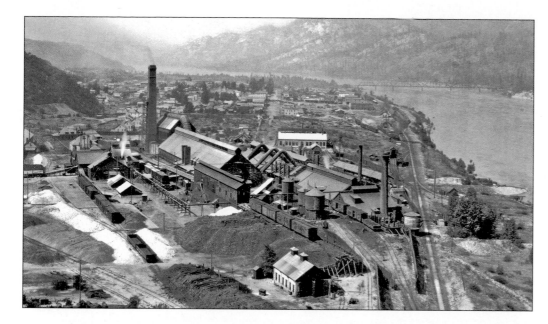

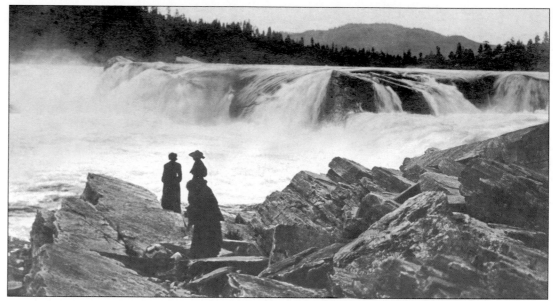

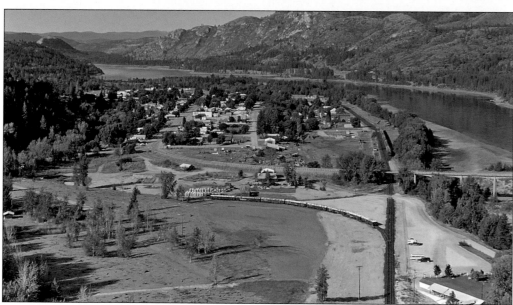

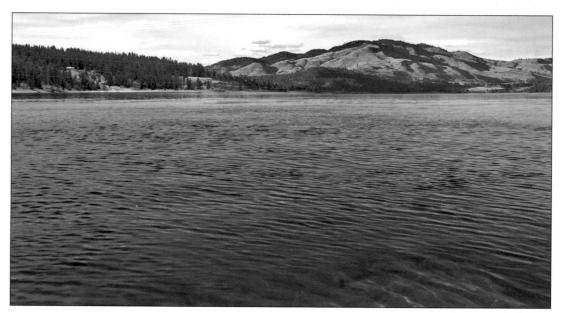

Northport, 1918

Just south of the Canadian border, little Northport struggles to survive, surrounded by natural beauty. Prior to the closure of its lead smelter in 1921, the town was home to many workers, also serving as a stop on the way to the gold mines in Nelson, British Columbia. Today, Northport is a shadow of its former self; the most obvious difference then and now is the absence of the smelter (left of center in the "then" photo), which until recently loomed as an abandoned "ghost mill" beside the Columbia.

We were guided to the right spot for the repeat photograph thanks to a serendipitous call to the former mayor of Northport, Ollie Mae Wilson, who knew precisely where the old photo was taken. The historical photographer had stood on Wilson Mountain. Mayor Wilson volunteered her ex-husband, Bob Wilson, as a backcountry guide, and he graciously donated his time and a four-wheel-drive truck to the effort.

—JS

Kettle Falls, circa 1895

Forty miles south of the Canadian border, Kettle Falls (*Shonitkwu* in Salish, meaning "noisy waters") names a place that no longer exists. For 9,000 years, Native peoples met here to fish and trade. They caught an estimated million pounds of salmon per year, which supplied half the tribe's nutrition.

In 1941, their way of life ended forever with the opening of the Grand Coulee Dam (see p. 143). At 550 feet, the dam was too high for fish ladders, and the salmon harvest, already diminished, disappeared completely from the upper Columbia. Today, the quartzite ledges over which the falls roared are buried deep beneath Franklin D. Roosevelt Lake. In our repeat, taken below the pillars of Highway 395, the lake's wind-rippled surface gives no hint of what was lost. The noisy waters are mute. —JS

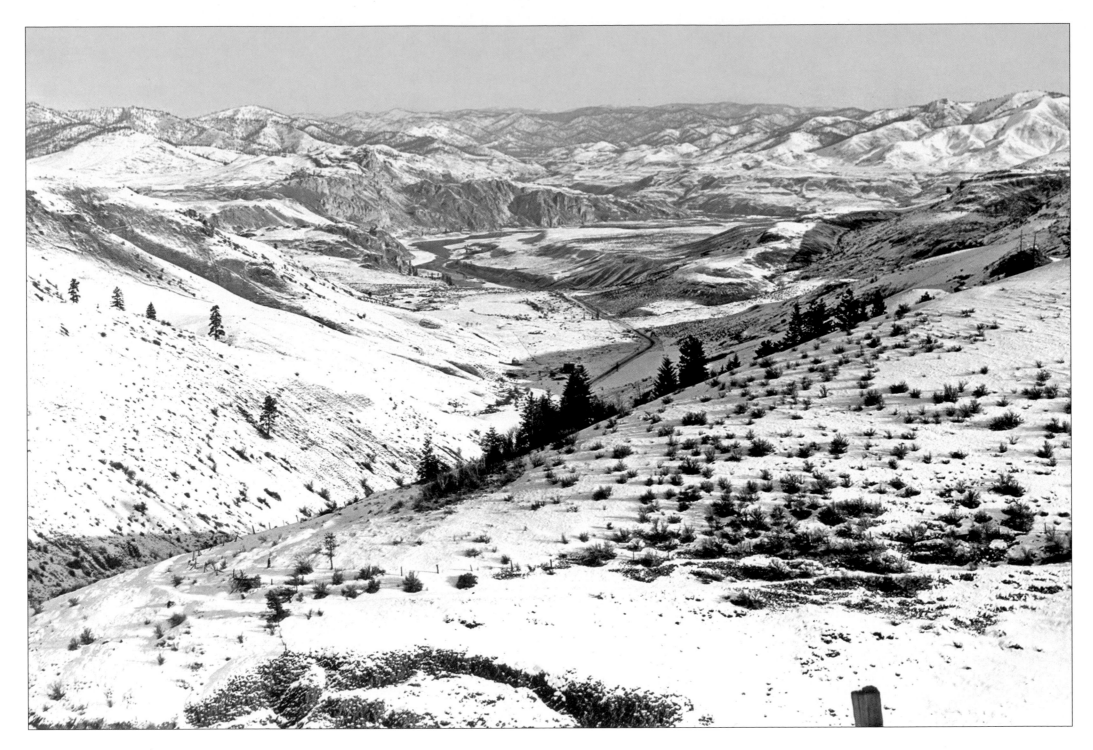

Confluence of the Sanpoil and Columbia Rivers, circa 1939

This "then" photo was one of our unsolved mysteries. Paul had narrowed it to an area near the Sanpoil River, but none of our usual sources recognized the prospect. Then, at Grand Coulee Dam, we had a breakthrough. My guide, Craig Brougher, recognized the view instantly, having driven past it on family vacations since he was a child. It was Keller Ferry, he said, which still offers ferry service at the confluence of the Sanpoil and Columbia Rivers. The original town of Keller lies under Franklin D. Roosevelt Lake; a new Keller was sited beside Highway 21 about 10 miles north of the old town. Consisting of a gas station, tavern, and little more, it reflects the once-lively ferry town in name

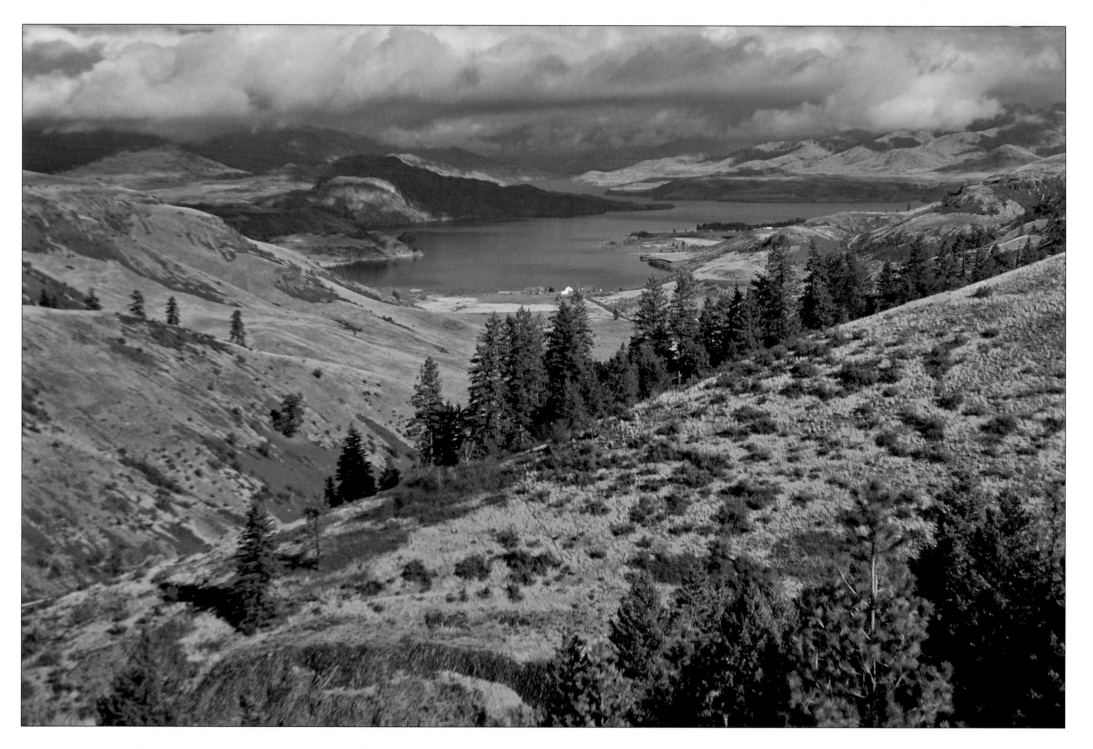

alone. For the "then" photo, a government photographer looked north across the Columbia River to record both the snow-defined hills of the Colville Indian Reservation and two rivers—the Columbia and its much smaller tributary the Sanpoil—that would soon be flooded by Lake Roosevelt.

On this trip, I came across the only speed trap in two years of travel across the state. On the 8-mile straightaway between Grand Coulee and Wilbur, I got my first speeding ticket. —JS

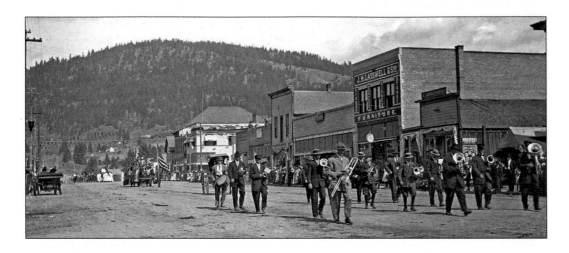

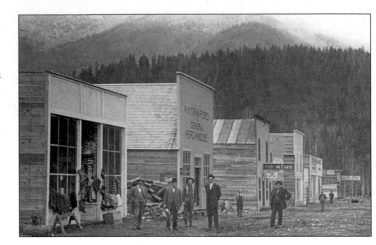

Metaline Falls, 1910 and circa 1911

Metaline Falls is the most remote location we cover in this book, at least from our Seattle-based perspective. It lies about 10 miles south of Canada and 15 miles west of Idaho through the Salmo-Priest Wilderness. To reach it, we needed help. So we asked Janis Haglund to take the "now" photo on a winter day, which she did with the snow brightening the summit of Mount Linton 3 miles to the east. Janis and her husband retired from their Seattle jobs in 1997 and moved to Metaline Falls because they "loved the place" and its boomtown history. (That's her husband Jeff Lindstedt steadying the telephone pole.) Janis surmises that the photo (right) dates itself to 1910. She notes, "Although the photo shows elaborate improvements on Main Street, these shots could have been taken as little as six months apart. The town went up like gangbusters in 1910. That year Lewis Larsen platted the townsite and built a cement plant and a power plant, and the Idaho & Washington Northern Railroad arrived." The older photo comes from Tony Bamonte, former Pend Oreille County sheriff, and the circa 1911 view from Janis. Tony introduced us to Janis, and we thank them both.

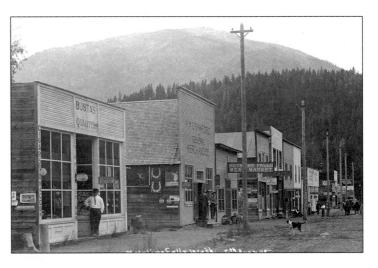

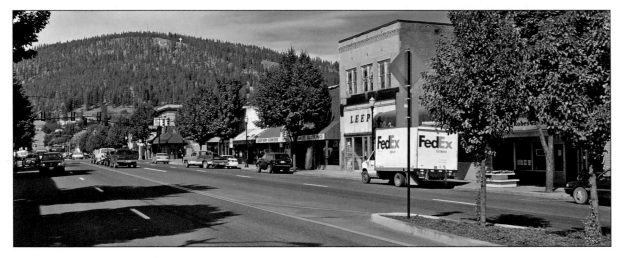

Colville, circa 1911

There have been three Colvilles. The first, named for Andrew Colvile, a Hudson's Bay Company director, was founded in 1825 on the Columbia River, a little way upstream from Kettle Falls. In 1859, the U.S. military embraced a name by then famous when it built its own Fort Colville, about 10 miles southwest of the Hudson's Bay fort and away from the river. This second Colville was distinguished by a second "L." The English fort was used for trading firs and farming. The American fort was used for keeping the peace among Indians and the miners drawn to the region when gold was discovered in 1859.

The English were long gone when the United States also closed its Fort Colville in 1883. About 2 miles southwest of the abandoned fort, the town of Colville was quickly constructed from lumber salvaged from the fort before the army could rescue it for their own relocation at Fort Spokane. Only six years later, the first train arrived from Spokane to the "third Colville," the largest town in Stevens County and the seat of its government as well.

Yep Kanum, a Native American name for an autumnal powwow, was adopted by the city for its own fall celebration, which included a civic parade. The city also dubbed its biggest park Yep Kanum, but the name's popularity has since faded and the splendid 18-acre green is more commonly called simply "City Park." The parade view looks north on Main Street toward Colville Mountain. For his repeat, Jean moved forward a few feet in order to look around the center line of trees, planted on Main Street as part of a citywide revitalization project in 2000. —PD

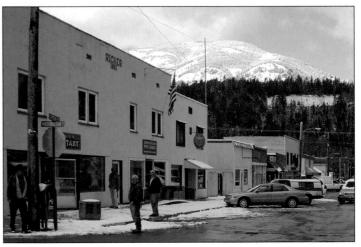

Nearly a century later, Metaline Falls survives and in a few admirable ways it also thrives. A working mine and the nearby Boundary and Box Canyon dams of the Pend Oreille River provide employment for about 200. The old mill town is also a destination for more than a handful of retirees; many of them first visited Metaline Falls as tourists and then returned as "End of the Roaders," a name they embrace. The town is also a magnet for artists and its award-winning exhibition and live performance space, the Cutter Theatre, is one of the reasons Metaline Falls has been included more than once in the national guidebook *The 100 Best Small Arts Towns in America.* —PD

ISBN-10: 1-56579-547-4 ISBN-13: 978-1-56579-547-1

CONTEMPORARY PHOTOGRAPHY: ©2007, Jean Sherrard, except where noted. All rights reserved.

TEXT: ©2007, Paul Dorpat and Jean Sherrard. All rights reserved.

EDITOR: Jenna Samelson Browning and Jennifer Jahner

PRODUCTION AND DESIGN: Craig Keyzer

PUBLISHED BY:
Westcliffe Publishers, Inc., P.O. Box 1261, Englewood, CO 80150
westcliffepublishers.com

PRINTED IN CHINA BY: Hing Yip Printing Co., Ltd.

LIBRARY OF CONGRESS CATALOGING-IN-PUBLICATION DATA:
Dorpat, Paul.
 Washington then & now / text and contemporary photography by Paul Dorpat and Jean Sherrard.
 p. cm.
 ISBN-13: 978-1-56579-547-1
 ISBN-10: 1-56579-547-4
 1. Washington (State)—Pictorial works. 2. Washington (State)
—History—Pictorial works. 3. Washington (State)—History,
Local—Pictorial works. 4. Repeat photography—Washington. I.
Dorpat, Paul and Sherrard, Jean. II. Title. III. Title: Washington
then and now.

 F892.D67 2007
 979.70022'2—dc22 2006023393

About the Authors

JEAN SHERRARD has worked as an actor, writer, director, photographer, teacher, carpenter, and private detective. Co-founder of the Globe Radio Repertory, he wrote and directed scores of radio plays for National Public Radio and has trod the boards of Seattle's finest theaters. His photos and articles have been featured in numerous publications. With Paul Dorpat, he co-produced *Bumberchronicles*, a KCTS-9 documentary, and co-wrote *Legacy*, a commemorative history of the Kreielsheimer Foundation. Currently, Sherrard teaches drama and writing at Hillside Student Community, a private secondary school in Bellevue, Washington.

PAUL DORPAT is a longtime Seattle resident. Paul has produced documentaries for local television, lectured widely, and since 1982 has written the weekly column "Now and Then" for *The Seattle Times*. Included among his dozen published books are three volumes of Seattle "now-and-then" comparisons drawn from his column and *Building Washington*, an illustrated encyclopedic study of the state's historical development that he co-authored with Genevieve McCoy. Dorpat's collaboration with Jean Sherrard began in 1999 with the production of *Bumberchronicles*, a video history of Bumbershoot, Seattle's annual arts festival.

Photography Credits

■ COVER

Front Cover: *(top)* George Robinson, courtesy Paul Dorpat
Front Cover Insets: *(left)* Bert Huntoon, University of Washington Libraries, Special Collections, UW7569; *(right)* Grant Gunderson, contemporary photographer
Front Endsheet: *(left)* Lee Pickett, University of Washington Libraries, Special Collections, Pickett 2275; *(right)* Chet Marler, contemporary photographer
Back Endsheet: *(left)* Courtesy Paul Dorpat
Back Cover: Courtesy Russ Langstaff

■ INTRODUCTION

3 *(left)* Courtesy Lonnie Henson and Mary Catherine Ruud; *(bottom right)* Berangere Lomont
4 Lawrence Denny Lindsley, courtesy Dan Kerlee
5 *(left and middle)* Courtesy Warren Clifford; *(bottom right)* Berangere Lomont

■ NORTHWEST CORNER

6 Bert Huntoon, University of Washington Libraries, Special Collections, UW7569
7 Grant Gunderson, contemporary photographer
8 Asahel Curtis, Maryhill Museum of Art
9 Old Seattle Paperworks
10 *(top left)* Peter Hegg, University of Washington Libraries, Special Collections, UW4047; *(top right)* J. Wilbur Sandison, Whatcom Museum of History and Art
11 University of Washington Libraries, Special Collections, WAS1218
12 *(top left)* University of Washington Libraries, Special Collections, UW26241Z; *(top right)* Carl J. Johnson, contemporary photographer; *(bottom left)* Washington State Department of Transportation
13 *(top left)* Juke Studio, Washington State Department of Transportation; *(bottom right)* Washington State Department of Transportation
14 Courtesy Dan Kerlee
16 *(top and middle)* Skagit Valley Historical Museum
17 John T. Wagness, courtesy Dan Kerlee
18 Skagit Valley Historical Museum
20 Courtesy Paul Dorpat
22 *(top left)* George W. Kirk, Everett Public Library; *(bottom)* Asahel Curtis, Washington State Historical Society, 19241 and 19242
24 Snohomish Historical Society
25 Snohomish Historical Society
26 *(top left)* Courtesy David Damkaer, Sky Valley Historical Society; *(top right)* Sultan Historical Museum
27 *(top left)* Lee Pickett, University of Washington Libraries, Special Collections, Pickett 2112; *(bottom)* Museum of History and Industry, Seattle
28 *(top left)* Lee Pickett, University of Washington Libraries, Special Collections, *(bottom right)* Lee Pickett, University of Washington Libraries, Special Collections, Pickett 2285
29 *(top left)* Lee Pickett, University of Washington Libraries, Special Collections, Pickett 1723; *(bottom)* Courtesy Paul Dorpat
30 Lee Pickett, University of Washington Libraries, Special Collections, Pickett 2275
31 Chet Marler, contemporary photographer

■ SEATTLE AND VICINITY

32 George Robinson, courtesy Paul Dorpat
33 *(bottom left)* Horace Sykes, courtesy Paul Dorpat
34 *(top and bottom)* Courtesy Russ Langstaff
35 Chapin Bowen, courtesy Murray Morgan
36 *(top left)* Webster and Stevens Studio, Museum of History and Industry; *(top right)* Curtis and Miller Studio, courtesy Paul Dorpat; *(bottom)* Paul Dorpat, contemporary photographer
37 *(top)* E.A. Clark, Seattle Public Library; *(bottom left)* Courtesy Russ Langstaff; *(bottom right)* Paul Dorpat, contemporary photographer
38 *(top)* O.T. Frasch, courtesy Paul Dorpat; *(bottom left)* Courtesy Greg Lange
39 *(top left)* Asahel Curtis, Seattle Public Library; *(top right)* Paul Dorpat, contemporary photographer; *(bottom)* Seattle Post-Intelligencer
40 Washington State Archives, Bellevue branch
41 Courtesy Dan Kerlee
42 Seattle Public Utilities
44 *(top left)* Courtesy Paul Dorpat; *(top right)* Harold Keller, Snoqualmie Valley Historical Society; *(bottom left)* Arthur Churchill Warner, University of Washington Libraries, Special Collections, WAR0600
45 *(top)* Seattle Public Utilities; *(middle)* Darius Kinsey, Snoqualmie Valley Historical Society

46 E.J. Siegrist, courtesy John Cooper
47 *(left)* Old Seattle Paperworks; *(bottom right)* Boeing Company Archives

■ TACOMA AND SOUTH SOUND

48 *(top)* Will Hudson, courtesy Jean Hudson Lunzer; *(bottom)* Courtesy Washington State Historical Society
49 *(top right)* Courtesy Paul Dorpat
50 *(top left)* Courtesy Paul Dorpat; *(top right)* Thomas Rutter, courtesy Murray Morgan
51 Thomas Rutter, courtesy Murray Morgan
52 Paul Richards, Tacoma Public Library
53 *(top left)* Courtesy Michael Maslan; *(top right and bottom)* Courtesy Paul Dorpat
54 Chapin Bowen Studio, courtesy Murray Morgan
56 *(top left)* Alfred Simmer, Washington State Department of Transportation; *(bottom right)* Fredrick Farquharson, University of Washington Libraries, Special Collections, 21422
57 *(top left)* Courtesy Paul Dorpat; *(top right)* Courtesy Dan Kerlee
58 *(top)* A.D. Rogers, Washington State Historical Society; *(middle)* T.W. Patterson, University of Washington Libraries, Special Collections, UW4876
59 *(top left)* Courtesy Paul Dorpat; *(bottom left)* Joseph Knight, University of Washington Libraries, Special Collections

■ ISLANDS AND OLYMPIC PENINSULA

60 Webster and Stevens Studio, courtesy Paul Dorpat
61 *(top right)* Old Seattle Paperworks
62 *(top left)* Courtesy Paul Dorpat; *(bottom left)* University of Washington Libraries, Special Collections UW11338; *(top right)* Courtesy Kristin Sherrard
63 *(top left)* Asahel Curtis, Washington State Historical Society, 61450; *(bottom left)* Courtesy Paul Dorpat
64 John Millis, courtesy Walter Millis
65 *(top and bottom left)* Courtesy Dan Kerlee
66 *(top left)* Asahel Curtis, Washington State Historical Society, 51715; *(bottom left)* Courtesy Paul Dorpat
67 Stuart Hoskinson, Bainbridge Island Historical Society
68 *(top and bottom left)* Poulsbo Historical Society
69 Huntington Studio, courtesy Michael Maslan
70 Torka's Studio, courtesy Dan Kerlee
71 *(top left and right)* Old Seattle Paperworks
72 *(top)* National Archives–Pacific Alaska Region; *(middle)* Fannie Taylor, courtesy Doreen Taylor and Museum and Arts Center in the Sequim-Dungeness Valley
73 Washington State Historical Society, 54261
74 *(top)* Philip Wischmeyer, Washington State Historical Society; *(bottom)* National Archives–Pacific Alaska Region
76 *(top left)* Courtesy Paul Dorpat; *(bottom left)* Jones Studio, courtesy Jones Photography
77 *(top left)* Courtesy Dan Kerlee; *(bottom)* Dale Northup, courtesy Gene Woodwick

■ SOUTHWEST CORNER

78 Charles F. Hill, Polson Museum
79 *(bottom)* H.G. Nelson, courtesy Dan Kerlee
80 *(top left and middle)* Aberdeen Historical Museum
81 *(top)* Courtesy Dan Kerlee; *(bottom left)* Jones Studio, courtesy Jones Photography
82 Jones Studio, courtesy AAA Washington/Inland
83 *(both left photos and top right)* Pacific County Historical Society
84 Pacific County Historical Society
85 *(both photos)* John W. Tollman, Pacific County Historical Society
86 *(top left)* Lewis County Historical Society; *(bottom left)* Courtesy Dan Kerlee
87 Wahkiakum County Historical Society
88 *(top left)* J.F. Ford, courtesy Dan Kerlee; *(right, 3rd from top)* Boyd Ellis, courtesy John Cooper; *(top right, 2nd from top, and bottom)* Courtesy Paul Dorpat
89 Ilwaco Heritage Museum
90 Ilwaco Heritage Museum
91 University of Washington Libraries, Special Collections
92 Lewis County Historical Society
93 *(both photos)* Courtesy Michael Maslan
94 Boyd Ellis, courtesy John Cooper

■ YAKIMA VALLEY

96 Boyd Ellis, Ellensburg Public Library
97 *(both photos)* Boyd Ellis, courtesy John Cooper
98 Asahel Curtis, Washington State Historical Society, 21992
99 *(top and bottom left)* Ellensburg Public Library
100 *(top left)* Boyd Ellis, courtesy John Cooper; *(bottom left)* Asahel Curtis, AAA Washington/Inland
101 Asahel Curtis, Washington State Historical Society, 11302
102 *(top left)* Partridge Studio, Yakima Valley Museum; *(top right)* National Archives–Pacific Alaska Region
103 *(top left)* Boyd Ellis, courtesy John Cooper; *(bottom left)* Asahel Curtis, Washington State Historical Society, 37648

104 Washington State Historical Society
105 *(both photos)* Museum of History and Industry, *Post-Intelligencer* Collection
106 Franklin County Historical Society and Museum
107 *(top left)* Klickitat Historical Society; *(top right)* Sunnyside Public Library
108 Samuel Lancaster, Maryhill Museum of Art

■ SOUTHEAST CORNER

110 M.H. Land, Waitsburg Historical Society
112 Penrose Library, Whitman College
113 *(top and bottom left)* Dayton Historical Depot Society
114 Courtesy Doug Renggli; Doug Renggli, contemporary photographer
115 *(bottom left)* St. Boniface Catholic Church; Jill Price Freuden, contemporary photographer
116 Will Hudson, Whatcom County Museum
117 Courtesy Dan Kerlee; Jill Price Freuden, contemporary photographer
118 *(top left and right)* Whitman County Historical Society; *(bottom)* Rich and Jim Weatherly, contemporary photographers
119 *(top left)* Walter Copy, Northwest Museum of Arts & Culture; *(bottom)* Horace Sykes, courtesy Paul Dorpat

■ SPOKANE AND VICINITY

120 *(top left)* Courtesy Paul Dorpat; *(top right)* University of Washington Libraries, Special Collections; *(bottom)* William O. Reed, University of Washington Libraries, Special Collections, WAS0591
122 Courtesy Michael Maslan
123 F. Jay Haynes, Tacoma Public Library
124 Northwest Museum of Arts & Culture
125 *(top left)* Libby Studio, Eastern Washington State Historical Society; *(top right)* Courtesy Paul Dorpat
126 *(top left)* Courtesy Michael Maslan; *(bottom left)* Wes Whaley, contemporary photographer; *(top right)* F. Jay Haynes, Tacoma Public Library
127 *(top left)* Libby Studio, Northwest Museum of Arts & Culture; *(top right)* Courtesy Paul Dorpat
128 *(top left)* Courtesy Judy Abbot and City of Medical Lake; *(top right)* Lincoln County Historical Society
129 *(top left)* Eastern Regional Archives, Eastern Washington University; *(bottom left)* Northwest Museum of Arts & Culture
130 *(top left)* Courtesy John Cooper; *(top right)* Courtesy John Cooper; *(bottom left)* Boyd Ellis, courtesy John Cooper
131 *(top left)* Courtesy Dan Kerlee; *(top right)* Courtesy Harland Eastwood; *(bottom left)* Rich and Jim Weatherly, contemporary photographers; *(bottom right)* Christopher Clutter, contemporary photographer

■ BIG BEND AND BEYOND

132 National Archives–Pacific Alaska Region
134 *(top left)* M.L. Oakes, courtesy John Cooper; *(top right)* Boyd Ellis, courtesy John Cooper; *(bottom left)* Peggy Daczewitz-Hamlin, padhphotography.com
135 *(top left)* M.L. Oakes, courtesy Paul Dorpat; *(bottom left)* Washington State Department of Transportation
136 Entiat Historical Society
137 Lawrence Denny Lindsley, courtesy Dan Kerlee
138 Boyd Ellis, courtesy John Cooper
139 *(top left)* Washington State Department of Transportation; *(bottom left)* Courtesy Paul Dorpat
140 *(top left)* Otto Henderson, Quincy Valley Historical Society; *(bottom left)* F. Jay Haynes, Tacoma Public Library
141 Boyd Ellis, courtesy John Cooper
142 Asahel Curtis, Washington State Historical Society, 34610
143 *(top left)* Courtesy Paul Dorpat; *(bottom)* Courtesy John Cooper
144 Libby Studio, courtesy Paul Dorpat

■ OKANOGAN AND NORTHWEST CORNER

146 Frank S. Matsura, Okanogan County Historical Society
147 Courtesy Dan Kerlee
148 *(top left)* Frank S. Matsura, Okanogan County Historical Society; *(top right)* Okanogan County Historical Society
149 Frank S. Matsura, Okanogan County Historical Society
150 *(both photos)* Ferry County Historical Society
151 *(top left)* Courtesy Stevens County Historical Society; *(top right)* Courtesy Dan Kerlee
152 Old Seattle Paperworks
154 *(top left)* National Archives–Pacific Alaska Region; *(top right)* Courtesy Tony Bamonte; *(right, 2nd from top)* Courtesy Janis Haglund; *(bottom right)* Janis Haglund, contemporary photographer

Acknowledgments

NORTHWEST CORNER: Grant Gunderson, Duncan, Gail, Gwyn, Amy Howat, and Bunny Finch of Mt. Baker Recreation Company; Debra C. Paul, U.S. Forest Service, Mount Baker; Bruce Brown, Sumas; Rose Anne Featherston, Everson; Marc Cutler and Tim Wahl of Bellingham; Jeff Jewell and Toni Nagel of Whatcom Museum of History and Art; Carl J. Johnson, Alger; Mari Anderson-Densmore, Skagit County Historical Society; Dana and Toni Rust and Nancy Williams, Edison; Noel V. Bourasaw, Sedro-Wooley; Karen Prasse, Stanwood Area Historical Society; Scott Chase, Camano Island; Deborah Compton and Sharon Jacobson, Silvana; Larry Bauman and Candace Harvey, Snohomish; Victoria Harrington, Snohomish Historical Society; Fred Cruger, Granite Falls; Ken Cage, Marysville; Margaret Riddle and David Dilgard, Everett Public Library; Robert and Brenda Kerr, Kathie and Shawn Hoban, Everett; Chuck LeWarne, Edmonds; Louise Lindgren, Index; David M. Damkaer, Sultan and Monroe; and Chester Marler and John Gifford, Stevens Pass.

SEATTLE AND VICINITY: Greg Lange, Michael Maslan, Michael Fairley, Dan Kerlee, John Hannawalt, Ellen Terry, Bob Royer, Larry Hoffman, Howard Lev, Dennis Andersen, Laura Vanderpool, Ted D'Arms, Margaret Bovington, Pliny Stevens, Kael Sherrard, Noel Sherrard, Ethan Sherrard, Karen Chartier, and Genevieve McCoy of Seattle; Larry Vogel, Steve Moddemeyer, Suzy Flagor, Sandy Gray and Dick Lilly of Seattle Public Utilities; Lisa Scharnhorst, Seattle Public Library; Historylink.org; Dave Battey, Snoqualmie Valley Historical Society; Erica Maniez, Issaquah Historical Society; Nicolette Bromberg and Kris Kinsey, University of Washington Libraries Special Collections; Carolyn Marr and Howard Giske, Museum of History and Industry; John Cooper, Mercer Island; Anne Murray Peacock and Tiffany Sweet, Bellevue; and Bellevue Historical Society.

TACOMA AND SOUTH SOUND: Brian Kamens and Robert Schuler, Tacoma Public Library; Lynette Miller and Elaine Miller, Washington State Historical Society; Keith Beck, Rick Nelson, and Tom Petramalo of Tacoma; Milt and Sue Davidson, Steilacoom; David Hanig, Adam Hanig, and Derek Valley of Olympia; Shanna Stevenson, Thurston County Regional Planning; Dave Hasting, Washington State Archives; Robert McIntyre and Naaman Horn, Mount Rainier; Laura Young, Elma Timberland Library; Jim Starks, Elma; Claudia Cornish, Washington State Department of Transportation, Gig Harbor; Erin Babbo, Gig Harbor; and John and Mary Hillding, Wilkeson.

ISLANDS AND OLYMPIC PENINSULA: Kristin Sherrard, Friday Harbor; John and Michelle Pope and Evelyn Adams, Anacortes; Robert Harbour, National Park Service, Whidbey Island; Thom Gunn, Whidbey Island; Gordon Stenman, A.J. Watland-Fureby, Dale Anderson, Glen Haskins, and Margene Smaaladen of Poulsbo Historical Society; Erica Varga, Kitsap County; Gerald Elfendahl and Lorraine Scott, Bainbridge Island Historical Society; Glenn Doremire, Winslow; Deborah Franz-Anderson, Bremerton; Virgil Reames, Port Orchard; Brian Eckerle, Port Gamble; Alfred Chiswell and Bill Roney, Puget Sound Coast Artillery Museum, Port Townsend; Bill Tennent and Marsha Moratti, Jefferson County Historical Museum; Rick Tollefson, Port Townsend; Keely Parker, Roxanne Parker, Rebecca Monette, and Kirk Wachendorf of the Makah Museum; Larry Burtness, Forks; James Jaime, Quileute Tribe, La Push; Li Clinton and Vickie Williams, Kalaloch; John Olson, Heidi Lambert, and Charlene Bottcher of Quinault Lodge; Kelly C. Cline, Pacific Beach; Kelly Calhoun, Museum of North Beach, Moclips; and Gene Woodwick, Ocean Shores Interpretive Center.

SOUTHWEST CORNER: John Larson, Polson Museum, Hoquiam; Gail Van Ogle, Aberdeen; Dan Sears, Aberdeen Museum of History; Charles Summers and Bruce Weilepp, Pacific County Historical Museum;

Adolph Huber, Frances; Aaron Webster and Donella Lucero, Cape Disappointment State Park; Barbara Minnard, Joan Mann, Nancy Olson, and Eileen Wirkkala of Ilwaco Heritage Museum; Carlton Appelo, Grays River; Kari Kandoll and Irene Martin, Skamokawa; T.W. Ginger Allred and Dan Kerlee, Longview; David Freece, Cowlitz County Historical Museum; Karen Johnson and Jesse Clark McAbee, Lewis County Historical Museum; Susan Wheeler and Nick Racine, Mount Saint Helens; Susan Tissot, Clark County Historical Museum; Mary Wheeler, Dean Baker, and Ted VanArsdol, Vancouver; Cami Joner, Vancouver National Historic Reserve Trust; Mary Wheeler, Center for Columbia River History, Vancouver; and Lucy K. Berkley and Richard Engerman, Oregon Historical Society.

YAKIMA VALLEY: Joan Neslund and Milton Wagy, Ellensburg Public Library; Kirsten Erickson and Dieter Ullrich, Central Washington University, Ellensburg; Erin Black, Kittitas County Historical Society; David Lynx and Mike Siebol, Yakima Valley Museum; Deloris Bowden, Moxee Library; Forest Baugher, Parker; Vivian M. Adams, Yakama Nation Library; Michelle Gerber, Pasco; Melanie Hendrix, Connie Estep, and Rene Legler of the Columbia River Exhibition of Science, History, and Technology, Richland; Paul Fridlund and Opal Martin, Prosser Historical Society; Rosie Rumsey, Wapato; Bonnie Beeks and Terry Durgan, Klickitat County Historical Society; Lee Musgrave, Marga, and Colleen Schafroth, Maryhill Museum of Art.

SOUTHEAST CORNER: Robert Bennett and Charles Potts, Walla Walla; Janet Mallen, Whitman College Northwest Archives; Jan Cronkite, Betty Chase, Loyal Baker, Tom Baker, and Anita Baker, Waitsburg; Jennie Dickinson, Joanne Whitemore, and Jenny Butler of the Dayton Historical Depot; Melinda McKeen, Washtukna; John Gordon, Betty Waldher, and Tina Keller of Pomeroy; Doug Renggli, Clarkston; Angie Meyer, Gene Dixon, and Shaun Freuden of Uniontown; Jill Price Freuden and John Weiss, Idaho-Washington Concert Chorale; Paul Brians, Pullman; Edwin P. Garretson Jr., Whitman County; Trevor Bond, Washington State University Library; Mark Truitt, Columbia Plateau Trail–Central; Norma Becker and Glenn Petersen, Colfax; Beverly Kilpatrick, Oakesdale; Glenn Alderman, Steptoe; Jean Johnson, Spokane; and Jim Weatherly and Mayor Rich Weatherly, Tekoa.

SPOKANE AND VICINITY: Tony Bamonte, Suzanne Schaeffer Bamonte, Tom McArthur, Scott Nelson, Mary Green, Jack and Janet Arkills, Wes Whaley, Bill Burke, and Bill Graham of Spokane; Jane Davey, Rose Krause, Northwest Museum of Arts & Culture, Spokane; Rayette Sterling, Spokane Public Library; Ross Schneidmiller, Liberty Lake; Charles V. Mutschler, Eastern Washington State University; Mike Barker and Jimmy and Edith Scroggie, Fishtrap Lake; Judy Abbott and Cherry Costello, Medical Lake; Trina Lee and Migs Nelson, Sprague Library; Mary Catherine Ruud, Gladys Engles, and Lonnie Henson of the Lincoln County Historical Society, Sprague; Tannis Jeschke, Lincoln County Historical Society, Davenport; and Jeff Creighton, Harland Eastwood, Christopher L. Clutter, and Jennifer Larson of Ritzville.

BIG BEND AND BEYOND: Peggy Daczewitz-Hamlin and Sherry Schweizer, Leavenworth; Jeri Freimuth and Steve Lachowicz, Chelan Public Utilities District; Bryan Stockdale, Vantage; Mark Behler and Lori Theimer, Wenatchee Valley Museum and Cultural Center; Kerri Gelb, Wenatchee Public Library; Jim Smothers, Phyllis Griffit, and Peggy Whitmore of Entiat; Linda Martinson, Lake Chelan Historical Society; Sandy Bareither and Jim Rogers, Waterville; Ann Golden, Harold Hochstatter, and Terry Mulkey of Moses Lake; Harriet Weber, Quincy Historical Society; Pat Witham, Grant County Historical Society; Kathy Kiefer, Soap Lake; Nancy Miller, Coulee City Public Library; and Paul Pitzer, Craig Brougher, and Craig Sprankle of Grand Coulee Dam.

OKANOGAN AND NORTHEAST CORNER: Roy Westerdahl, Brewster; Karen West and Richard Hart, Shafer Museum, Winthrop; Jean Fitzgerald and Richard Ries, Okanogan County Historical Society; George Frank, Riverside; Terry Knapton, Republic; Jean Urhausen and Evelynn Bolt, Kettle Falls; Ollie May Wilson, Bob Wilson, and Carol Jean Broderius, Northport; Diana L. Baxter, Colville National Forest; Camille Pleasants, Confederated Tribes of the Colville Reservation; Todd Booth and Shirley Dodson, Colville; Judy Smith, Janet Thomas, and Marvin Ray, Stevens County Historical Society; Mark Bigham and Marie DeFrank, Chewelah; and Janis Haglund, Metaline Falls.